JOHN WATERS
POPE of TRASH

edited by

JENNY HE
DARA JAFFE

with contributions by

Jeanine Basinger
B. Ruby Rich
David Simon
John Waters

interview by Sean Baker, Debbie Harry, Barry Jenkins, Johnny Knoxville, Bruce LaBruce, Ricki Lake, Orville Peck, Iggy Pop, Cindy Sherman, Kathleen Turner, Christine Vachon, Edgar Wright

ACADEMY MUSEUM OF MOTION PICTURES, LOS ANGELES | DELMONICO BOOKS • D. A. P., NEW YORK

CONTENTS

We got it all, and we show it all

DIRECTOR'S FOREWORD

John Waters: Pope of Trash is the first museum exhibition dedicated to the films of John Waters, whose bold sensibility and keen understanding of the zeitgeist have cemented his exalted position in cinematic history. Redefining the possibilities of American independent cinema with films such as *Multiple Maniacs* (1970) and *Female Trouble* (1974), Waters has turned trash into treasure. He pushes audiences' comfort levels with shocking scenarios while making them laugh uproariously along the way. In his challenge of traditional institutions, he has brought queer identity to the forefront, a hallmark of his body of work.

This complete retrospective looks back at forty years of his filmography—four shorts and twelve feature films—through handwritten scripts, concept artwork, costumes, props, posters, film clips, and more. The majority of these original production-related materials have never before been on public view. I am beyond thrilled that the Academy Museum of Motion Pictures is the site of this landmark exhibition. As the largest institution in the United States to explore and reveal moviemaking in all its facets, we are privileged to be one of the few places worldwide where movie lovers and film historians can come together to share in the appreciation of this singular art form.

I offer my deep gratitude to John for trusting the museum with the formidable endeavor of telling the story of his film career. As the subject of numerous exhibitions on his visual art and photography, John is accustomed to the process of exhibition making. But for *John Waters: Pope of Trash*, he has uniquely plumbed decades of remembrances and searched high and low (attics and basements) for the works seen in the exhibition. I thank John for his openness, for his generosity with his time, and for giving the world *Pink Flamingos* (1972) and *Hairspray* (1988).

Academy Museum Exhibitions Curator Jenny He and Associate Curator Dara Jaffe have crafted a thoughtful and rigorous review of John's filmmaking and his cultural impact, working closely with the director and members of his casts and crews. Their careful balance of the sacrilegious, hilarious, and poignant is certain to appeal to both visitors well versed in John's world and those new to it. I extend my appreciation to Jenny and Dara for their unending passion, effort, and dedication to the exhibition and this publication.

Bill Kramer, the Academy's chief executive officer, has been a steadfast champion of John's work and this project from the very beginning. I am truly grateful for his support and partnership in the museum's initiatives. Our other essential exhibition partners at the Academy include Chief Operating Officer Brendan Connell, Jr., who also serves as the museum's general counsel; Randy Haberkamp, executive vice president of the Margaret Herrick Library, Academy Film Archive, and SciTech Council; Michael Pogorzelski, director of the Academy Film Archive; and Matt Severson, director of the Margaret Herrick Library.

At the museum, I would also like to acknowledge Chief Audience Officer Amy Homma and Vice President of Curatorial Affairs Doris Berger for their exceptional leadership. Utmost thanks as well to Director of Publications Stacey Allan for overseeing the creation of this ambitious exhibition catalogue, which owes a considerable debt to its numerous contributors: Jeanine Basinger, B. Ruby Rich, David Simon, John Waters, Sean Baker, Debbie Harry, Barry Jenkins, Johnny Knoxville, Bruce LaBruce, Ricki Lake, Orville Peck, Iggy Pop, Cindy Sherman, Kathleen Turner, Christine Vachon, and Edgar Wright.

Many donors, partners, and supporters came together to make *John Waters: Pope of Trash* a reality. The exhibition is made possible by major funding from Robert and Eva Shaye, The Four Friends Foundation, and with generous support from Sara Risher. Bob and Sara are producers whose decades-long relationships with John have helped bring films such as *Polyester* (1981) and *Hairspray* to life. I thank Bloomberg Philanthropies, whose ongoing sponsorship of the Academy Museum's digital engagement platform extends the reach of our initiatives. Film historian Jeanine Basinger and Wesleyan University, which houses the John Waters Archive in its Ogden and Mary Louise Reid Cinema Archives at the Jeanine Basinger Center for Film Studies, have been valued collaborators in this endeavor as well.

Finally, I sincerely thank the trustees and staff of the Academy Museum and the Academy of Motion Picture Arts and Sciences, our parent organization. Their contributions are vital to the shared goal of safeguarding and celebrating cinema's rich heritage.

Jacqueline Stewart
Director and President,
Academy Museum of Motion Pictures

ACKNOWLEDGMENTS

Our most profound gratitude is reserved first and foremost for John Waters, who has trusted us with the privilege of curating this first-of-its-kind exhibition. We cannot thank John enough for his immense generosity in welcoming us, repeatedly, to his Baltimore home, studio, and office to select loans from his personal collection. Although busy with book tours, stage performances, speaking engagements, and myriad other projects, John always carved out time to talk with us, sharing illuminating recollections and facilitating communication with his network of equally generous collaborators and friends. His original contributions to this publication made us laugh out loud, a cherry atop our delightful collaboration. We also extend our deepest thanks to John's staff—Jen Berg, Caitlin Billard, and Trish Schweers—for coordinating our joint efforts with such kindness and resourcefulness.

We are much beholden to the lending institutions that made this exhibition and publication possible. At Wesleyan University, where the John Waters Archive is housed in the Ogden and Mary Louise Reid Cinema Archives at the Jeanine Basinger Center for Film Studies, we effusively thank Scott Higgins, Lea Carlson, and Joan Miller. We're also grateful to Wesleyan's president, Michael S. Roth, and to University Archivist Amanda Nelson. This exhibition would not exist without the foresight of Jeanine Basinger, who brought John's collection to Wesleyan. We greatly value Jeanine for her unending support and mentorship. By pure coincidence, both curators are Wesleyan alumnae, and it was a thrill to be among family on our old academic stomping grounds.

At Yale University, where the Vincent Peranio Papers are held in the Beinecke Rare Book and Manuscript Library, we thank Michelle Light, Melissa Barton, Rebecca Hatcher, and Marie-France Lemay. Recognition, as always, goes to the Academy's Margaret Herrick Library and the Academy Film Archive, both overseen by Randy Haberkamp. At the library—where we drew from its expansive collection of photographs, posters, and papers—we especially thank Matt Severson, Anne Coco, Dawn Jaros, and Warren Sherk. In particular, Anne spearheaded the acquisition of works expressly for the exhibition. For the restoration of John's early films, excerpted in the exhibition, we gratefully acknowledge Michael Pogorzelski, Joe Lindner, and Mark Toscano at the Academy Film Archive. Mark's care in overseeing this work enables the rediscovery of this important period of John's career. We also owe a debt of gratitude to Rajendra Roy, Katie Trainor, and Peter Williamson at the Museum of Modern Art for the loan of film materials from the museum's collection.

Over the course of this project, we have considered ourselves immeasurably lucky to have spoken with so many of the extended Dreamlander family. The firsthand insights and relationships gained from these meetings have been invaluable. Bob Adams, David Davenport, Gene Mendez, Pat Moran, Mary Vivian Pearce, Mink Stole, and Chuck Yeaton warmly welcomed us over meals or to their homes (and at times both). Brook Yeaton of Mobtown Prop Rentals in New Orleans gave us unfettered access to his treasure trove of props as well as our favorite answer to the question "So how did you meet John?" ("Well, he was in the room when I was born.") We are extremely appreciative of the conversations—whether by Zoom, phone, text, email, or post—with Jonathan Benya, Dolores Deluxe, Dennis Dermody, Tony Gardner, Jeffrey Pratt Gordon, Ricki Lake, Traci Lords, Susan Lowe, Vincent Peranio, Howard "Hep" Preston, Scout Raskin, Zandra Rhodes, Emily Sienicki, and Rachel Talalay. We would like to specially recognize Peter Koper. When we spoke to him in April 2022, we could not have known that he would pass away soon after; all we knew was how enchanted we were by the poetic way in which he described his experiences with John. We are grateful to have crossed his path.

Among our lenders is Noah Brodie of Divine Official Enterprises, who graciously opened his home and collection to us. Ted Sarandos, on first hearing of this exhibition, immediately offered works related to John's Netflix project, *This Filthy World* (2006). Thank you to Scott Rutherford, a neighbor of the Fishpaw house, for opening the door to two strangers knocking on a summer day and to his sister Deborah Rausch for preserving a key piece of set decoration from *Polyester* for more than forty years. We are indebted to every one of our lenders, whose names are listed on page 250.

John Waters: Pope of Trash owes its inception to Academy of Motion Picture Arts and Sciences Chief Executive Officer Bill Kramer. When he accompanied us on our Charm City visits, it was clear that Bill's Baltimore upbringing and lifelong appreciation of John Waters fostered a personal connection to this project. Academy Museum Director and President Jacqueline Stewart's enthusiasm and exceptional leadership have been essential to the development of this exhibition. Academy Museum Chief Operating Officer and General Counsel Brendan Connell, Jr., Chief Audience Officer Amy

Homma, and Vice President of Curatorial Affairs Doris Berger also offered their unwavering support.

We have many colleagues to thank at the Academy Museum. Curatorial assistant Esme Douglas, research assistants Manouchka Kelly Labouba and Emily Rauber Rodriguez, and curatorial coordinator Jaclyn Wu were crucial in bringing this exhibition to fruition. From the start, Vice President of Exhibition Planning Susan Jenkins and her team constructed the framework for this project to thrive. We thank Kate Weinberg and especially Cindy Ha for going above and beyond as the exhibition's project manager. We express immense gratitude to Vice President of Registration and Collection Management Sonja Wong Leaon and her team, who were indispensable in preparing an exhibition made up mostly of materials never before on public view. In particular, we thank the exhibition's lead registrar Bernie Sale, Celina Candrella, the exhibition's lead conservator Sophie Hunter, Rio Lopez, Sara Bisi, Lance Bad Heart Bull, Melinda Kerstein, and Cara Varnell.

For the innovative design of the exhibition, we are indebted to Senior Vice President of Exhibition Design and Production Shraddha Aryal and Exhibition Design Director Laura Belevica. They worked with Phyllis Cottrell, Andrew Mueller, Christopher Richmond, Bert Thomas, Noah Ulin, Joe Gott, Kristy Jennings, Tiana Plotnikova, Stephen Morrissey, Kelly Howland, Emily Tobias, and Corey Saldana in exhibition design and production to beautifully bring the vividness and sensationalism of John's universe to life. We also thank Chelsea Bingham and Lindsey Westbrook for their careful editing of our exhibition texts.

We greatly appreciate Associate General Counsel Lena Wong and Legal Manager Bria Grant for their licensing and legal expertise. We are profusely grateful to Senior Director of Communications Stephanie Sykes and her team, including Daniel Gomez and Owen Kolasinski for bringing the exhibition public. Additionally, we acknowledge Matt Youngner, Dawn Mori, Christine Joyce Rodriguez, and Barbara Turman in Advancement; Marty Preciado in Community and Impact; Agnes Stauber, Teague Schneiter, Martha Polk, Linsay Deming, Sarin Cemcem, and Connor Uretsky in Digital Content and Strategy; Christina Ybarra, Tuni Chatterji, Lohanne Cook, Stephanie Samera, and Eduardo Sánchez in Education and Public Engagement; Chris Roginski, Kimberly Stephens, and Ashleymae Elmore in Events and Talent Relations; K. J. Relth-Miller, Hyesung ii, and Patrick Lowry in Film Programs; Shawn Anderson and Adriana Fernández in Marketing and Communications; Mariah Gelhard, Kristina Cucchia, and Nathalie Gohel in Retail; our theater operations staff led by Ethan Caldwell; and our visitor experience staff led by Atshumi Richards.

We are bolstered and inspired daily by all of our museum colleagues, whose names are listed at the back of this book. We thank our former colleagues Ross Auerbach, Sherry Huang, and Bernardo Rondeau, as well as Heather Abbott, Matt Connolly, and Henry Kaplan, who contributed to the project's early stages; exhibition montage editors Josh Porro and Levan Tkabladze; photographers Leah Gallo, Chris Gardner, Mitro Hood, and Alex Jamison; and Academy Chief of Staff Mariko Yoshimura-Rank. Personal thanks go to Jonathan Green and Omar Madkour for their encouragement while we burned much midnight oil.

This catalogue was a result of a fruitful partnership with Director of Publications Stacey Allan, who assembled and oversaw a talented network of collaborators. The thoughtful design of this book is due to Kimberly Varella of Content Object Design Studio. Thank you to Karen Jacobson for the impeccable editing that thoroughly considered the singularity of John's work, to Dianne Woo for her meticulous proofreading, to McKell Forbes and Gina Broze for image clearances, to Publications Coordinator Lars Eckstrom for keeping us all on task, to Mary DelMonico and Karen Farquhar at DelMonico Books and Tony Manzella at Echelon for guiding this book's printing and production, and again to Research Assistant Emily Rauber Rodriguez for her skillful support on numerous aspects of this volume.

To Sean Baker, Debbie Harry, Barry Jenkins, Johnny Knoxville, Bruce LaBruce, Ricki Lake, Orville Peck, Iggy Pop, Cindy Sherman, Kathleen Turner, Christine Vachon, and Edgar Wright, we are enormously appreciative of the introspective and entertaining interview questions you posed to John. We were riveted and tickled by every answer elicited.

Finally, for their incisive, humorous, and illuminating essays, we extend deep gratitude to Jeanine Basinger, B. Ruby Rich, and David Simon. Their combined insights offer a three-dimensional rendering of the many facets of John Waters as auteur: his context, his inspiration, and his enduring legacy and influence. We could not have asked for more fitting companion pieces to our exhibition.

Jenny He
Exhibitions Curator

Dara Jaffe
Associate Curator

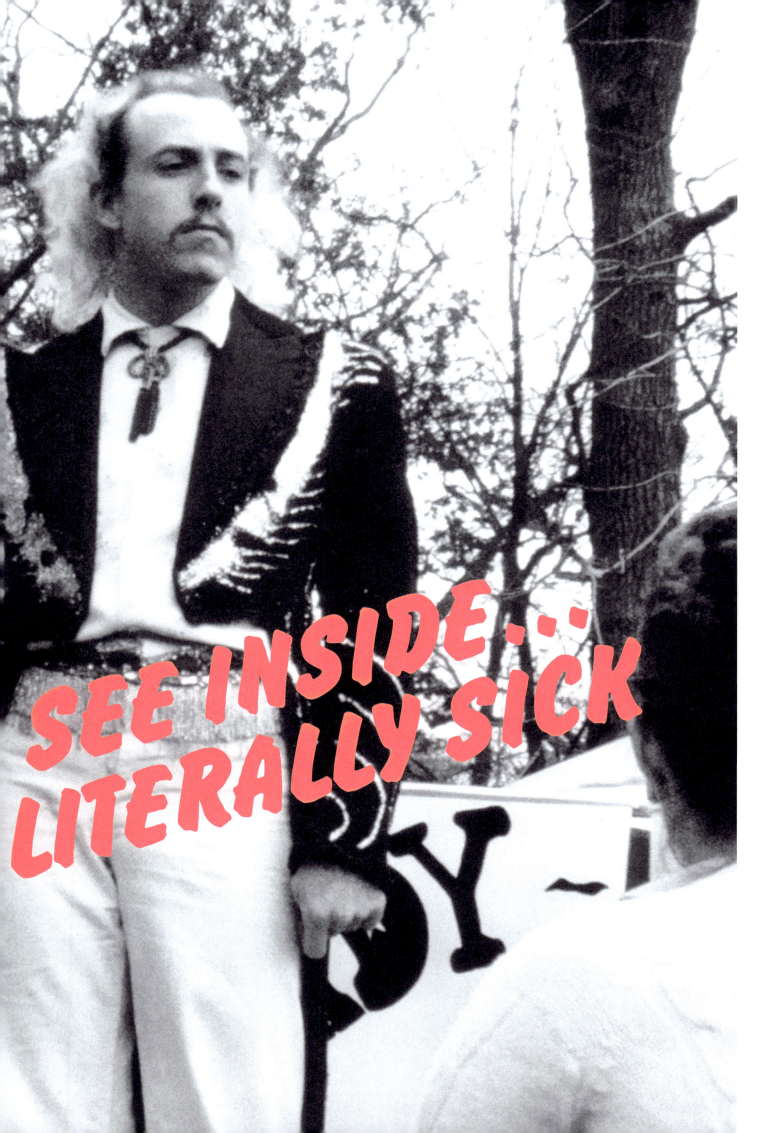

X-CATHEDRA

John Waters

When William S. Burroughs called me the Pope of Trash in 1986, not even he could have imagined my work ending up at the Academy Museum of Motion Pictures in 2023. From Lutherville, Maryland, to the corner of Wilshire and Fairfax in Los Angeles. How could that have happened? Yet here I am in the same building as the Shirley Temple Education Studio. Blasphemy? A miracle? Both, I hope.

I hate that pompous word "journey," but might I call this lunatic fifty-year trip a twisted turnpike of trash, a fantastic freeway of filth? The whole fourth floor of the museum dedicated to me! Up, up, up you'll go in the Dis-May Company of dreams to a crackpot cathedral of sinema treasures. Go ahead, Academy Museum curators, rob my hoarder house of my Foot Stomper paintings, my 16mm camera, even Edith Massey's "Zingy Zip-up" heels, the ones she wore in *Female Trouble*. Invade my archives at Wesleyan University, pick clean the collections of the Divine Estate, the private souvenirs of living Dreamlanders. Show my trash to the world! Fill those 11,400 square feet of the Marilyn and Jeffrey Katzenberg Gallery with my negative-review scrapbooks, unlaundered costumes, and nutso keepsakes, some stolen from the very locations we shot in.

I'm not one bit humbled. How could I be? I'm revved up, proud as polluted punch, and so excited to crash such a brand-new institution. William Castle, I honor you. Andy Warhol, I genuflect to your infallibility. Pier Paolo Pasolini, I pray to you nightly. I believe in the higher power of shock value, and this Holy Trinity has been my guiding light through the climb up from the underground to Hollywood and right back down to where I started, the glamorous gutter of art-exploitation films.

Now for my Oscar speech. Here goes. Thank you, Academy Museum, without the slightest bit of irony, not even a smirk, for having the nerve to honor me and my comrades who helped me make my "celluloid atrocities," as they were once called. Especially to my fans—the smart, slightly pissed-off moviegoing folk who can laugh first at their own twisted tastes and then at mine, allowing me to get away with this career for more than half a century.

Yes, I am the joyous fag in a black leather jacket, the Roman candle vandal who ate my makeup and vomited it right back up on the mondo trasho screen. And you . . . the multiple maniacs who led me to the extremes of *Pink Flamingos*. You are the filthiest people alive, not I! Divine didn't have female trouble or live a desperate life because your hairspray acclaim firmed up his legend so that he never had to be a crybaby. No, he was a serial man with a pecker in real life. Cecil B. DeReinvented indeed. The fact that he is not here with us in person at this exhibition is a dirty shame, but only a fruitcake would think his spirit is missing. As Dawn Davenport cried out to her public from the electric chair, "Please remember, I love every fucking one of you!" I do too. Forever.

LET'S GET NAKED

AND SMOKE

JOHN WATERS: POPE OF TRASH
AN INTRODUCTION

Jenny He

I AM GOING TO OVERDOSE ON RESPECTABILITY AND THAT IS A NEW HIGH. —JOHN WATERS

In an unexpected turn of events, John Waters has found himself in a peculiar state. He opens his latest memoir, *Mr. Know-It-All: The Tarnished Wisdom of a Filth Elder* (2019), with the line "Somehow I became respectable."[1] His evidence includes career film retrospectives, invitations to give commencement speeches at colleges, medals from international governments, and collaborations with classy distributors like Criterion and cathedrals of culture like New York's Museum of Modern Art. Since the book's release, Waters's singular opus of filth, *Pink Flamingos* (1972), has been inducted into the National Film Registry, added in 2021. The following year *Hairspray* (1988) also joined the list.[2] There is perhaps nothing more subversive for a subversive filmmaker than these detours into respectability. Next stop: a museum exhibition dedicated to his film canon, the first exhibition of its kind. Has Waters himself become one of those institutions he loves to lampoon?

The multihyphenate filmmaker, author, and visual artist is well known for transgressive cinema, having spent his career skewering traditional institutions and violating the boundaries of acceptability imposed by society.[3] His do-it-yourself, underground approach has informed his four shorts and twelve features, films that revel in irreverence, laugh-out-loud humor, and heart. It was the novelist William S. Burroughs who in 1986 anointed the writer-director the Pope of Trash, a fitting honorific that communicates succinctly the through lines of Waters's career.[4] It touches on aspects of Waters's upbringing, speaks to the exhibition venues of his early films, and carries through to the themes of his movies. His mother was Roman Catholic, and he attended a Catholic high school, Calvert Hall, in Towson, Maryland, a suburb north of Baltimore. His early films had their illustrious premieres in the great halls of churches (though, notably, not of the Catholic persuasion).[5] And "sacrilegious depictions of Catholicism and its imagery" appear throughout his filmography, as detailed by Dara Jaffe later in this volume.

Waters's high-shock-value movies—rebellious acts against the "tyranny of good taste"—have cemented his position as one of the most revered

Divine in *Pink Flamingos* (1972)

You stand convicted of assholism. The proper punishment will now take place.

WATERS'S HIGH-SHOCK-VALUE MOVIES HAVE CEMENTED HIS POSITION AS ONE OF THE MOST REVERED AUTEURS IN AMERICAN INDEPENDENT CINEMA

Electric chair from *Female Trouble* (1974)

auteurs in American independent cinema.[6] Often described as "trash" films, his movies find kinship with and concurrently diverge from exploitation films that emphasize violence, sex, and situations of tenuous morality, like the offerings from his cinematic heroes Herschell Gordon Lewis (the King of Gore) and Russ Meyer (according to Waters, "the Eisenstein of sex films").[7] Outside of major metropolitan areas, movies such as Lewis's *Blood Feast* (USA, 1963) and Meyer's *Faster, Pussycat! Kill! Kill!* (USA, 1965) were typically shown at drive-in theaters, where Waters saw them.[8] Unable to compete with the multiplexes by showing

Hollywood productions, these venues formed a symbiotic relationship with moviemakers by giving them a specific platform and encouraging the creation of lurid fare, which drew in audiences hungry for niche experiences. Waters would soon expertly adopt this method of matching form with distribution for his own work. While his films—from his first short, *Hag in a Black Leather Jacket* (1964), to his latest feature, *A Dirty Shame* (2004)—all contain shocking situations, he intends his exploitation films for the art house.[9]

Although it is often assumed that a tension exists between high and low, art and trash, trash is not antithetical to art. Instead trash here is defined as a deliberate deviation from the conventional, similar to the camp aesthetic often attributed to Waters.[10] Susan Sontag, in her 1964 essay "Notes on 'Camp,'" articulated camp as an approach that challenged dominant notions of taste: "The essence of camp is its love of the unnatural: of artifice and exaggeration."[11] While camp had been employed by other artists as a rebellion against the mainstream, Waters shaped this mode to his singular sensibilities. He recognized that moviegoers retreat to the darkness of theaters sometimes for "a vacation from proper behavior and good taste and required responses," an apt description of trash films applied by Pauline Kael in her 1969 article "Trash, Art, and the Movies."[12] Trash has enabled Waters, via stylized exaggeration, to use humor as a counterbalance to perverse or off-limits subject matter that would have been impossible to stomach if treated matter-of-factly. Making audiences laugh uproariously is a Waters trademark as much as, if not more so than, the moments of shock that are often noted. Waters's marriage of trash and art is found throughout his renegade films, which are replete with misfit muses; themes derived from fetishes, obsession, and celebrity culture; and tributes to his hometown of Baltimore.

The exhibition *John Waters: Pope of Trash* unearths decades of cinematic memories that had been relegated to lore, written about at length in books and articles, memorialized on-screen via the final art object of the movie, and at times glimpsed out of filmic context in exhibitions of Waters's visual art. The works on view in the exhibition have been preserved largely through the efforts of the film historian Jeanine Basinger, who approached Waters in 1986 and proposed that she become the steward of his collection through Wesleyan University's Ogden and Mary Louise Reid Cinema Archives, and Waters's own diligence in collecting materials from his cast and crew and shepherding them to the university's campus in Middletown, Connecticut.

Each of Waters's films is unreeled in depth in the galleries, which display handwritten scripts, costumes, props, posters, correspondence, scrapbooks, photographs, film clips, and more that recall moments that are absolutely recognizable to cult fans, those who relish the taboo of his outré themes, seared into their memories through repeated viewings. The exhibition also enlightens those admirers who were gained during the current phase of respectability, who know the filmmaker through his accomplished storytelling in print, onstage, and through cameos in films and in television series such as *The Simpsons* and *The Marvelous Mrs. Maisel*.[13] This John Waters may come across as an amiable if ribald "Uncle John," whose movie *Hairspray* begat a hit Broadway musical (2002).[14] With the potential to (delightfully) surprise this segment of visitors, *John Waters: Pope of Trash* journeys through Waters's film career chronologically, tracing the grotesque, lush, tacky, putrid, and salacious elements that recur throughout a forty-year body of work. The exhibition, like his movies, is amplified by hyperbole and populated by artisans and performers who devote their crafts to this paragon of American originality, a born showman.

THERE ARE A HANDFUL OF DIRECTORS WHO ARE INTRINSICALLY LINKED TO A CITY OR A TOWN, BUT NO OTHER DIRECTOR IS A LOYALIST THE WAY WATERS IS

John Samuel Waters Jr. came into the world in Baltimore's Franklin Square Hospital at 11:17 p.m. on April 22, 1946, and grew up in Lutherville, Maryland, a northern suburb of Baltimore, not too far from where he currently resides. There are a handful of directors who are intrinsically linked to a city or a town, but no other director is a loyalist the way Waters is. With the exception of a few scenes, all his films were shot in Baltimore and take place in and around the city. Fells Point, a waterfront neighborhood in southeastern Baltimore and the site of many of his creative endeavors, is where Lobstora went "back" into the sea, ceremoniously thrown into Chesapeake Bay by Waters and its creator, Vincent Peranio, after the production of *Multiple Maniacs* (1970). For the setting of 1998's *Pecker*, Waters selected Hampden, historically a

Mink Stole and Divine in *Multiple Maniacs* (1970)

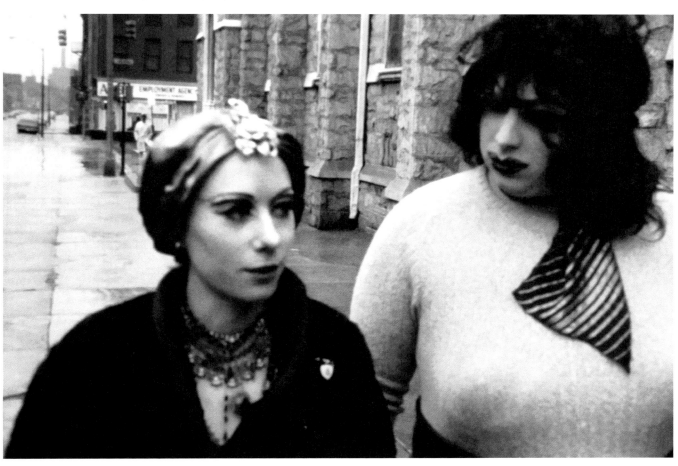

seedy, grungy working-class neighborhood filled with Formstone-covered row houses and uplifted by the character and charm of real life.[15] Touched by gentrification in the 1990s, the filming location doubles as an allegory for the dichotomy at the heart of *Pecker*: the sincerity of art-naive real-folk Baltimoreans versus the pretentious elitism of denizens of the New York art scene. The film parodies the two groups equally, and Waters holds affection for both sides of the divide.

The Baltimore area is where Waters met many of his longtime collaborators, most of them known as Dreamlanders, after his first production company, Dreamland Studios. In fact, Mary Vivian Pearce, who has appeared in all of Waters's films to date, has known him since birth. (Their parents were best friends, a relationship that was later strained by the collaborations and antics of the coconspirators.)[16] In high school, Waters lived up the street from Harris Glenn Milstead, who would later become Divine, a name coined by Waters. Through Milstead, Waters met David Lochary and Pat Moran. These neighborhood friendships would later prove pivotal to Waters's film work. Even outside the city, Waters gravitated toward fellow townsfolk. In 1966 he met Baltimore native Nancy Stoll in Provincetown, Massachusetts. Stoll would soon become known as Mink Stole, likewise named by Waters.

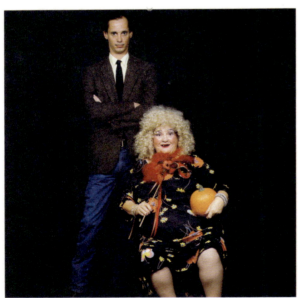

Both Have "Shocked" Baltimore With Their Talent

John Waters (Film Producer) Edith Massey (Punk Rock Singer & Film Actress)

John Waters and Dreamlander Edith Massey, featured in Baltimore's 1st Annual Sexiest Celebrity Calendar, 1983

His home city is equally enamored of Waters. In 1988 then Maryland governor William Donald Schaefer proclaimed February 14–20 John Waters Week on the occasion of the release of *Hairspray* "as his movies have served . . . as a source of pride and inspiration for [Baltimore's and Maryland's] citizens."[17] Of course, this accolade pales in comparison to a previous honor: Waters's inclusion in Baltimore's 1st Annual Sexiest Celebrity Calendar. Later in this volume, another well-known Baltimorean—the author, writer, and producer David Simon—expands on the approach by which Waters first entered "the collective mind of Baltimore" by wholeheartedly upending society's ideas of normalcy.

> Used to be, reader, if a man took off his pants in public you called the police. Now you applaud. Drug freaks, revolutionaries, unisexies—you love them all, which is okay for you, maybe, but hell for people trying to stay ahead, like Andy Warhol.
> —Elenore Lester, *Esquire*, May 1969[18]

Hag in a Black Leather Jacket was Waters's first film, made when he was 17 years old. This 8mm short— a silent film with musical score, including a snippet from a live performance of "Over the Rainbow"— had a budget of $30.[19] Filmed at his parents' house (a common shooting location for Waters), it features a Ku Klux Klan member perched atop a chimney who officiates an interracial wedding between a Black man (Bobby Chappel) and a white ballerina (Mona Montgomery). Waters's next film, *Roman Candles* (1967), was made on a budget of $300.[20] Influenced by the split-screen structure of Andy Warhol and Paul Morrissey's *Chelsea Girls* (USA, 1966), the triple-projection film featured some of his Dreamland retinue—Pearce, Stole, Lochary, Moran—and starred Maelcum Soul, a model and a hostess-barmaid at Martick's Tavern in Baltimore, whom Waters had met through Moran. Waters has said, "Maelcum was the most astonishing bohemian I've ever known, and she influenced my twisted vision of how women should look more than any film, book, or painting."[21] Had it not been for a fatal overdose in 1968 at the age of 27, she might have been his biggest star. Instead that mantle was taken up by Divine, who made his debut in this film. Warhol had his superstars, and Waters had his Dreamlanders.

At first glance, Waters's forebears and peers are arguably the artists of the post–World War II American avant-garde, antiestablishment painters, playwrights, and filmmakers who created

WARHOL HAD HIS SUPERSTARS, AND WATERS HAD HIS DREAMLANDERS

Maelcum Soul, early 1960s

experimental works. Redefining cinema, avant-garde moviemakers had very small budgets, necessitating the use of 8mm and 16mm formats. Their nonnarrative shorts and features were a rebellion against the dominant landscape of American mainstream movies and often included queer themes and depictions. Understandably, reviewers often grouped Waters with underground filmmakers like Jack Smith, and *Roman Candles* was presented on a double bill with Kenneth Anger's *Eaux d'Artifice* (USA, 1953). Screened in art galleries and other unconventional theatrical settings, the films mostly existed outside commercial channels of distribution.

In New York City, venues like Amos Vogel's Cinema 16 and Jonas Mekas's Film-Makers Cinematheque (later Anthology Film Archives) helped to cultivate an audience. As B. Ruby Rich notes in her essay in this volume, Waters religiously followed Mekas's Movie Journal column in the *Village Voice*, and he would take the bus to New York, where he frequented the city's movie houses. Waters continued this filmgoing habit in lieu of attending classes during a short stint at New York University. He also patronized John Vaccaro's Play-House of the Ridiculous and later Charles Ludlam's Ridiculous Theatrical Company, with the latter group influencing the lobster rape scene in *Multiple Maniacs*. Soon, however, Waters would diverge from American avant-garde and cult underground contemporaries such as Anger and Smith. He pivoted away from experimental shorts in favor of the

picaresque narratives that would come to define his filmic output. In *Eat Your Makeup* (1968), Soul plays an unhinged governess who abducts young women and forces them to model for her and her friends to the point of death, an early example of Waters's outrageous cinematic storytelling. The film also features the much-mentioned scene in which a young Divine reenacts the Kennedy assassination in the role of Jacqueline Kennedy.

In further contrast with the underground film movement, Waters actively sought wide distribution, in part by displaying shrewd marketing acumen. In *Cult Cinema* (2011), Ernest Mathijs and Jamie Sexton write that Waters "constructed his own cult image . . . through carefully courting scandal through the press (in order to widely publicize his films via controversy)."[22] But this notoriety was in some cases happenstance. When Waters and his actors were arrested during the filming of his first feature, *Mondo Trasho* (1969), it was entirely unplanned. A scene involving a nude hitchhiker, filmed at Johns Hopkins University, was interrupted by campus police. The cast and crew scattered, and several members were later caught and charged with participating in indecent exposure; in Baltimore a man taking off his pants in public was not yet applauded. Of course, Waters subsequently turned this incident to his advantage, using the crime story to advertise the film.

Waters's promotional tenacity is fully demonstrated by *Pink Flamingos*. After the film premiered at a festival held at the University of Baltimore in March 1972, Waters set his sights on national exposure. The filmmaker reached out to Bob Shaye, president of New Line Cinema, whom he had contacted regarding his previous films. This time he was successful in finally convincing Shaye to distribute his latest film.[23] Waters was not content, however, to sit idly by with no involvement in the marketing. Knowing where to find his audience, he actively persuaded New Line to release the film at midnight at the Elgin Theater, in New York City's Chelsea neighborhood. As Waters recounts in *Shock Value*, the Elgin "agreed to show it one night," so he and Lochary, one of the film's stars, "called every person [they] knew in New York and begged them to attend." The attendance they generated encouraged the theater to show *Pink Flamingos* again the following weekend.[24] The rest is history. He has in his home the armrest from a theater seat marking its fifty-week run at the (now defunct) Elgin. A darling of the midnight movie scene, the film was Waters's first taste of show business profit. He had found a distribution mode that perfectly aligned with his cinematic inclinations.

Armrest commemorating the fifty-week run of *Pink Flamingos* (1972) at the Elgin Theater in New York

Distinct from a movie shown at midnight, which, as Neil Strauss writes in the *New York Times*, is mostly a way for a theater to "pump a few more dollars out of a feature it is showing regularly during the day," a midnight movie "is a film shown exclusively in the dead of night. Usually, it is fun, weird, campy or creepy. Sometimes it is fun, weird, campy *and* creepy. Always, it is an event."[25] Although avant-garde filmmakers had shown their films late at night in nontraditional locations in the early 1960s, the first showing of a midnight movie is generally agreed to have taken place at the Elgin Theater in late 1970, when *El Topo* (USA/Mexico, 1970) by Alejandro Jodorowsky was screened. *Pink Flamingos* was the Elgin's second-ever midnight movie. The film's lasting impact resulted from this extended yearlong residency at the Elgin, spurred by word of mouth and eager repeat audiences.

The highest-grossing film in the year of *Pink Flamingo*'s release was *The Godfather* (USA, 1972), which was also named Best Picture at the Academy Awards. With *Pink Flamingos*, Waters had solidified a reputation and following on the American cinematic landscape that was more analogous to the audience for Coppola's popular film than to that for Warhol's *Blow Job* (USA, 1964), further widening the chasm from Waters's experimental beginnings. Filmgoers could readily picture the last shot of *The Godfather*, in which a door closes on Kay (Diane

A DARLING OF THE MIDNIGHT MOVIE SCENE, *PINK FLAMINGOS* WAS WATERS'S FIRST TASTE OF SHOW BUSINESS PROFIT

Keaton), separating her from the world of her husband, Michael (Al Pacino). Likewise, even for John Waters neophytes, the mere mention of *Pink Flamingos* conjures up thoughts of canine coprophagia, an act featured in its famous last scene.

Unsurprisingly, Waters's films were a point of contention for the Maryland State Board of Censors and its lead censor, Mary Avara, who once said that the mere mention of Waters's name made her mouth feel dirty.[26] Waters in turn has called Avara the greatest press agent ever because of the free publicity their legendary clashes generated.[27] Before *Female Trouble* (1974) was approved to screen publicly in Maryland, Waters was forced to cut a cunnilingus scene from his only print and had to pay the board $16 for his trouble. Nearly fifty years later, the receipt for this payment is still proudly in his possession. *Desperate Living* (1977), with its depiction of a town for society's outlaws and outcasts that was constructed out of literal garbage, rounded out the "trash trinity" that began with *Pink Flamingos.*

Waters and Peranio, who served as art director and set designer, scoured Baltimore for people tearing down their homes and used the detritus they collected to build Mortville.[28] Their adventures were not unlike those undertaken by the curatorial team in assembling this exhibition. Over the course of three years, Dara Jaffe and I searched for props, costumes, and other screen-used objects that had been scattered to the wind before Waters's Wesleyan collection started. One such investigation led us to Severna Park, southwest of Baltimore, where *Polyester* (1981) was filmed. We had learned that Waters and his crew held a yard sale after production wrapped in the cul-de-sac where the film's main setting, the Fishpaws' residence, was located. On our first try, knocking on neighbors' doors, we serendipitously found the bar cart that was prominently featured in the opening scenes of the film. This piece of set decoration epitomizes the themes of domesticity and class that *Polyester* so deftly satirized. It—along with the Fishpaws' house sign and a tennis outfit worn by Edith Massey as Cuddles Kovinsky, also on view in the exhibition—illustrates a tonal shift in Waters's filmography. Starting with *Polyester*, his star, Divine, evolves from an explosive bombshell fashioned after Jayne Mansfield, a persona seen in earlier films, to a put-upon matron.

Why not do the *Deane Show* on Baltimore TV again? Just once. A special. The ultimate reunion.
—John Waters[29]

By 1988 Waters was well known as a purveyor of on-screen trash, taboo, and filth. Firmly cemented as the provocateur of American independent cinema, how else could he create original shock? By making a PG movie, of course. Three years before the release of his dance film *Hairspray*, Waters published an essay—"Ladies and Gentlemen . . . the Nicest Kids in Town!"—in *Baltimore* magazine that recollected, with ardor, the Baltimorean phenomenon of *The Buddy Deane Show*.[30] This teen dance show, the local version of *American Bandstand*, aired six afternoons a week on WJZ-TV (channel 13) in Baltimore from 1957 until 1964 and was hosted by Winston "Buddy" Deane. Although Waters was

FIRMLY CEMENTED AS THE PROVOCATEUR OF AMERICAN INDEPENDENT CINEMA, HOW ELSE COULD HE CREATE ORIGINAL SHOCK?

From left: Cyrkle Milbourne, Alan J. Wendl, Ruth Brown, Michael St. Gerard, Divine, Ricki Lake, Shawn Thompson, Mink Stole, Leslie Ann Powers, and Clayton Prince in *Hairspray* (1988)

John Waters and Divine at the premiere of *Hairspray*, Baltimore, 1988

never a Committee member, as the regulars were known, he and Mary Vivian Pearce appeared as guest dancers when the show did an event at their local swim club (later the inspiration for Turkey Point in *Cry-Baby*). His personal experiences informed the idealistic rewriting of the story of *The Buddy Deane Show* into the fictional *Corny Collins Show* of *Hairspray*, a film that serves as a counternarrative to mid-20th-century mores and circumstances.[31]

Tracy Turnblad, the protagonist of *Hairspray*, which is set in 1962, takes on the integration of the segregated *Corny Collins Show* two years before the Civil Rights Act of 1964.[32] While Baltimore may have been more progressive than other segregated cities—it was the first city in the South to officially integrate its public schools after the Supreme Court's 1954 ruling in *Brown v. Board of Education*—it was segregated nonetheless. So was *The Buddy Deane Show*. Deane recalled that when the show started airing in 1957, management decided to follow "the local custom" of segregation and "separate but equal" dance days.[33]

The activism in *Hairspray* recalls actual protests surrounding *The Buddy Deane Show*, which were among the innumerable actions by those fighting for equality in various arenas during the US civil rights movement. In June 1962 members of Morgan State College's Civic Interest Group, made up of white and Black high school and college students from Baltimore, picketed the show, demanding

integration. Similarly, in *Hairspray*, Seaweed (Clayton Prince) and Penny (Leslie Ann Powers) chant "Segregation Never! Integration Now!" when L'il Inez (Cyrkle Milbourne) is barred from entering the whites-only preteen day on the fictitious show. On August 12, 1963, Baltimore Youth Opportunities Unlimited (BAYOU), the Baltimore branch of the Northern Student Movement, planned an integration event. During a "Black Monday" reserved for Black teens once a month, a group of both Black and white kids stormed the station and started dancing together on live TV. The result contrasted starkly with the sunny ending of *Hairspray*. *The Buddy Deane Show* responded immediately by blurring the picture, but it was too late. Bill Henry, then head of BAYOU, recalled, "I remember that the lights on the show got so dim the kids were silhouettes. But you could still tell it was white and black kids dancing together."[34] Proponents of segregation continually sent the show bomb threats, forcing its sudden cancellation in January 1964.

While Hollywood productions are known to view reality through rose-colored lenses, Waters's simple resolution to decades of ingrained and systemic racism wasn't in service of a happy ending. Rather, the relative ease with which Tracy accomplishes integration in the film speaks to the film's shock value. Waters set out to make a comedy about segregation starring a plus-size heroine who proudly embraces her weight. *Hairspray* showcases pimples, pus, and

puke (all coming from the "beauty queen" character, Amber Von Tussle, played by Colleen Fitzpatrick), and as Janet Maslin writes in her film review, "There's no shade of mustard or chartreuse too awful to be re-created here."[35] Waters stated: "My movie was never supposed to be the truth. It's not even the dream version. It's the John Waters version."[36]

> In Hollywood, being fired is a good job.
> I'd apply if I were you.
> —John Waters[37]

Following *Hairspray*, Waters entered a new phase of his film career in which his movie budgets climbed to astronomical levels (when compared to the "trash trinity," which cost less than $100,000 altogether, or *Polyester*, which cost $300,000).[38] Even *Hairspray* was made on a modest $2.7 million budget. His next film, the musical *Cry-Baby* (1990), had a budget of $12 million. This turning point coincided with the profound loss of Waters's stalwart star Divine, who died in his sleep after suffering a heart attack two weeks after the premiere of *Hairspray*.

Without Divine, Waters cycled through a coterie of Hollywood actors who were central to his films, each in their own unique way, including Johnny Depp in *Cry-Baby*, Kathleen Turner in *Serial Mom* (1994), and Melanie Griffith in *Cecil B. Demented* (2000). Waters had gone Hollywood, but instead of the mainstream diluting him, it was quite the opposite. He made these well-known actors part of his merry band of misfits, giving them roles that purposefully debased their polished images. Then famous for the television show *21 Jump Street* (1987–91), in which Waters would later guest star, Depp was cast as the lead in *Cry-Baby*, a story of Drapes (the "bad kids") versus Squares (the "good kids") set in the 1950s. Depp's celebrity as a teen idol who graced the covers of magazines such as *Bop* and *Us* was enticing to Waters, who conspired with the actor to "haywire that image" and make fun of his "dreamboat" status.[39]

Before Turner played the titular mother, Beverly Sutphin, in *Serial Mom*, she was Peggy Sue, from *Peggy Sue Got Married* (1986), and Barbara Rose, from *The War of the Roses* (1989). In Waters's send-up of the true-crime genre, Turner increases the range of her acting roles to portray a seemingly sweet and proper suburban mom who turns out to be a serial killer. Riotously, her victims are condemned for committing etiquette faux pas such as not rewinding a videocassette before returning it to the rental store or wearing white shoes after Labor Day. Stylized after criminal-case dramas, *Serial Mom* starts with a fake-out, a satirical twist on the standard disclaimer: "This film is a true story. The screenplay is based on court testimony. Sworn declarations. And hundreds of interviews conducted by the film-makers." Turner's convincing performance had viewers second-guessing whether Beverly was indeed out in the world, pummeling unsuspecting neighbors with legs of lamb.

25

Kathleen Turner in *Serial Mom* (1994)

Johnny Knoxville in *A Dirty Shame* (2004)

Waters said of Griffith, "Audiences don't know how hard it is to play a bad actress without being one."[40] Featuring Griffith as a Hollywood starlet who is kidnapped by a band of renegade filmmakers and forced to act in their movie, *Cecil B. Demented* may appear, on the surface, to be an autobiographical work. One can see why viewers might recognize something of Waters in Cecil, the director played by Stephen Dorff, with his DIY credo and belief in his particular filmmaking sensibility no matter the outside forces saying otherwise. The film's ensemble cast of cinematic nonconformists could even be Waters's own Dreamland crew. But the film makes a point of critiquing the self-serious, militant title character, a dogmatic cineaste. Even Waters's own image as an auteur filmmaker is not off-limits from parody.

The generation who grew up watching the *Jackass* franchise, which began as a television series in 2000, may not realize how relatively tame its boundary-pushing, gross-out antics were when compared to the films of John Waters or how the *Jackass* episodes and films are inheritors of Waters's oeuvre. One of *Jackass*'s creators, Johnny Knoxville, stars in *A Dirty Shame* (2004) as Ray-Ray, a spiritual leader of sex addicts. In behind-the-scenes footage, Knoxville acknowledges Waters's new phase by noting how, in contrast to the earlier Dreamlander films, "for us Hollywood people, it's one movie and out!"[41]

By virtue of being made by Waters, the film, which also featured well-known actor Tracey Ullman, was marked with an NC-17 rating by the Motion Picture Association of America. Although nothing extreme is depicted in the film, it was nevertheless given a rating that forbids the admittance of anyone 17 years of age or younger and cautions those who might be easily offended. The rating exemplifies Waters's stamp on the cinematic landscape through forty years of filmmaking. The phrase "a film by John Waters" brings forth an expectation. How can you fault Waters for seeking out new ways to shock? And what would be more unexpected than being viewed as respectable?

Love them or hate them, his movies leave no one indifferent. Waters himself loathes middle-of-the-roaders, so this reaction suits him just fine. Famously, the marketing campaign for *Pink Flamingos* included a trailer that showed no footage from the film, only testimonials and quotes from audience members who were either riveted or revolted by the film—no tepid responses. After experiencing a complete immersion in his film history, visitors to the exhibition may question whether Waters is indeed respectable. Perhaps he is getting the last laugh, and for such a storied provocateur, there is no higher accolade.

Notes

Epigraph John Waters, e-mail correspondence with the author, June 18, 2022.

1. John Waters, *Mr. Know-It-All: The Tarnished Wisdom of a Filth Elder* (New York: Farrar, Straus & Giroux, 2019), 3.

2. Since 1989 the National Film Registry has designated films for preservation based on their significance to American cinematic heritage. As of 2022, the list totals 850 titles. The films are annually selected by the Librarian of Congress from nominations by the public and the National Film Preservation Board (NFPB), which was founded in 1988 through the National Film Preservation Act. In 2023 the board chair of the NFPB is Jacqueline Stewart, director and president of the Academy Museum of Motion Pictures.

3. Waters served as writer and director for the entirety of his filmography and as producer, cinematographer, and editor on his first eight films.

4. Waters was first referred to as the Pope of Trash by William S. Burroughs on the occasion of the publication of *Crackpot*, a collection of essays by the filmmaker.

5. *Roman Candles* (1967), *Eat Your Makeup* (1968), and *Mondo Trasho* (1969) were all first screened at the Emmanuel Episcopal Church in Baltimore, and *Multiple Maniacs* (1970) was first screened at the First Unitarian Church in Baltimore.

6. Waters writes in the afterword to *Director's Cut* (Zurich: Scalo, 1997): "I can't stand the tyranny of good taste in David Lean's movies. His direction is so fucking sweeping, so cinematically correct, so goddamn perfect, that I dread his influence on the next generation of 'highbrow' wannabees" (287).

7. John Waters, *Shock Value: A Tasteful Book about Bad Taste* (New York: Thunder's Mouth, 2005), 192.

8. Waters, *Shock Value*, 192, 202.

9. "John Waters Retrospective Opens at Film Society of Lincoln Center," *Wall Street Journal*, September 4, 2014.

10. Ernest Mathijs and Jamie Sexton, *Cult Cinema: An Introduction* (Chichester, West Sussex: Wiley-Blackwell, 2011), 120.

11. Susan Sontag, "Notes on 'Camp'" (1964), in *Against Interpretation and Other Essays* (New York: Picador USA, 2001), 275.

12. See Pauline Kael, "Trash, Art, and the Movies" (1969), in *Going Steady: Film Writings, 1968–1969* (London: Marion Boyars, 1970), 87–129.

13. Waters guest starred as a gay novelty store owner on *The Simpsons* (1989–present) in the episode "Homer's Phobia," which first aired on February 16, 1997. His role on the network television show—appearing months before Ellen DeGeneres announced, "Yep, I'm gay," on the cover of *Time* magazine and her character came out on *Ellen* (1994–98) in April 1997—was monumental for queer representation in the mainstream cultural landscape.

14. Uncle John is a character from an unrealized animated television series called *John Waters' Patent Leather Dreamhouse*, developed in the early 2000s, in which Waters plays himself. The persona of a congenial uncle, quite distant from his earlier, renegade years, is further affirmed in an interview in which Waters has said of his family relationships: "I've got a lot of nieces and nephews. . . . I'm a good uncle. I'll get you an abortion, get you out of jail or take you to rehab. . . . I don't want children but I like children and children like me . . . because I look like a cartoon character." Nick McGrath, "John Waters: My Family Values" (interview), *Guardian*, September 18, 2015, https://www.theguardian.com/lifeandstyle/2015/sep/18/my-family-values-john-waters-film-director-hairspray-serial-mom.

15. Formstone is a type of faux masonry that was patented in 1937 by Baltimorean Albert Knight. The simulated stonework was widely used throughout Baltimore to cover building facades. Waters famously called Formstone the "polyester of brick" in the 1998 documentary *Little Castles: The Formstone Phenomenon*, directed by Skizz Cyzyk (Truckstop Motion Pictures, 1998).

16. Waters, *Shock Value*, 37.

17. Certificate from the Office of the Governor, box 59, John Waters Papers, Special Collections & Archives, Wesleyan University (hereafter referred to as Waters Papers).

18. Elenore Lester, "The Final Decline and Total Collapse of the American Avant-garde," *Esquire*, May 1969, 142.

19. Waters, *Shock Value*, 41.

20. Carl Schoettler, "Underground Film Shown," *Baltimore Evening Sun*, May 11, 1967, scrapbook of newspaper clippings, box 3, folder 23, p. 60, Waters Papers.

21. Waters, *Shock Value*, 42.

22. Mathijs and Sexton, *Cult Cinema*, 68–69.

23. *Pink Flamingos* marked the start of a long collaboration between Waters and New Line Cinema. The film company went on to distribute eight of his twelve features to date: *Multiple Maniacs, Pink Flamingos, Female Trouble, Desperate Living, Polyester, Hairspray, Pecker,* and *A Dirty Shame*.

24. Waters, *Shock Value*, 21.

25. Neil Strauss, "It Must Be Midnight and Must Be Weird," *New York Times*, July 7, 1995.

26. Michael Ollove, "Waters Owes His Career Partly to the One Woman Who Hated His Films Most," *Baltimore Sun*, August 12, 2000.

27. Waters, *Shock Value*, 89.

28. Waters, *Shock Value*, 167.

29. John Waters, *Crackpot: The Obsessions of John Waters* (New York: Scribner, 2003), 110.

30. John Waters, "Ladies and Gentlemen . . . the Nicest Kids in Town!," *Baltimore*, April 1985, https://www.baltimoremagazine.com/section/artsentertainment/john-waters-on-keeping-the-memory-of-the-buddy-deane-show-alive/.

31. See Taunya Lovell Banks, "Troubled Waters: Mid-Twentieth Century American Society on 'Trial' in the Films of John Waters," *Stetson Law Review* 39, no. 1 (2009): 153–82.

32. The Civil Rights Act prohibited discrimination on the basis of race, color, religion, sex, or national origin in employment, schools, and public places.

33. Laura Wexler, "The Messy Truth of the Real 'Hairspray,'" *Washington Post*, September 17, 2003, https://www.washingtonpost.com/archive/lifestyle/2003/09/17/the-messy-truth-of-the-real-hairspray/6be8c494-2ca1-42a1-bdee-fd3969d7fc90/.

34. Wexler, "Messy Truth."

35. Janet Maslin, "'Hairspray,' Comedy from John Waters," *New York Times*, February 26, 1988.

36. John Waters, quoted in Wexler, "Messy Truth."

37. Waters, *Mr. Know-It-All*, 66.

38. The film budget for *Pink Flamingos* was $10,000; for *Female Trouble*, it was $27,000; for *Desperate Living*, it was $60,000 (press notes for Dreamland Films, March 6, 1976, box 7, folder 6, Waters Papers); the budget for *Polyester* is found in *Polyester* Finance Agreement, 1980, box 10, folder 3, Waters Papers.

39. Waters, *Mr. Know-It-All*, 51.

40. Waters, *Mr. Know-It-All*, 95.

41. Johnny Knoxville, in "All the Dirt on 'A Dirty Shame,'" directed by Mark Rance, bonus content on *A Dirty Shame*, directed by John Waters (New Line Home Video, 2005), DVD.

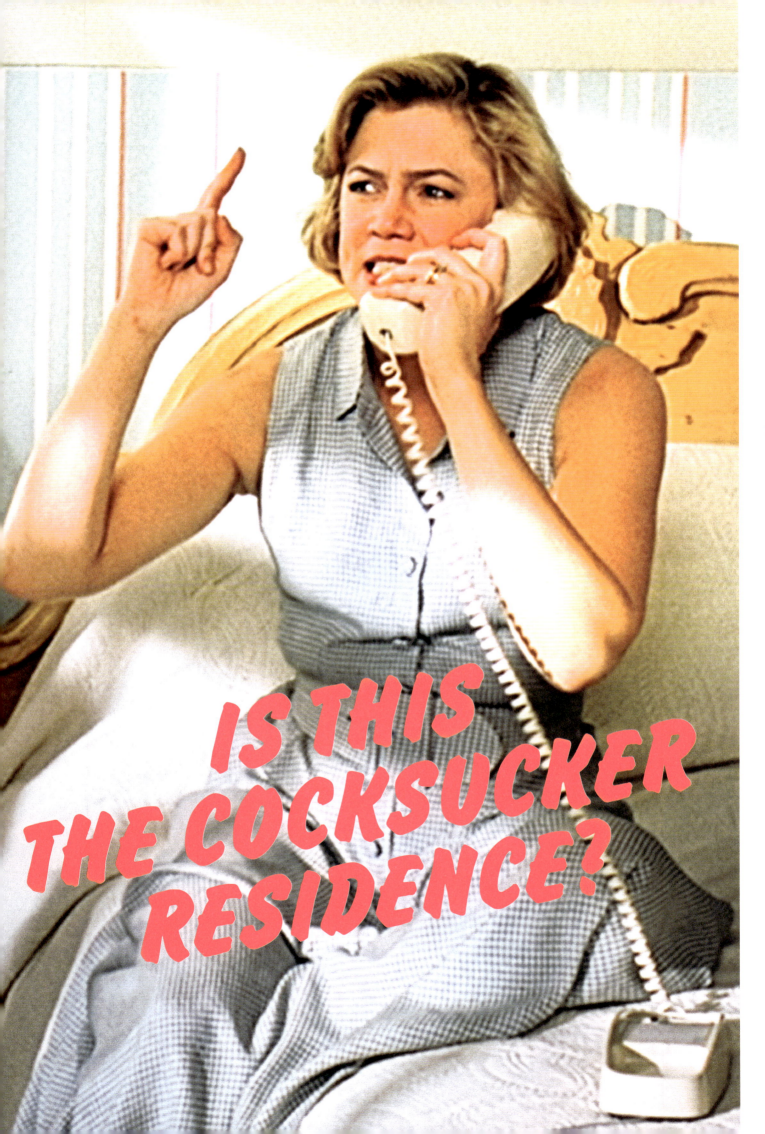

CAVALCADE OF PERVERSION
THE OBSESSIONS OF JOHN WATERS

Dara Jaffe

John Waters, 1958

IN HIS WORLD, POOR TASTE IS PREFERRED, THE GROTESQUE IS BEAUTIFUL, AND RESPECTABILITY IS A FILTHY WORD, YET FILTH ITSELF COMMANDS RESPECT

In August 1955, 9-year-old Johnny Waters of Lutherville, Maryland, was having what many would consider to be an idyllic childhood sheltered in upper-middle-class suburbia. But a sheltered life was hardly the primary ambition of the future Prince of Puke.[1] Years before Waters penned and helmed the films that would make him notorious, his writing efforts consisted of elementary school essay assignments, including one dedicated to the excitement he had felt at the news that he and his friends at Camp Happy Hollow might soon be visited by Hurricane Connie. Little Johnny recounted his gleeful anticipation as "the sky got blacker and blacker," but ultimately his hopes were dashed, as he awoke the next day to find that the storm had passed them by: "Not a thing had happened! . . . This might have been good for some people but it was quite a disappointment for us!"[2]

This portrait of a child eagerly wishing for a dark cloud to settle over his too-peaceful slice of the American dream is a fitting harbinger of a filmography rife with subverted visions of domestic bliss. It also tracks with the description given by Waters twenty-six years later in his autobiographical book *Shock Value* (1981), recalling himself as a young boy who adored amusement parks but longed for a roller-coaster accident; who obsessed over

fairy-tale cinema such as *The Wizard of Oz* (1939), *Cinderella* (1950), and *Peter Pan* (1953) but idolized the villains; and who loved to play an imaginary game of "car accident"—a quirk he bestowed upon the bratty young character Taffy in his 1974 film *Female Trouble*.[3] Further proof that the spirit of John Waters has remained constant from the beginning can be found in his 1986 book *Crackpot*, in which his account of an experience from the prior year echoes little Johnny's tale of his near encounter with Hurricane Connie: "When the entire eastern seaboard was riled to panic by the news media over Hurricane Gloria, I was in seventh heaven. . . . The next morning I was crushed to see that nothing had happened."[4]

The notion of John Waters as the Great Inverter of societal ideals is well established: in his world, poor taste is preferred, the grotesque is beautiful, and respectability is a filthy word, yet filth itself commands respect. That his cinematic execution of these values elicits considerable shock is both deliberate and incidental—both the point and an organic by-product of his sensibilities. He certainly aimed to shock his viewers as a means of raising his profile and filling theater seats. That this was his goal is evident in the creative and tireless ways he promoted his films and in his own identity as a provocateur. Waters is a professed student of the storied history of promotional gimmicks in the cinema. He knows that shocking material on the screen will more successfully translate to wildfire word of mouth when combined with extratextual ploys that elevate said material to almost urban-legend status. In this quest he is guided by the influence of showmen such as Kroger Babb and William Castle, the latter of whom paired his horror movies with theatrical gimmicks such as life insurance policies for audience members, ghost-viewer glasses, and buzzers under the seats.[5] In Waters's presentations, gimmicks take the form of barf bags for screenings of *Pink Flamingos* (1972) and his own variation on Smell-O-Vision, which he dubbed Odorama, for *Polyester* (1981).[6]

The character of Mr. David (David Lochary) in Waters's 1970 film *Multiple Maniacs* entices passersby to attend a performance of a traveling troupe of exhibitionists called Lady Divine's Cavalcade

Barf bag distributed at screenings of *Pink Flamingos* (1972)

IN SO MANY WAYS, WATERS IS A CARNIVAL BARKER, PROMISING THE NEED FOR VOMIT RECEPTACLES, DARING PATRONS TO ENTER FOR THE MERE SHOCK OF IT

of Perversion. "Come on in, folks!" he beckons. "What you will see inside of this tent will make you literally sick. We got it all, and we show it all!" In so many ways, Waters is himself this carnival barker, promising the need for vomit receptacles, daring patrons to enter for the mere shock of it. But his product is no sideshow two-headed fetus fakery. The shock he offers stems organically from substance: his inimitable point of view on the specific subject matter that enthralls him, always presented with his signature sense of humor and heart. The man has produced celebrated works—movies, books, live performances, visual art, exhibitions—in seven different decades (eight if you count his childhood puppet show, a violent affair involving

death by dragon)! Surely that would not be possible on the basis of shock alone. Across his life's work—yes, even going back to his childhood writings and performances—one can trace the exploration of his own obsessions, which are too deeply rooted to be anything but genuine.

The often visited themes and motifs of his filmography include but are not limited to Catholicism, sexual fetishes, hairstyling, dance crazes, garage rock, Baltimore, birds, cars/hitchhiking/hit-and-runs, juvenile delinquency, infamy and media, protest, performative rebellion, drugs, beauty, dying for art, crime (often ripped from the headlines), fairy tales, taboos, the family unit (whether biological or chosen), domesticity and class, the inherent queerness of sexuality and relationships, and all manner of cross-pollination within. It's important to note that all subject matter is approached with irreverence and no corner of society is safe from send-up.

That said, Waters has theorized that one reason he was able to get away with his early disregard for polite society is because he focused his satire on outsiders to polite society, applying his good-natured teasing to delineations of various counterculture identities and their self-enforced rules.[7] At the end of his first feature, *Mondo Trasho* (1969), the protagonist, played by Mary Vivian Pearce, suddenly finds herself derided by two judgmental strangers on a street corner, played by Mink Stole and Mimi Lochary (David's mother) but voiced by Stole and David Lochary. Scandalized by her presence, they scoff back and forth, rattling off all the potential labels they think might apply to her: "Is it a faggot? It's a dyke! No, it's a hippie! . . . a communist? . . . perhaps it's a drag queen!" The possible accusations include speed freak, pothead, some sort of intellectual, rimmer, chicken queen, narc, beatnik, acidhead, flower child, glamour girl, warmonger, just a teenager, Hell's Angel, fag hag, closet queen, hair hopper, movie star, draft dodger, runaway, peacenik, yippie, jet-setter, and size queen. These epithets, ranging from the broad to the specific, from opposing positions to various shades of the same thing, make fun of both the alarmist outrage of polite society and those who cling to some of these outsider identities.

Waters's debut novel, *Liarmouth* (2022), features a pride parade for "rimmers," those whose sexual identity revolves around anilingus. Waters refers to them as a "subculture of the sexual underground," and this is a perfect term for the very specific labels he lovingly pokes fun at in his work.[8] Both his first talkie feature, *Multiple Maniacs*, and his most recent, *A Dirty Shame* (2004), showcase a variety of these

sexual subcultures, introducing them one by one almost as a kind of pageant. In *Multiple Maniacs*, the aforementioned Cavalcade of Perversion boasts a lineup of several fetishists in action, including bicycle-seat sniffers, puke eaters, and bra fondlers. In *A Dirty Shame*, Johnny Knoxville's character, Ray-Ray, acts as a sexual shaman of sorts, with his mechanic's shop doubling as a safe haven for sex addicts of specific persuasions ("It's like Noah's Ark around here: there's one of every perversion"). The fellow travelers he introduces to the main character, Tracey Ullman's Sylvia—herself a recently discovered cunnilingus power bottom—include an adult baby, a mysophiliac, bears, and a badge bunny.

These two films, made thirty-four years apart, demonstrate Waters's unwavering interest in exploring specific fetish communities and what he finds entertaining about the concept—he even returns to certain fetishes multiple times. He recently pointed out to me, with a twinkle in his eye, that Edith Massey's character in *Pink Flamingos* is technically also an adult baby, enjoying her beloved eggs from the comfort of her playpen. His comedic focus is trained on the specificity of these fetishes. When Mr. David of *Multiple Maniacs* wishes for his lover to

Top: Edith Massey in *Pink Flamingos* (1972); bottom: Alan J. Wendl in *A Dirty Shame* (2004)

join the troupe, he matter-of-factly states, "She's an autoerotic, a coprophagiac, and a gerontophiliac." (Perhaps there's a bit of foreshadowing there with the mention of coprophagia, as Waters's next film would famously feature unsimulated consumption of feces.) In addition to spoofing the narrow delineations that serve as the basis for these characters' entire identities, he is of course making fun of the characters and audience members who find the cinematic representation or even the mere existence of these fetishes so scandalous.

While Waters has featured many a character whose sexuality is rigidly defined, his films also establish a world in which sexuality is inherently fluid. In *A Dirty Shame*, sex addictions can be turned on and off by a concussive knock to the head. Divine's characters in *Multiple Maniacs* and *Female Trouble* (1974), as well as Mink Stole's Peggy Gravel in *Desperate Living* (1977), begin the film engaging in heterosexual relations before drifting into lesbianism with little to no fanfare. When asked point blank in *Pink Flamingos* if she's a lesbian, Divine responds resoundingly, "Yes! I have done everything!" The fact that even Divine's apparently heterosexual female characters are played by an actor in drag who identifies as a man establishes a base level of queerness—or at least an underlying refusal to conform to conventional portrayals of straightness.

In many ways, Divine's roles in Waters's films—and their cumulative arc—represent a personification of the filmmaker's obsessions. Several of these go hand in hand, such as the subversion of the conventionally idealized suburban family unit, juvenile delinquency, and infamy gained through crime. What could be a clearer depiction of these intertwined obsessions than Divine's performance as Dawn Davenport in *Female Trouble*? On Christmas morning, moments after finishing a rendition of "Silent Night," Dawn's parents learn there is to be no heavenly peace for them. Their dreams of familial harmony are dashed when Dawn tears open her gift and does *not* find the cha-cha heels she demanded. (According to her father, nice girls don't wear those.) Dawn shoves her mother into the Christmas tree and runs away to a life of teenage motherhood, cat burgling, and—eventually—murder in the name

33

John Waters and Divine, New York City, 1975

of art. Juvenile delinquents run gloriously amok across Waters's filmography. Though they may have been toned down a bit as he progressed through his career, even as late as *Pecker* (1998) we encounter Matt, whose propensity for shoplifting would make any Divine character proud.[9]

If Divine's turn as a delinquent teenage daughter represents a subversion of the idealized American family, her role as Francine Fishpaw in *Polyester* subverts the subversion. Flipping the script on Divine's established persona, *Polyester* casts her as the long-suffering mother, desperately trying to keep the peace in her suburban tract home and maintain a wholesome reputation among her neighbors. Foiling these plans are her philandering porn-theater-owning husband; her thrill-seeking daughter, who is ultimately sent to a Catholic home for unwed mothers;[10] and her foot-fetishist son, whose compulsion to stomp on women's feet lands him in jail.[11] *Hairspray* (1988), a 1960s period piece, once again finds Divine as the mother to a boundary-pushing teen, with a few tweaks. First of all, Divine's character is no longer the protagonist: the viewer is primarily aligned with her daughter,

IF DIVINE'S TURN AS A DELINQUENT TEENAGE DAUGHTER REPRESENTS A SUBVERSION OF THE IDEALIZED AMERICAN FAMILY, HER ROLE AS FRANCINE FISHPAW IN *POLYESTER* SUBVERTS THE SUBVERSION

Tracy Turnblad, played by Ricki Lake. Tracy is perhaps reminiscent of fellow 1960s hair hopper Dawn Davenport (and even faces disciplinary action for refusing to lower the height of her do in class), though her boundary pushing isn't quite so salacious.[12] Rather than murdering for fame, Tracy just wants to dance and fight for integration. And for the first time we see the otherwise conventional parent support and even take up the cause of the rebellious teen. Both Dawn and Tracy find themselves behind bars, but only Tracy's charge (civil rights protest) would be considered righteous by a mainstream audience. Perhaps the most shocking

aspect of *Hairspray* was a PG rating for a John Waters film!

Waters is constantly reformulating his constellation of obsessions to keep things interesting. Perhaps the most notable subversion of his early juvenile delinquent portrayals can be found in *Serial Mom* (1994). Here, as in *Polyester*, the protagonist is once again a mother living what appears from the outside to be an idyllic representation of the suburban dream, in yet another tract home sweet home. As with the Davenports of *Female Trouble*, however, this dream bubble is once again popped by a member of the family who is prone to crime and murder. Only this time it's the mother: Beverly Sutphin, played by Kathleen Turner. Beverly's compulsion to kill isn't motivated by the promise of infamy, as with so many of Divine's characters, but she does seem to take to the spotlight, charming the public, the jury, and even Suzanne Somers (who cameos as herself, set to portray Beverly in the television version of her story). Meaningfully, this "film within the film" TV special is the exact kind of true-crime fictionalization that Waters is spoofing with *Serial Mom*.

Waters has long been obsessed by true crime and, before he became too recognizable, would religiously attend the various trials that interested him. Trial scenes are a staple of his films, from the kangaroo court of *Pink Flamingos*, in which the Marbles are found guilty of "assholism"; to Dawn Davenport's death sentence; to the juvenile delinquent Drapes appearing before the judge in *Cry-Baby* (1990).[13] Though entirely fictional, *Serial Mom* is satirically presented as true crime, opening with text claiming that the screenplay was based on real court testimony and interviews, that names have been changed to protect the innocent, and that no one involved with the crimes received financial compensation. Beverly's trial is the climactic and hilarious third act. Waters even depicts trial fanatics like himself conversing outside the courtroom: "Didn't I see you at Hinckley?" Perhaps no one is more representative of Waters's alter ego than Beverly herself. She keeps a scrapbook of newspaper clippings related to serial killers, cult leaders, and other crimes of interest, much like Waters's own scrapbooks, which are now housed with the rest of his personal collection in the Ogden and Mary Louise Reid Cinema Archives at Wesleyan University. And years before Beverly murdered a jury member (played by Patricia Hearst) for the crime of wearing white shoes after Labor Day, Waters facetiously wished to do the same in his book *Crackpot*.[14]

From the beginning of his career, Waters's movies have been littered with references to the infamous figures of true-crime lore, from Alice Crimmins to Richard Speck to the Manson family

Dinner's on the table!

Divine in *Polyester* (1981)

Kathleen Turner in *Serial Mom* (1994)

WATERS—A FORMER CATHOLIC SCHOOLBOY—WAS VERY EAGER TO LAMBASTE THE TWO FRAMEWORKS IMPOSED UPON HIM IN HIS ADOLESCENCE: RELIGION AND SUBURBIA

to Ray Buckey. When production of *Multiple Maniacs* began, the Manson murders had been committed, but the perpetrators had not yet been identified. In the beginning of the film, Divine takes credit for the murder of Sharon Tate, and though the Manson family had been identified as the perpetrators by the time production had concluded, Waters has stated that his initial hope was that someone out there might actually spend the rest of their life wondering if Divine really had something to do with it.[15] Referencing these devastating current events before they had even been resolved is the very definition of "too soon?" And that's not even the most drastic example of it in Waters's filmography. When television personality Art Linkletter's daughter Diane leaped to her death from a sixth-floor window in October 1969, not a day had gone by before Waters filmed the ten-minute short *The Diane Linkletter Story*, with Divine in the titular role. Naturally Waters portrayed Diane as under the influence of LSD when she jumped, in line with the soon-to-be urban legend based on her family's explanation of her death. A similar example that has become something of a holy grail among Waters and Divine fans: in the rarely shown *Eat Your Makeup* (1968), there is a daydream sequence in which Divine's character imagines herself as Jackie Kennedy on November 22, 1963, pillbox hat and all. In front of his parents' house, Waters filmed a reenactment of the assassination of John F. Kennedy that predated the public broadcast of the Zapruder film—footage considered so disturbing that it was not shown on network television until March 1975, nearly twelve years after JFK's death. Until then, the scene was viewable only via still images in magazines, elusive bootleg copies, and of course, as re-created in John Waters's *Eat Your Makeup*.[16] He prides himself on having tackled this restaging decades before Oliver Stone revisited the event in *JFK* (USA, 1991).[17] For Waters, "the sooner the better" takes on new meaning.

Once again, these examples reflect the intersection between Waters's genuine interests and his desire to deliberately breach the taboo. Another perfect marriage between the two lies in his frequent sacrilegious depictions of Catholicism and its imagery. His filmography abounds with it, from the priest-kissing nun played by Maelcum Soul in *Roman Candles* (1967) to the "talking" statuette of the Blessed Virgin Mary in *Pecker*. Most outrageously, there is a lengthy sequence in *Multiple Maniacs* in which Divine is led to a church by the Infant of Prague. Inside she is seduced by a strange woman (Mink Stole) who gives her a "rosary job" among the church pews, inserting her beads into one of

Divine and Howard Gruber in *Eat Your Makeup* (1968)

Divine's "most private parts." Intercut with this explicit sequence is the rest of the Dreamlanders performing the stations of the cross as Mink Stole narrates in voiceover. Jesus is portrayed by George Figgs, Mary by Edith Massey, and the miraculously replenished food by cans of tuna and loaves of bread in grocery store wrappers. It seems that Waters—a former Catholic schoolboy—was very eager to lambaste the two frameworks imposed upon him in his adolescence: religion and suburbia.

At the end of the rosary job sequence, a junkie can be seen shooting up at the front of the church. Though Waters has since called the moment gratuitous ("just for added sacrilegious shock value"), it does represent another of his often depicted obsessions meant to scandalize the viewer: drugs.[18] *Roman Candles* also features a man injecting heroin (in this instance, unsimulated), and his oeuvre is rife with drug use of all kinds.[19] Sometimes the drug use is metaphoric, as in *Female Trouble*, when Dawn Davenport is encouraged to mainline liquid eyeliner by her mentors Donna and Donald Dasher. Sometimes the drug use is outwardly cartoonish, as with the character of Lyle (Adrian Grenier) in *Cecil B. Demented* (2000), who portrays

a stereotypical experience with a different drug in every scene.

One can see how Waters playfully draws connections between drugs, sustenance, crime, and beauty. In addition to becoming hooked on liquid eyeliner, Dawn Davenport and the Dashers also consume mascara brushes, a concept revisited from *Eat Your Makeup*, in which models are kidnapped and forced to become addicted to eating beauty products. (For this film, Waters, with his father's help, constructed a "dope machine," a vending machine for drugs.)[20] One could even draw a line all the way from the kidnapped models of *Eat Your Makeup*—who are ultimately forced to model themselves to death in front of an enthusiastic audience—to the character of Honey Whitlock, played by Melanie Griffith in *Cecil B. Demented*. Honey is a Hollywood actress abducted by underground filmmakers and forced to act in their movie, carrying out often unsimulated violence and stunts. Like the kidnapped models, the kidnapped actress is compelled to enact the purest (and most dangerous) form of her profession. Waters loves to conflate his various obsessions. As the Dashers in *Female Trouble* proclaim about beauty and crime: "We feel them to be one." In

37

Margie Skidmore in *Eat Your Makeup* (1968)

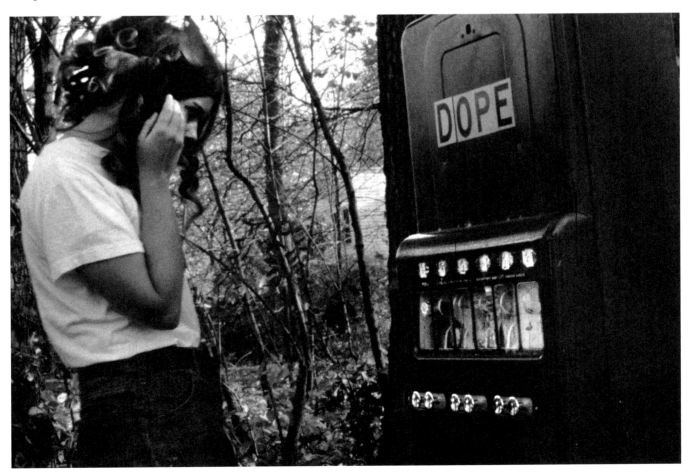

turn, beauty can be drugs, and drugs can be sex. In *Multiple Maniacs*, Mary Vivian Pearce's character exclaims mid-coitus, "This is even better than amyl nitrate!"

Both this scene and the rosary job sequence epitomize another John Waters staple: incredibly over-the-top sex scenes. Sex in his films is never meant to be titillating, even when unsimulated. It's always meant to be funny, shocking, or a combination of the two. Cartoonish sound effects often mark the moment of entry and exit; excessive use of tongues and exaggeratedly orgasmic vocal performances are par for the course. (If closed captions are enabled for home viewing, a substantial amount of the on-screen text reads simply "moaning . . . moaning continues . . . panting" and, yes, the occasional "slurping.") In some instances Waters has gone to extreme measures to make sure that his sex scenes are uncomfortable for actor and viewer alike. *Pink Flamingos* contains two particularly infamous sex scenes. In one, a live chicken is crushed to death between the naked bodies of actors Cookie Mueller and Danny Mills (sex: simulated; chickens from multiple takes: most sincerely dead). Another sees Divine giving oral pleasure to her on-screen son, played by Mills, as he moans such things as "Oh, Mama, I should have known you'd be better than anyone" (incest: simulated; fellatio: as real as

it gets). This shock treatment not only ensured that *Pink Flamingos* would grab the attention of a curious public but also created something of an art-imitates-life-imitates-art persona for the muse Divine. While Divine's characters in *Multiple Maniacs*, *Pink Flamingos*, and *Female Trouble* are willing to murder and die for infamy, the real-life Divine was willing to perform fellatio on-screen, crawl through pig excrement, writhe around with dead fish, and—the pièce de résistance—consume dog feces. Waters promised him fame in return for this commitment to art, and he delivered.

Just as Waters knew cinematic choices like these would bring fame, he also knew they would bring protesters, and he beat them to the punch. Surely no one protests more vehemently than the characters within the films themselves. From the picketers gathered to condemn Elmer Fishpaw's porno theater in *Polyester*, to the protesters on both sides of the integration issue in *Hairspray*, to the family

THERE IS ALWAYS A SURROGATE AUDIENCE ON-SCREEN TO LET THE CHARACTERS KNOW THAT WHAT THEY ARE DOING IS JUST SICK

38

Divine and Mink Stole in *Multiple Maniacs* (1970)

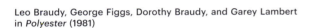

Leo Braudy, George Figgs, Dorothy Braudy, and Garey Lambert in *Polyester* (1981)

What if Mary and Joseph had had an abortion? What then?!

film proponents in *Cecil B. Demented*, there is always a surrogate audience on-screen to let the characters know that what they are doing is just sick. There is indeed a "meta" nature to much of Waters's work: In the three early films mentioned above, we see characters seeking the infamy that Waters knows these performances will soon bring to him and his friends. In later films such as *Cecil B. Demented* and *Pecker*, Waters seems to muse retrospectively on what it was like to have achieved this notoriety. *Pecker* begins the film as an unassuming Baltimorean who finds unexpected sources of art through the viewfinder of his secondhand camera: two rats mating in a trash can, the pubic hair of a stripper, and a middle finger from a stranger are just some of his many humble subjects. His life is turned upside down when a high-profile gallery owner from New York takes notice and turns him into a darling of the art world (a world that Waters himself had recently joined).[21] While Waters courted fame in a way that Pecker doesn't, it's not hard to find the autobiographical traces in the culture clash between Baltimore and New York City.

Similarly meta, *Cecil B. Demented* follows a militant group of guerrilla filmmakers—the Sprocket Holes—that both echoes Waters's own Dreamlanders and diverges from them. On the one hand, Waters seems to be sending up the idea of a filmmaking collective such as Dogme 95 that would take themselves so seriously as to create a

manifesto. On the other, there are unmistakably autobiographical elements, and the trajectory of Waters's career is evident in such lines as "Your Hollywood system stole our sex and co-opted our violence, so there's nothing left for our kinds of movies." The film climaxes with Melanie Griffith's character—the star of the film within a film—agreeing to light her hair on fire for her director, which Waters had famously asked of Mink Stole during production of *Pink Flamingos*. (Stole at first acquiesced but later changed her mind.) While reminiscent of the aforementioned plot of *Eat Your Makeup*, there's also a clear connection to the true story of Patricia Hearst, the young heiress kidnapped in 1974 by the Symbionese Liberation Army and conditioned into participating in their crimes. Lest the blurred line between autobiography and fiction remain too subtle, Hearst herself is a regular among Waters's constellation of actors and actually appeared in *Cecil B. Demented*—as well as in every Waters film since 1990.

While Waters's early work created notoriety for his then unknown family of filmmakers, once established, Waters used his platform to rehab the public personas of those who'd already gained notoriety. For figures such as Hearst and Traci Lords—who found herself at the center of a scandal when the FBI learned she'd been starring in pornographic movies while underage—he offered a chance to reinvent their fame on their own terms. Acting in his films

DREAMLAND STUDIOS CAN BE INTER-PRETED AS A KNOWINGLY IRONIC NOD TO THE FILTHY, INVERTED-FAIRY-TALE WORLDS IN WHICH WATERS'S FILMS TAKE PLACE

Mary Vivian Pearce in *Mondo Trasho* (1969)

gave them something new to be famous for and an agency of which they'd previously been robbed. This evolution of Waters from social outsider to celebrated filmmaker able to share his umbrella with others almost mirrors the way in which he turns respectability upside down in his films.

Edith Massey's character in *Female Trouble* wishes nothing more than for her heterosexual hairdresser nephew to come out as gay. She's worried that he'll "work in an office, have children, celebrate wedding anniversaries"—live the "sick and boring life" of a heterosexual! She pleads with him to consider homosexuality to no avail, in a clear reversal of intergenerational conflict that has played out in countless traditional households—still today but even more so in 1974, the year of the film's release—to the detriment of so many queer children who've come out to unaccepting parents. Twenty-six years later, in *Cecil B. Demented*, Waters presents yet another heterosexual hairdresser, Rodney (Jack

Noseworthy). This time it's Rodney himself who laments his heterosexuality—the shame he feels at not being able to truly love his gay boyfriend. These satirical moments are perhaps just as much a joke about male hairdresser stereotypes as an invitation to see the world a different way: through the John Waters lens, in which queer is the norm and everything else an unnatural departure.[22]

It might seem antithetical that the Pope of Trash is a lifelong devotee of fairy-tale stories such as *Cinderella*, *The Wizard of Oz*, and *Peter Pan*, but certainly Waters has created parallel film worlds

From left: Jack Noseworthy, Melanie Griffith, and Maggie Gyllenhaal in *Cecil B. Demented* (2000)

40

Edith Massey in *Female Trouble* (1974)

that offer a subversion of mainstream life as we know it. One could argue that *Desperate Living* most overtly engages in dialogue with the fairy-tale formula while simultaneously upending its execution: within the narrative of the film, there is a make-believe alternative world (Mortville) removed from regular society, reached only by a journey. But unlike a magical Oz or Neverland, it is literally made of trash, and everyone who lives there must receive a reverse makeover to look horrible. Even the name Dreamland Studios can be interpreted as a knowingly ironic nod to the filthy, inverted-fairy-tale worlds in which Waters's films take place. And yet, in the same way that filth is to be respected, there is a paradoxical wholesomeness to this cinematic universe in which every sexuality of (or over) the rainbow is embraced.

One might wonder if Waters is indeed crafting a fantasy or instead encouraging us to take a closer look—from his perspective—at the world we already inhabit. Consider his first feature, *Mondo Trasho*. One of the protagonists, played by Mary Vivian Pearce, encounters a stranger in the park, a "shrimper" (foot fetishist) who promptly begins to romance her lowest extremities. A prolonged foot-sucking sequence is intercut with imagery of Pearce as Cinderella and the shrimper as Prince Charming in search of the foot that fits just right.

Should the viewer be thinking, "Wait a minute! Was *Cinderella* actually about a foot fetish *this whole time*?" At the end of the movie, when Pearce clicks the heels of her now surgically altered feet together three times à la Dorothy Gale, should the viewer be thinking, "*Wizard of Oz* too?!" Is Edith Massey's hook for a hand in *Female Trouble* any more or less outlandish than Captain Hook's in *Peter Pan*? Aunt Ida, with her satirized queer agenda, could be placed in interesting dialogue with a character whose feminine tinge and loss of limb has long been thought to represent castration anxiety—a character so flamboyant that Waters coined "Captain Hook drag" to refer to his own childhood obsession with dressing up as the pirate villain.[23] Even the Disney universe itself would come to reflect the perspective of this boy who so loved its villains: the sea witch Ursula in *The Little Mermaid* (USA, 1989) was in part inspired by Divine.[24] Rather than thinking of the filmmaker as purposefully subverting both the real world of repressed society and the fairy-tale world of traditional films, perhaps the truth is that these worlds were already subversive, but we needed the particular camera lens of John Waters to reveal what he's seen his whole life: that the world truly is a cavalcade of perversion and we are all both actors and audience.

Notes

1. Waters stated in an interview that the *Baltimore Sun* had dubbed him the "Prince of Puke" early in his career, much to the dismay of his mother. Simon Hattenstone, "They Called Me the Prince of Puke. Mother Didn't Like That," *Guardian*, February 3, 1999, https://www.theguardian.com/film/1999/feb/03/features.

2. John Waters, "What a Disappointment!" (1955), box 2, folder 2, John Waters Papers, Special Collections & Archives, Wesleyan University (hereafter referred to as Waters Papers).

3. John Waters, *Shock Value: A Tasteful Book about Bad Taste* (New York: Thunder's Mouth, 2005), 24–25, 29.

4. John Waters, *Crackpot: The Obsessions of John Waters* (New York: Scribner, 2003), 69.

5. Kroger Babb (1906–1980) was a film producer known for his titillating marketing gimmicks built around exploitation films such as *Mom and Dad* (USA, 1945). William Castle (1914–1977) was a screenwriter, director, and producer whose cinematic presentations often included gimmicks to underscore the horror of films such as *The Tingler* (USA, 1959) and *13 Ghosts* (USA, 1960).

6. Theatergoers for *Polyester* received an "Odorama Card" with ten numbered scratch-and-sniff circles corresponding to numbers that appear on-screen to indicate moments when viewers can "smell along" with the characters.

7. John Waters, conversation with the author, May 25, 2022.

8. Waters has stated that his fascination with this concept began when he read Lars Ullerstam's *The Erotic Minorities* (New York: Grove Press, 1966) as a teenager: "I find it so bizarre how some people can give up their whole sexual life just to have one single tiny thing that they like to do and become real extreme about that." John Waters, in "All the Dirt on 'A Dirty Shame,'" directed by Mark Rance, bonus content on *A Dirty Shame*, directed by John Waters (New Line Home Video, 2005), DVD.

9. In a subtly autobiographical moment, Matt steals film for Pecker's camera, just as Waters's childhood friend stole the film needed to shoot his earliest movies. Waters, *Shock Value*, 40.

10. Homes for unwed mothers, which were common in the United States in the period between World War II and the Supreme Court decision in *Roe v. Wade* (1973) are one of Waters's fixations. His earliest published article—an exposé titled "Inside an Unwed Mother's Home," published in *Fact* magazine under the pseudonym Jane Wiemo—was based on a friend's experience of being sent to one (Waters, *Shock Value*, 40). In May 2022 he excitedly pointed out to me the former location of one of these homes near his office in Baltimore.

11. Based on a real-life "foot stomper" Waters read about in the *Atlanta Constitution* (Ken Willis, March 1, 1977) and the *Atlanta Journal* (Linda S. Tyrrell, March 7, 1977). Clippings of both articles are preserved in the Waters Papers (box 9, folder 1).

12. *Hair hopper* is slang, possibly native to Baltimore, referring to someone who spends an inordinate amount of energy on their coif, especially towering 1960s styles enabled by massive amounts of hairspray. The term carries the implication that the hair hopper is unsuccessful in pulling off their look and attempting to compensate for being lower-class.

13. Waters based Dawn's courtroom antics on those of Alice Crimmins, a woman charged in the 1965 murders of her children. John Waters, conversation with the author, September 10, 2022.

14. Waters, *Crackpot*, 93 (from "Why I Love the *National Enquirer*," originally published in *Rolling Stone*, October 10, 1985, 43–44, 71–72).

15. Waters, *Shock Value*, 62.

16. Unknown to Waters until after he'd made *Eat Your Makeup*, Andy Warhol had also filmed a version of the JFK assassination for his 1966 film *Since* with even lower production values than Waters's reenactment, using a couch as a stand-in for the car.

17. John Waters, conversation with the author, May 25, 2022.

18. Waters, *Shock Value*, 65.

19. Waters, *Shock Value*, 49.

20. John Waters, quoted in Robert Pela, *Filthy: The Weird World of John Waters* (New York: Alyson, 2002), 33.

21. In the early 1990s Waters began creating photography-based installations; his visual art has now been shown in prestigious galleries around the world, including in several solo exhibitions.

22. Many of Waters's friends in his early days were male hairdressers, including Divine. Waters, *Shock Value*, 42, 52.

23. Captain Hook's creator, J. M. Barrie, wrote of the character, "In his dark nature there was a touch of the feminine, as in all the great pirates." J. M. Barrie, *Peter and Wendy* (London: Hodder & Stoughton, 1918), 114. Waters has described his childhood obsession with Captain Hook, which led him to dress up as the character: "Every day I'd awake in the suburbs, block it out, and pretend I was on a pirate ship. From my vast collection of childhood props, I'd choose an especially nasty-looking hook made from a bent coat-hanger." Waters, *Shock Value*, 29–30.

24. *The Little Mermaid* producer/lyricist Howard Ashman, who was heavily involved in character development and performance coaching, was himself from Baltimore and a fan of Waters and Divine. In the documentary *Howard* (USA, 2018), character animator Rob Minkoff recalls how he drew a character design concept for Ursula based on Divine that Ashman "zeroed in on."

What A Disappointment!

It was about five o'clock and we were just coming back from supper at camp. We turned on the radio and the radio announcer said that a hurricane was coming about midnight. It was hurricane Conny!

The counselors said that we had to go to bed early in case it came full force. The sky got blacker and blacker and it got windier and windier.

Nobody went to sleep because we were so excited. Everybody finally got to sleep about ten o'clock. The wind was still blowing very hard.

I'M A THIEF AND
AND I'D LIKE TO

A SHIT KICKER
BE FAMOUS

WELCOME TO DREAMLAND

Jenny He and Dara Jaffe

From left: Divine, Mary Vivian
Pearce, Mink Stole, Danny Mills,
John Waters, Edith Massey, and
David Lochary on the set of *Pink
Flamingos* (1972)

In 1966, when John Waters named his first film
company Dreamland, he couldn't have foreseen
that the ragtag ensemble of self-described
"freaks" who tirelessly supported him as his
cast, crew, and lifelong friends would come
to be known as Dreamlanders. His exposure to
the New York City independent movie scene
and Jonas Mekas's column on experimental and
underground films in the *Village Voice* led
Waters to realize that he didn't need money to
make movies: "You could use your friends."[1] It
wasn't until his ninth film, *Desperate Living*
(1977), that Waters even sought a professional
actor outside the Dreamlander family. The same
faces and names appear over and over again,
both in front of the camera and behind it. Many
have been involved in every film he has ever
made, and some simultaneously established
successful entertainment careers beyond the
Waters oeuvre.

BOB ADAMS
BORN 1946, DALLAS

Bob Adams met Waters when he was enlisted to move Waters and his belongings from Baltimore to Provincetown, Massachusetts. As a professional buyer and seller of exquisitely curated junk, Adams applied his talents to locating key props for Waters, such as the iconic "God Bless Our Mobile Home" plate seen in *Pink Flamingos*. The location of the mobile home itself was suggested by Adams; it was the site of a commune where he was living at the time. Adams also acted in Waters's films. He made a lasting impression as Ernie in *Female Trouble*, in which he appeared in scenes with Edith Massey's Aunt Ida and her nephew Gator (Michael Potter). An in-demand photographer, he has captured decades of candid moments involving Waters and his cast and crew, on set and off. Additionally, Adams (also known as Bobby Adams) is a visual artist whose work has been celebrated by the American Visionary Art Museum in Baltimore.

48

[JOHN'S] LIKE THE JIMMY STEWART CHARACTER IN *IT'S A WONDERFUL LIFE*. WHERE WOULD WE HAVE BEEN IF WE HADN'T KNOWN HIM?[2]

ELIZABETH COFFEY
BORN 1948, BROOKLYN

Elizabeth Coffey's memorable Dreamlander debut in *Pink Flamingos* cast her as a victim of serial flasher Raymond Marble (David Lochary). Coffey's character ultimately turns the tables on her would-be harasser, flashing first her breasts and then her penis, much to Raymond's surprise. Two years later, post–bottom surgery, Coffey appeared in *Female Trouble* as Divine's cellmate girlfriend. Today Coffey cofacilitates a trans and gender-nonconforming support group in Philadelphia called TransWay and was on hand at the Baltimore Museum of Art in 2021 for the unveiling of the all-gender John Waters Restrooms.

JOHN KNEW I WAS GAME, AND THAT I HAD A GOOD SENSE OF HUMOR AND I WOULD GET IT. IF PEOPLE DON'T GET IT, I'M OKAY WITH THAT.[3]

DIVINE

BORN 1945, BALTIMORE; DIED 1988, LOS ANGELES

Dreamland's most famous star, Divine, was born Harris Glenn Milstead and befriended Waters when the two were in high school. Waters christened the actor Divine when he appeared briefly in the director's second film and first Dreamland production, *Roman Candles*. After Divine took on larger roles in *Eat Your Makeup* and *Mondo Trasho*, Waters realized that audiences responded to the actor and began to center his projects on Divine as star and muse. Ultimately Divine starred in *Multiple Maniacs*, *Pink Flamingos*, *Female Trouble*, and *Polyester*, before his final Dreamland role as Edna Turnblad in *Hairspray*.

Divine's unforgettable performances—paired with wildly original makeup and costumes by Van Smith—are at the heart of the Waters films that first caught the world's attention. Divine became an icon in his own right, launching a live performance career that included theater, music, and comedy. He left his mark in the world of drag by carving out space for plus-size performers and further subverting beauty expectations with an innovatively grotesque aesthetic. Divine passed away at the age of 42 the night before he was to begin filming a role as a series regular on the sitcom *Married . . . with Children* (1987–97), which no doubt would have carried the actor to even greater heights of mainstream recognition. As it is, Divine remains a bona fide pop culture queen whose influence seems only to grow as time goes by.

PEOPLE SAY THAT WE'RE THE MOST SHOCKING, AND IF WE'RE THE MOST SHOCKING, WELL PFFFFFT! I DON'T SEE WHAT'S SHOCKING ABOUT A MAN IN A DRESS.[4]

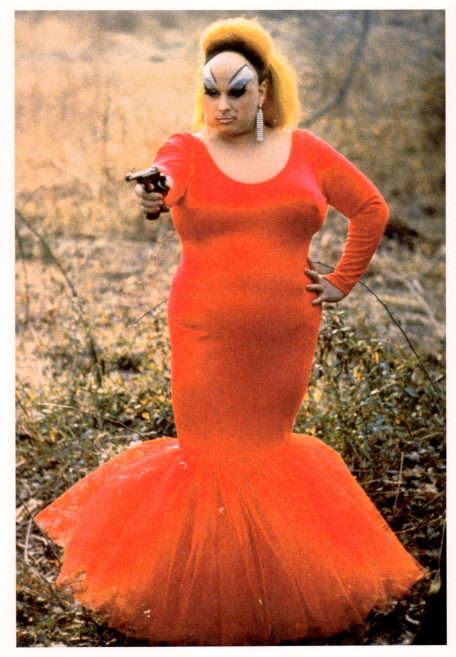

This page: Divine on the set of *Pink Flamingos* (1972)

Opposite, left: Bob Adams in *Female Trouble* (1974)

Opposite, right: Elizabeth Coffey in *Pink Flamingos* (1972)

JEAN HILL

BORN 1946, BALTIMORE; DIED 2013, BALTIMORE

When Waters was disappointed by the response to a *Desperate Living* casting call for a four-hundred-pound Black actress to play Grizelda, the main character's partner in crime, a friend introduced him to Jean Hill. In his book *Shock Value*, Waters describes meeting Hill at her audition: "The first thing she did was goose me to totally unnerve me. She asked for a drink and got it. She laughed and said she had no objection to nudity ('I've got a lot to show, honey')."[5] After *Desperate Living*, Hill remained in the Dreamlander orbit personally and professionally, appearing briefly in *Polyester*; her final role was a cameo in Waters's most recent film, *A Dirty Shame*.

SHE HAD A PERSONALITY ALMOST TOO LARGE FOR SHOW BUSINESS, AND SHE STARTLED CLOSED-MINDED PEOPLE IN EVERY LEVEL OF SOCIETY. —JOHN WATERS[6]

50

This page: Jean Hill on the set of *Desperate Living* (1977)

Opposite, left: Peter Koper and Susan Lowe at the premiere of *Cecil B. Demented*, Baltimore, 2000

Opposite, right: David Lochary in *Pink Flamingos* (1972)

PETER KOPER

BORN 1947, GERMANY; DIED 2022, NEW YORK CITY

Peter Koper met Waters in 1968 in the Fells Point neighborhood of Baltimore, where a group of outré art makers was living together in a defunct bakery made over by future production designer Vincent Peranio. According to Koper, Waters had heard about the bakery and that "there were all manners of miscreants in Fells Point."[7] Koper described his first impression of Waters, noting that, with his striped bell-bottom pants and long, stringy hair, the filmmaker gave off the air of a praying mantis. The group became fast friends and collaborators. Koper, having moved to a twenty-six-acre farm on the outskirts of Baltimore, provided the filming location for *Desperate Living*. He allowed Waters's crew to construct on his land the exteriors of the fictional world of Mortville, inhabited by criminals, outcasts, and nudists. In addition to his Dreamland activities, Koper was a writer, reporter, producer, and professor of journalism.

DAVID LOCHARY

BORN 1944, BALTIMORE; DIED 1977, NEW YORK CITY

The original leading man of Dreamland, David Lochary, was introduced to a school-age Waters by their mutual friend Glenn (Harris Glenn Milstead, later known as Divine). At the time Lochary was a high school dropout enrolled in beauty school, and with his long, silver-dyed hair, he seemed quite worldly to the young Waters. Lochary first appeared in Waters's second film, *Roman Candles*, and had prominent roles in every subsequent Waters film until his death. His characters in *Pink Flamingos* and *Female Trouble*—Raymond Marble and Donald Dasher, respectively—are instantly recognizable for their extravagant appearances, especially their hairstyles. All the early Dreamlanders credit Lochary for influencing their style and attitudes—Divine had not even heard of drag before Lochary introduced him to the concept. Waters has called his death the end of an era, and one can trace a concurrent shift in his filmography as well.

WHEN WE DID *POLYESTER*, I WAS A DRUG SMUGGLER, AMONG OTHER THINGS. JOHN RAN OUT OF MONEY, SO I ROUNDED UP SOME MARIJUANA MONEY, PUT IT IN SHOPPING BAGS, AND DELIVERED IT TO JOHN'S FINANCIAL PEOPLE. I STILL GET CHECKS. IT WAS ONE OF THE BEST INVESTMENTS I EVER MADE.[8]

MY FAVORITE LEADING MAN.

– JOHN WATERS[9]

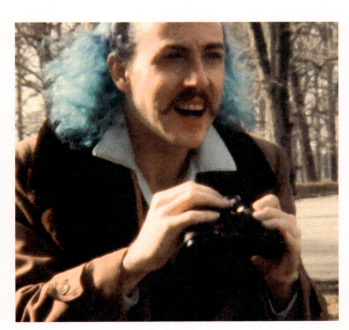

SUSAN LOWE

BORN 1948, REIDSVILLE, NORTH CAROLINA

When Susan Lowe was a student at the Maryland Institute College of Art in the 1960s, her then boyfriend, George Figgs, had just appeared in *Eat Your Makeup*, and he brought Lowe to Waters's house for an introduction. The two hit it off immediately. Lowe recalls introducing Waters to the Fells Point crowd that lived in a former industrial bakery and frequented a bar called Pete's Hotel, which lead the filmmaker to Dreamlanders Vincent Peranio and Edith Massey, among others. Lowe has screen credits in many of Waters's films, from *Mondo Trasho* to *Cecil B. Demented*, but by far her biggest role was as co-lead Mole McHenry in *Desperate Living*. Her notable contributions to Waters's filmography also include lending her new-born baby—covered in fake blood—to serve as Divine's baby in *Female Trouble*, much to the horror of Lowe's mother-in-law. Lowe is also a painter, photographer, and writer.

DREAMLAND WAS A SAFE PLACE FOR BALTIMORE'S BEST RENEGADE MISFITS. WE WOULD DO ANYTHING FOR HIS FILMS, AND HE KNEW IT.[10]

CHRISTINE MASON

BORN 1949, BALTIMORE; DIED 1999, BALTIMORE

The teased hairdos in *Hairspray*—the beehive, the double bubble, the artichoke, and the airlift—and the slick coifs of the Drapes and Drapettes in *Cry-Baby* were characters of their own, according to Waters. Christine Mason was the main hairstylist and wigmaker for his films, from *Female Trouble* to *Cry-Baby*, working with Van Smith to create hairstyles that were instrumental to the comedic aspects. Howard "Hep" Preston joined the Waters hair team starting with *Cry-Baby*, focusing on the male characters' hair, while Mason designed hairstyles for the female characters. Mason also had cameos in *Female Trouble* and *Cry-Baby*, playing hardcore prison guards in both.

ONLY CHRIS COULD BLEACH OUT A CERTAIN HIDEOUS COLOR LIKE THEY DO IN BALTIMORE. – JOHN WATERS[11]

52

EDITH MASSEY

BORN 1918, NEW YORK CITY; DIED 1984, LOS ANGELES

Edith Massey had already lived several lives by the time Waters met her in Baltimore in the 1960s, when she was working as a barmaid in a Fells Point tavern called Pete's Hotel. The cheap drinks at Pete's made it a favorite haunt of the group of creative filthsters that attracted Waters to the neighborhood. Massey had overcome a tragic childhood of orphanages and reform schools and had bounced all around the country—selling pencils on the side-walk, becoming a Hollywood extra in the 1940s, working as a "B-girl" in honky-tonks. Waters first asked Massey to play herself in *Multiple Maniacs*, but it was her role as Edie the Egg Lady in *Pink Flamingos* that first brought her fame. Her roles in *Female Trouble*, *Desperate Living*, and *Polyester* solidified her appeal to audiences drawn to her inimitable style of deliv-ery, which was effortlessly comedic in that Massey never tried to be funny; she simply was. In the early 1970s Massey left Pete's to open her own thrift shop, Edith's Shopping Bag, a few doors down. She made many pop culture appear-ances outside Waters's films and even fronted her own punk rock band, Edie and the Eggs. Massey later moved her thrift shop to Venice, California, where she lived for some time before her death.

WHEN I WAS A TEENAGER, I ALWAYS WANTED TO PLAY IN THE MOVIES, SO YOU MIGHT SAY I'M ONE PERSON WHO WISHED UPON A STAR AND GOT HER WISH.[12]

This page: Edith Massey on the set of *Female Trouble* (1974)

Opposite, left: Susan Lowe on the set of *Desperate Living* (1977)

Opposite, right: Christine Mason in the documentary *Divine Trash* (USA, 1998, dir. Steve Yeager)

MARINA MELIN
BORN 1945, WASHINGTON, DC

In 1967 Waters moved into a downtown Baltimore slum duplex with friends Bob Skidmore and Marina Melin. As he writes in *Shock Value*, it became "the new Dreamland Studios."[13] (The previous location for the studio was his bedroom at his parents' house.) Melin, a painter known for her beauty and scanty outfits, first met the filmmaker in Provincetown, Massachusetts. Waters cast her as one of the main characters in *Eat Your Makeup*—a model who is kidnapped and forced to consume beauty products and walk the runway for a crazed audience of reprobates. Melin can be seen in minor but recognizable roles in *Mondo Trasho*, *Pink Flamingos*, *Female Trouble*, *Desperate Living*, and *Polyester*, in which she appears as one of the Foot Stomper's victims.

I ASKED MARINA TO BE MY NEW STAR AND SHE CAME BACK TO BALTIMORE WITH ME. – JOHN WATERS[14]

COOKIE MUELLER
BORN 1949, BALTIMORE; DIED 1989, NEW YORK CITY

Ever the lover of gimmicks, Waters offered a door prize of dinner for two at "one of the sleaziest hamburger shops in town" when he premiered *Mondo Trasho* (1969) at the Emmanuel Episcopal Church in Baltimore.[15] The winner was none other than Cookie Mueller, who would immediately become a dear friend and prominent Dreamland performer. Her first role was in Waters's next feature, *Multiple Maniacs*, as Divine's often nude hippie daughter. She was equally memorable in *Pink Flamingos*, *Female Trouble*, *Desperate Living*, and *Polyester*. Mueller even provided inspiration for one of Waters's film titles: when he visited her in the hospital where she was recovering from pelvic inflammatory disease, he asked, "God, what happened, Cook?" The response: "Oh, just female trouble, hon."[16] Outside Waters's filmography, Mueller gained traction as a writer (her books include *How to Get Rid of Pimples* and *Garden of Ashes*), art critic, and general fixture of the downtown New York scene, where she became a muse to other artists.

I WAS FASCINATED BY COOKIE'S HARD-AS-NAILS ATTITUDE, AND REALIZED SHE COULD BE A PERFECT DREAMLAND GIRL. – JOHN WATERS[17]

EVERYBODY HAS A "YES MAN." JOHN HAD A "NO MAN," AND THAT WAS ME.[21]

PAT MORAN
BORN 1942, BALTIMORE

Waters's right-hand woman, Pat Moran, describes her decades in the film and television industry as "an accidental career."[18] When she met Waters in 1964, she was an "aimless lit major, who never knew what she wanted to be."[19] She and Waters bonded as lifelong movie geeks, and she would ultimately become indispensable on the filmmaker's sets as a wearer of many hats—production manager, associate producer, assistant director. She had an innate understanding of his needs and the firmness to implement them, describing his early features as grueling labors of love ("You couldn't pay someone to work as hard as we did").[20] Eventually Moran settled into the role of casting director and built a robust career that extended far beyond Waters's filmography, truly with too many prominent credits to list, not to mention three primetime Emmys. Moran and Waters remain close friends, both still residing in Baltimore. Filmmaking has been a family affair, as Moran, along with her husband, Chuck Yeaton, and their children, Brook and Greer, have all worked on Waters's films in various capacities, both on- and off-screen.

This page: Pat Moran and John Waters on the set of *Hairspray* (1988)

Opposite, top: Marina Melin, 1973

Opposite, bottom: Cookie Mueller, ca. 1981

MARY VIVIAN PEARCE

BORN 1947, BALTIMORE

Mary Vivian Pearce, known as Bonnie to those close to her, is Waters's oldest friend; they have known each other since infancy. She also holds the distinction of having appeared in every one of Waters's films to date, in both starring roles and cameos. Waters fashioned Pearce into his Jean Harlow (with Divine as his Jayne Mansfield). She was his cohort in his first taste of infamy: in 1961 the *Baltimore Evening Sun* reported on their attempts to throw snowballs at the faces of unsuspecting motorists, as documented in a clipping preserved in one of Waters's now storied scrapbooks.[22] Their (mis)adventures also provided inspiration for his cinematic stories. Seen as bad influences on each other and forbidden by their parents to associate, Waters and Pearce devised a clever stratagem to circumvent this obstacle. Pearce would set up fake dates with straitlaced boys, who picked her up from her house only to see her jump out of their cars and into Waters's waiting vehicle down the street. This ruse would later become a plot point in *Polyester*.

MY FAVORITE SCENE [IN *PINK FLAMINGOS*] IS THE SCENE WITH THE BIRTHDAY GIFT. IT'S DIVINE'S TURD, ACTUAL TURD, BECAUSE HE SHIT IN THE BOX THE NIGHT BEFORE. IT REALLY DID STINK, AND IT DID ENHANCE EVERYONE'S PERFORMANCES.[23]

This page: Mary Vivian Pearce in *Multiple Maniacs* (1970)

Opposite, left: Vincent Peranio on the set of *Pink Flamingos* (1972)

Opposite, right: Bob Skidmore and Divine in *Pink Flamingos* (1972)

56

VINCENT PERANIO
BORN 1945, BALTIMORE

When Dawn Davenport (Divine) poses a question to the audience watching her maniacal nightclub performance in *Female Trouble*—"Who wants to die for art?"—it is Vincent Peranio who jumps up and shouts, "I do!" Waters met Peranio at a party the latter was hosting in Fells Point, Baltimore. Having attended the Maryland Institute College of Art, Peranio brought a new group of art school creatives into Waters's crew. Waters had just directed his first feature film, *Mondo Trasho*, and was in the market for someone who could make a fifteen-foot lobster for his second feature, *Multiple Maniacs*. Peranio took on the task of crafting a papier-mâché crustacean that he and his brother Ed operated. ("It cost $37 to make and looked like it cost $38."[24]) He has since created the look of all of Waters's films as set designer, art director, or production designer and is one of his key cinematic collaborators. Peranio was also production designer for two Baltimore-set television series: *Homicide: Life on the Street* (1993–99), based on the book by David Simon, and *The Wire* (2002–8), created by Simon.

BOB SKIDMORE
BORN 1946, HOUSTON

Bob Skidmore grew up with Waters; he and Mary Vivian Pearce were the filmmaker's best friends. The trio's time together in the 1950s informed their creative pursuits in the next decade and beyond. Skidmore and Pearce appeared in Waters's first short film, *Hag in a Black Leather Jacket*, as wedding guests witnessing an interracial marriage officiated by a Klansman. In *Roman Candles*, Skidmore attacks Pearce with an electric fan. In *Mondo Trasho*, Skidmore opens the film as a chicken executioner, a scene that satirized exploitation documentaries like *Mondo Cane* (Italy, 1962), which showed vignettes of global cultural practices intended to shock Western audiences and appeal to their voyeuristic tendencies. He also appeared in *Multiple Maniacs*, *Pink Flamingos*, and *Pecker*.

57

BOB LOOKED VERY NORMAL, BUT UNDERNEATH IT ALL LURKED A CLOSET PSYCHOTIC. –JOHN WATERS[26]

IT NEVER FELT LIKE WORK WITH JOHN, THOUGH PEOPLE TOOK IT SERIOUSLY. IT WAS AN EXPERIENCE, A JOYFUL ONE.[25]

VAN SMITH

BORN 1945, MARIANNA, FLORIDA; DIED 2006,
MARIANNA, FLORIDA

If Vincent Peranio was tasked with design-
ing the worlds of Waters's films, Van Smith,
another key collaborator and graduate of the
Maryland Institute College of Art, was charged
with designing their characters, and none was
more distinctive than Divine. On the occasion
of Divine's first personal appearance in San
Francisco to accompany a screening of *Multiple
Maniacs* at the Palace Theater, Smith conceptu-
alized a new look for the actor that involved
the shaving back of his hairline to allow more
room for eye makeup, including abundant eye
shadow and extremely arched eyebrows. Smith
oversaw makeup and hair in Waters's films from
Pink Flamingos to *Cry-Baby* and costumes from
Pink Flamingos to *A Dirty Shame*, creating a
rich filmic legacy. The iconic red fishtail
dress from *Pink Flamingos* was honored by
Balenciaga in its spring 2022 collection via
"a red stretch velvet ballroom gown inspired
by and in tribute to Divine."[27]

SHUT UP. YOU'RE WEARING IT.[28]

This page: Van Smith (right) and
Divine, 1980s

Opposite: Maelcum Soul, 1965

58

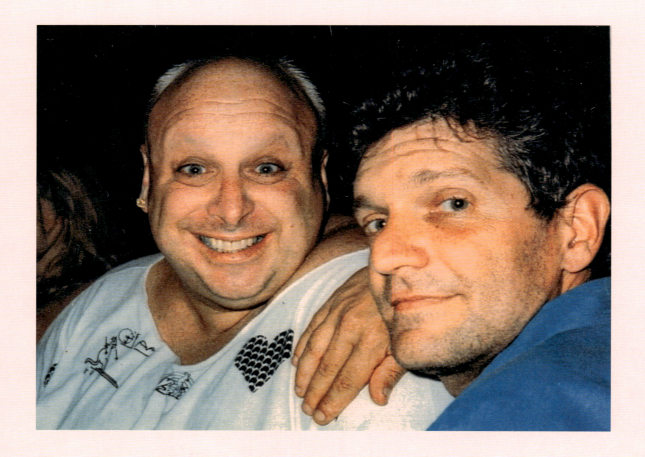

MAELCUM SOUL

BORN 1940, BALTIMORE; DIED 1968, BALTIMORE

In his youth, before he was of legal drinking age, Waters would have his mother drop him off at Martick's Tavern in downtown Baltimore. This venue was not only a watering hole but also a gathering place for bohemian intellectuals that was inclusive to LGBTQ+ patrons. Waters was struck by the bar's hostess, Maelcum Soul (born Patricia Ann Soul), who was also an artist's model, and cast her as the lead in his early shorts. Soul appears several times in the triple-projection collage film *Roman Candles*, including as a nun who makes out with a priest, and starred in *Eat Your Makeup* as the evil governess who forces girls to consume beauty products and model themselves to death for her and her boyfriend's (David Lochary) enjoyment. Soul would certainly have been a major part of Waters's later films if not for her untimely death at the age of 27.

STORIES ABOUT MAELCUM ARE MANY—MY FAVORITE BEING THAT SHE HAD AN EROTIC ENCOUNTER WITH JACK KEROUAC IN THE BUFFALO PITS OF THE BALTIMORE CITY ZOO.
—JOHN WATERS[29]

MINK STOLE
BORN 1947, BALTIMORE

Waters first met Baltimore native Nancy Stoll in Provincetown, Massachusetts, in 1966. After a short time together in New York City, where Waters earned income by scamming department stores, they returned to Baltimore to make *Roman Candles* with the rest of their friends. Just as Divine gained a stage name courtesy of this film, Stoll became Mink Stole. Stole has appeared in all of Waters's subsequent feature films to date. She has remarked that her favorite role was that of Taffy Davenport, the daughter of Dawn Davenport (Divine) in *Female Trouble*. Of his ensemble, Stole has perhaps evolved the most, transforming from the hysterical and histrionic Peggy Gravel in *Desperate Living*—directed by Waters to overemote because of his fear that faulty sound equipment would be unable to capture his impeccable and precise dialogue—to the understated, naturalistic Dottie Hinkle, terrorized by Kathleen Turner's Beverly Sutphin in *Serial Mom*.

IT WAS GREAT TO BE ON JOHN'S SETS. WE WERE A FAMILY, HAVING FUN AND LAUGHING TOGETHER. BUT IT WAS ALSO 100 PERCENT PROFESSIONAL. WE WERE THERE TO WORK.[30]

60

PAUL SWIFT

BORN 1934, BALTIMORE COUNTY; DIED 1994, BALTIMORE

Before Paul Swift became known to audiences as the Egg Man in *Pink Flamingos*, he was a familiar face in Fells Point, Baltimore, as a local character who wore hundreds of bracelets and danced naked atop the bar at Leadbetters Tavern. After making his film debut in *Multiple Maniacs* as the boyfriend of Cookie (Cookie Mueller), he went on to appear in Waters's "trash trinity": *Pink Flamingos*, *Female Trouble* (1974), and *Desperate Living*. But his most prominent role was that of Edie's (Edith Massey) sweetheart, who made daily deliveries of her much-coveted eggs.

I CAN'T IMAGINE PAUL EVER BEING NORMAL. I WOULDN'T SAY HE WAS AN ACTOR IN THE SHAKESPEAREAN SENSE, BUT HE WAS AN ACTOR PEOPLE REMEMBERED. —JOHN WATERS[31]

This page: Paul Swift with Edith Massey in *Pink Flamingos* (1972)

Opposite: Mink Stole on the set of *Female Trouble* (1974)

SUSAN WALSH

BORN 1948, BALTIMORE; DIED 2009, BALTIMORE

Susan Walsh was part of the acting troupe that inhabited Waters's early films. She appeared in *Mondo Trasho*, *Multiple Maniacs*, *Pink Flamingos*, and *Female Trouble*. In the latter film Walsh played Chicklette, one of a trio of feisty females with Divine's Dawn Davenport and Cookie Mueller's Concetta. In this picaresque chronology of Davenport's life, the three ladies are first seen as high school truants who smoke in the ladies' room, tease their hair to new heights, and sass the teachers. As Davenport engages in increasingly outrageous behavior, Concetta and Chicklette are by her side, robbing drunks together, encouraging her grotesque transformation, and eventually cheering Davenport's murder of her own child, Taffy (Mink Stole).

62

AS A SHOCKED CHURCHGOER WITNESSING THE "ROSARY JOB" IN *MULTIPLE MANIACS* AND ONE OF THE KIDNAPPED GIRLS IN THE PIT IN *PINK FLAMINGOS*, SUSAN WAS OBVIOUSLY UNAFRAID TO TAKE ON CONTROVERSIAL ROLES IN MY EARLY CELLULOID ATROCITIES. – JOHN WATERS[32]

CHANNING WILROY

BORN 1940, BALTIMORE

Waters knew Channing Wilroy from his youth, having watched him on *The Buddy Deane Show* (1957–64), the television dance program on which Wilroy was a regular for three years. But it was in the Cape Cod enclave of Provincetown, Massachusetts, that Waters nurtured enduring friendships with collaborators such as Wilroy, who first visited Provincetown in 1966 and has been a permanent resident there since 1969. Waters, for his part, has spent every summer in Provincetown since 1964. Wilroy first appeared in a Waters film as the manservant Channing, attending to the Marbles (Mink Stole and David Lochary) in *Pink Flamingos*. He has had roles in five other Waters films to date and served as music consultant on *Cry-Baby*.

Top: Susan Walsh in *Female Trouble* (1974)

Bottom: Channing Wilroy on the set of *Pink Flamingos* (1972)

[JOHN IS] PUTTING [GREAT MESSAGES] OUT THERE: "WHY DON'T WE ALL TAKE A LOOK AT THIS. IT'S NOT SO SILLY AT ALL. BE A LITTLE MORE ACCEPTING AND WE CAN LAUGH AT IT."[33]

Notes

1. Quoted in Dale Sherman, *John Waters FAQ: All That's Left to Know about the Provocateur of Bad Taste* (New York: Applause Theatre & Cinema Books, 2019), 117.

2. "Archivist Finds Fast Friendships on Movie Sets," *Baltimore Sun*, November 23, 1999.

3. "Elizabeth Coffey Williams: Value in Visibility," *Philadelphia Gay News*, November 16, 2021.

4. "Divine Just 'Cross-dressing for Success,'" *Journal News*, January 12, 1988.

5. John Waters, *Shock Value: A Tasteful Book about Bad Taste* (New York: Random House, 1981), 131.

6. "Jean E. Hill, Actress in John Waters Film," *Baltimore Sun*, August 6, 2013.

7. Peter Koper, telephone conversation with the authors, April 6, 2022.

8. Koper, telephone conversation.

9. Waters, *Shock Value*, 160.

10. Susan Lowe, text message conversation with the authors, October 5, 2022.

11. "Christine Mason, 49, Stylist Who Created 'Character' Hairdos for John Waters' Films," *Baltimore Sun*, October 18, 1999.

12. *Love Letter to Edie*, directed by Robert Maier (1975; Nextgen Video, 2000), VHS.

13. Waters, *Shock Value*, 50.

14. Waters, *Shock Value*, 50.

15. Waters, *Shock Value*, 59.

16. Waters, *Shock Value*, 108.

17. Waters, *Shock Value*, 60–61.

18. Pat Moran, video conversation with the authors, October 21, 2021.

19. Moran, video conversation.

20. Moran, conversation with the authors, May 24, 2022.

21. Moran, video conversation.

22. Waters, *Shock Value*, 38.

23. *I Am Divine*, directed by Jeffrey Schwarz (2013; Wolfe Video, 2014), DVD.

24. Vincent Peranio, video conversation with the authors, October 6, 2021.

25. Peranio, video conversation.

26. Waters, *Shock Value*, 39.

27. "Balenciaga Couture: Spring 22 Collection 2022," https://couture.balenciaga.com/en/2022/spring-22-collection-2022.

28. "Van Smith, 61, Dies; Created Divine's Distinctive Look," *New York Times*, December 9, 2006.

29. Waters, *Shock Value*, 44.

30. Mink Stole, conversation with the authors, September 15, 2021.

31. "Paul Swift, 'Eggman' in Waters' 'Pink Flamingos,'" *Baltimore Sun*, October 10, 1994.

32. John Waters, e-mail correspondence with the authors, October 26, 2022.

33. "All the Dirt on 'A Dirty Shame,'" directed by Mark Rance, bonus content on *A Dirty Shame*, directed by John Waters (New Line Home Video, 2005), DVD.

1964 HAG IN A BLACK LEATHER JACKET

Armed with a Brownie 8mm camera gifted by his grandmother, along with film shoplifted by a friend, Waters shot his first movie, *Hag in a Black Leather Jacket*. It depicts an interracial wedding officiated by a Ku Klux Klan member and closes with a sequence of Mary Vivian Pearce dancing the Bodie Green (the Baltimorean version of the Dirty Boogie). *Hag* premiered at a local beatnik coffeehouse on Howard Street.

Scenes from *Hag in a Black Leather Jacket* featuring Mona Montgomery, Bobby Chappel, and Trish Waters

1967 **ROMAN CANDLES**

DREAMLAND PRESENTS

JOHN WATERS'
First Film

" The ROMAN CANDLES "

★ a triple projected trash epic ★

triple-projected

triple-projected

triple-projected

triple-projected

triple-projected

STARRING* MAELCUM SOUL* BOB SKIDMORE*

JUDY BOUTIN* MINK STOLE*

BONNIE PEARCE* DAVID LOCHARY*

" a triple threat production, era Joseph Von Sternberg"

Carl Schoettler-
Balto. Eve. Sun

"the film jerked, jiggled and bugalooed.....it

shimmied, shooked, and rocked and rolled.....

Roman Candles surfaced not with a whimper but
with a bang." Balto Morning sun

" junk" Cedrone- Balto Eve. Sun

3 8mm. films shown simultaneously- 35 minutes

Triple-projected scenes from *Roman Candles* featuring Maelcum Soul, Barbara Miley, Steve Dankin, Divine, Bob Skidmore, and Mark Isherwood.

This triple-projected "trash epic" consists of a vertical presentation of three separate 8mm films shown simultaneously. Influenced by Andy Warhol and Paul Morrissey's split-screen, nonnarrative *Chelsea Girls* (USA, 1966), *Roman Candles*, the first Dreamland production, is similarly a plotless medley of appropriated footage and scenes featuring Waters's recurring retinue, including Maelcum Soul and Divine. This 1967 review of the film's world premiere has been preserved in Waters's scrapbooks for decades, along with his collection of newspaper clippings on a variety of subjects that inform his filmic work.

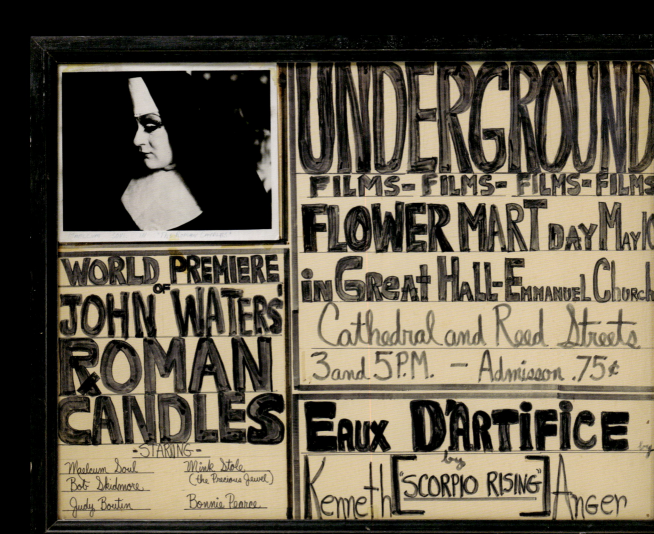

Underground Film Pops To Surface With Bang

By Carl Schoettler

While the rest of Baltimore demonstrated in support of flower-power yesterday at the Washington Monument, the hippy underground surfaced and went to this movies.

The underground — a yeasty confection of mods, aging beatniks, teeny-boppers and hippies —emerged into daylight for the world premiere of "The Roman Candles," a triple - projected "trash epic."

"What does that man?" John Waters, the 21-year-old producer-director, was asked before the screening at the Great Hall of Emmanuel Lutheran Church.

"Self-Explanatory"

"It's sort of self-explanatory once you see it," Mr. Waters said. He was right. One lady emerged stunned and speechless.

Mr. Waters, a sort of mixed-media era Josef von Sternberg, stood at the rear of the Gothic arched auditorium surrounded by his underground starlets.

Mr. Waters, who wore a double-breasted white linen suit, a checked shirt, an ear-splitting red and yellow tie and sideburns that caressed his throat

"Roman Candles" was his second film.

Cost About $300

"The Hag in the Black Leather Jacket," a movie about a wedding erformed by a K.K.K. preacher, was the first Mr. Waters said "Candles" cost about $300 and took six months to make on location and at the "Dreamland Studios."

"Does it have a plot?" he was asked.

"Not really," he said "It has a kind of idea that goes with all three segments."

"Roman Candles" is actually three separate 8 - milimeter films shown vertically on a 20-foot high screen.

New York Inspiration

Mr. Waters said he was inspired to make his movie after seeing underground films in New York city.

His film shared billing yesterday in a double feature with "Eaux d'Artifice," a short by a certified underground fi

[Continued, 70 6.

[Continued From Page D 20]

ma er named Kenneth Anger, whose "Scorpio Rising" is a camp classic that helped earn him a Ford Foundation grant.

Shortly before the doors were opened to the public, Maelcum "Superstar" Soul arrived on the scene, looking every bit as glamorous as Gary Cooper at the premiere of "High Noon."

Motif Is Black

She wore black glasses, a black turtleneck sweater, black slacks, a wide black belt with a brass buckle, a brown vest, brown suede boots, black super-star eyelashes and a black su-perstar asterisk painted under her right eye.

Miss Soul, who has gained some fame as a model for brush and paint artists around town, was making her debut in a moving picture.

She shares billing with Mink Stole, a striking blonde who appeared at the premier in a psychedelic minidress; Judy Boutin, a dark-haired girl in a military - cut minisuit; Bonnie Pearce; David Lochary and Bob Skidmore.

Hall Fills

The audience, who donated 75 cents each, quickly filled the 100 folding chairs set up in the great hall and more were added.

There were girls in pants

suits; a boy in a flowered shirt; a motorcyclist in helmet and fur-lined jacket; a gray-haired gentleman in a business suit tie, and neat raincoat; a pair of girls in pioneer women bonnets carrying toy airplanes, and a sprinkling of matronly house-wives who apparently thought they were going to see a religious picture.

The program opened with "Eaux d'Artifice," which rough-ly means water fireworks, which is what the film is about:

Jetting, spraying, spouting, bubbling, trilling, running, rip-pling, dripping, gleaming, glit-tering, glinting, green water in an elaborate Tuilleries - style garden through which a masked figure in a Louis Quinze gown moves occasionally. Fifteen minutes.

Mere Prelude

The audience applauded but it was merely a prelude to Mr. Waters's triple - threat production.

"Roman Candles" opened with a blank screen and a soundtrack voice from radio advertising wigs, then the Me-tro - Goldwyn - Mayer fanfare theme that a blast of rock 'n' roll and the screen light with: A boy and a girl walking

through a cemetery at the top, a mustache youth reading in an armchair in the middle and a portly Nero-like figure dancing to the music at the bottom.

Weirdie Effects

The Roman Candles had ex-ploded. The film jerked, jiggled and bugalooed, it freaked out like the Mothers of Invention, it shimmied, and shook and rock and rolled.

The rock 'n' roll soundtrack gave way to Shirley Temple and Maelcum Superstar appeared on one screen reading the "Wi-zard of Oz." Below a youth played in a yellow roadside emergency sandbox.

Pope John XXIII was seen several times and the voice of Lee Harvey Oswald's mother turned up at one point.

More In Flopper

In blazing color, the triple screens showed simultaneously: a girl being attacked by an electric fan, another girl ab-ducted by a sick holdup man, and two girls in hairpulling battle.

Dogs, cats and a Rasputin-like painter appeared. The un-derground had surfaced not with a whimper but with a bang.

1968 **EAT YOUR MAKEUP**

UNDERGROUND FILM PREMIERE

DREAMLAND PRESENTS

John Waters' new film
EAT YOUR MAKEUP

Starring Maelcum Soul, David Lochary
and introducing Marina Melin

with bob skidmore/diving/judy boutin/
bonnie pearce/extreme unction/howard gruber/
and the child star Lizzy Temple Black

"The story of a deranged governess and
her lover who kidnap models and
force them to eat their makeup
and model themselves to death"

TWO NIGHTS ONLY !!
Fri + Sat. Feb 23rd + 24th
8 and 10 P.M.
Great Hall- Emmanuel Church
Cathedral and Read Sts
Donation 99¢

ALSO
"Short Circuit" by the 8 yr. old
DAVID WISE
"bits and moments of free creative
expression..... a small wonderland"
Jonas Mekas, Village Voice

After shooting his first two films in 8mm, Waters upgraded to a Bell & Howell 16mm camera for his third, *Eat Your Makeup*. While the soundtrack is not synced, Waters did record dialogue to lay over the picture as closely as possible. The story follows an evil governess (Maelcum Soul) and her boyfriend (David Lochary) who kidnap models and force them to subsist only on makeup, keeping them in handcuffs until it's their turn to walk the runway for the couple and their friends. Waters famously re-created the assassination of John F. Kennedy as part of a daydream sequence in which Divine imagines herself as Jackie. The movie also features a "horror house" much like the one a young Waters used to run out of his garage for the neighborhood kids.

Makeup . . . makeup . . . Oh God, makeup

* DREAMLAND

PRESENTS

JOHN

WATERS'

EAT YOUR

MAKEUP

Scenes from *Eat Your Makeup* featuring Maelcum Soul, Marina Melin, David Lochary, Mona Montgomery, Mary Vivian Pearce, Howard Gruber, Divine, Jean Zemarel, and Gilbert McGill

1969 **MONDO TRASHO**

AT LAST....A "GUTTER FILM"

BALTIMORE EXPERIMENTAL
FILM SOCIETY PRESENTS
the gala world premiere
of

JOHN WATERS'

MONDO TRASHO

STARRING MARY VIVIAN PEARCE, DIVINE, DAVID LOCHARY, AND MINK STOLE

WITH BOB SKIDMORE, MARGIE SKIDMORE, BERENICA CIPCUS, JACK WALSH, CHRIS ATKINSON, MARK ISHERWOOD, child star LIZZY TEMPLE BLACK and introducing JOHN LEISENRING as "the shrimper"

A DREAMLAND PRODUCTION

NINE BIG SHOWS!!! FRI., SAT., SUN. MARCH 14th, 15th, 16th
Emmanuel Church Cathedral & Read Sts—Admission 1.25, 1.50
Showtimes: 8:00, 10:00, and Midnight (doorprizes)

DONT MISS IT

Waters's first feature captures the episodic
adventures of two blondes, played by Mary
Vivian Pearce (styled after Jean Harlow) and
Divine (styled after Jayne Mansfield). Making
appearances are the Virgin Mary, a hitchhiker
whom Divine undresses with her eyes, and
a mad doctor who grafts monster feet onto the
feet of Pearce's character. Early in the film,
Waters's copy of the filmmaker Kenneth Anger's
Hollywood Babylon (US edition, 1965), a collection
of largely spurious accounts of Hollywood
scandals, is used as a prop. The book's promi-
nence in *Mondo Trasho* signals Waters's nod
to Anger and his adoration of the salacious,
tabloid elements of cinema.

How about a kiss for our readers? Great, Miss Divine, great!

Please, Mary, I only ask you for what is rightfully mine—what the good lord has bestowed on me: being Divine!

1970 **THE DIANE LINKLETTER STORY**

THE GIRL. . .THE TRAGEDY. . .THE GAP

JOHN WATERS'

THE DIANE LINKLETTER STORY

STARRING DAVID LOCHARY, MARY VIVIAN PEARCE AND DIVINE AS "DIANE"

a dreamland short subject - 10 minutes

Prior to making *Multiple Maniacs*, Waters acquired new camera equipment capable of recording synced sound. He needed to test it, and a story in the news caught his attention: the death of Diane Linkletter. Her father, the television personality Art Linkletter, blamed her fatal fall on LSD. *The Diane Linkletter Story* was shot that very day, with Divine in the titular role and Diane's parents portrayed by Mary Vivian Pearce and David Lochary, all improvising their lines.

This page: Divine in *The Diane Linkletter Story*. Opposite: wire service article, *Baltimore Evening Sun*, October 7, 1969, clipped and annotated by Waters

The Weather

Cloudy, with chance of rain tonight, low in '50's. Rain likely tomorrow, with highs in 70's.

Detailed report on Page A 2

'A Tiger In Her Bloodstream'

Linkletter, Burying Daughter, Tells Parents To Learn Of Drug Peril

Los Angeles (P)—Art Linkletter says parents should learn the truth about drugs, alcohol and narcotics—"and get this information to their children in a rememberable, sensible, nonpanic way, repetitively."

Today, in private, graveside services at Forest Lawn Memorial Park, the Linkletter family buries daughter Diane, 20, whose death plunge Saturday he blames on LSD—"a tiger in her bloodstream."

Plans Lecture Push

From the fifth grade up, the entertainer says, children "should be grounded as thoroughly in the dangers of putting chemicals into your system as they are in walking across a superhighway with their eyes shut."

The television star and businessman, already a lecturer to college and other groups on "the permissiveness of this society," said:

"I intend now to step up and give it much more point. I think my daughte . death is going to be paid for many, many times by the kinds of things I can say and get done, using this as an example."

Diane, youngest of five Linkletter children, plunged from the kitchen window of a sixth-floor apartment where she had lived about eight months. By phone, from seclusion with his wife Lois and son, Robert, 24, in their Lake Tahoe cabin, Linkletter said:

"Since this has happened to Diane, you cannot imagine the number of people who have called, wired, written me—important people, well known, who

have daughters in sanitariums, sons in sanitariums, children who have killed themselves. They have hushed this up as a terrible family secret.

"They'll Join Me"

"All of a sudden they're coming out and telling me" . . . his voice choked and halted . . . "They'll join me."

In publicizing these evils?

"Yes," he said. "Many are lawyers, bankers, so-called community pillars of decency . . . journalists." He knows none personally.

Linkletter, 57, said he doesn't have all the answers, but "I've been as good a parent as I could possibly be, I think. We've beer a very close family. We've done everything you do according to the book—taken vacations together, gone on pack trips to

[Continued, Page A 2, Col. 1]

[Continued from Page A 1]

gether, traveled extensively all over the world.

"We've been a good Christian family. My wife and I have tried to set a good example by being a good example.

"The Most Daring"

"We have tried to keep our children up to date on what the dangerous things are, but perhaps we did not bear down as hard as we should have.

"Diane, of all the children, was always the most daring. She was the most emotionally up and down. She was either on top of the mountain or in the alley of despair—over trivial things.

"She was the one who would dare to sneak out at night, and be willing to accept the punishment for it. If she came in later than she was supposed to come in, as she did frequently, she got a tongue lashing and took it in good spirits.

Share Of Spankings

"She used to be spanked. When a child knows why he's being punished, not in anger or brutality, he should be punished. So she's had her good share of spankings.

"Of course, becoming an actress, as she was training to be, was absolutely perfect for her because she had the emotional highs and emotional lows that could have done a lot for her as a career actress. She would charm the birds right out the trees.

"So when I heard, indirectly, that she might be going with a group that was experimenting around, I brought it out, as I do everything.

"She Did It Again"

"Our lines of communication were open as far as I was concerned. I said, 'Is it true, Diane, that this group has been experimenting with some of the new things?' And she admitted that it did.

"I pointed out to her the obvious dangers. She agreed and with consummate skill acted out the part that she would never do it again. Obviously she did it again.

"Her mother would have talks with her, good long talks about what was going on among the children of today. My daughter would tell Lois what some of the other girls were doing and how worried she was.

"We now know that she probably was voicing worries about herself, worries that began to gnaw at her. She was concerned that she had quit and was having recurring highs she couldn't control.

"Stronger Dose"

"Over the months she found she had a tiger in her bloodstream. "Apparently what finally happened was she was despondent over a spat with her boy friend and took a much stronger dose of this poison than she should have. She was worried that she would never come out of it mentally, and this led to her death.

"Parents can feel they have all the lines of communication open. But you can't live with your children all the time. They've got to be by themselves. It's impossible to create an atmosphere in which there can be no contamination."

Tips To Parents

So what can parents do? Get information on drugs from the Department of Health, Education and Welfare, or any city or state health department, Linkletter said, and get it to their children along with:

"Such things as dinnertime reading of newspaper stories that will confirm this, which is one of the reasons I gave this story to the papers.

"I want the parents, I want their kids, to read about this and be shocked, be frightened at what can happen.

"What you have to do is not just say using drugs is a bad thing but have incontestable scientific proof. And when somebody like Timothy Leary comes

out and justifies it, we have got to jump on him with hobnailed boots. Such people are casting doubt on the authority of people who know how deadly these things can be.

"No Place To Hide"

"Those kids I've talked to who use it tell me that when you're on what they call a downer, with a heavy dose of LSD, every one of your faults and shortcomings stands out in stark, naked, unrelieved, unrationalized relief. There is no place to hide, It would be like standing up naked on a pedestal in a spotlight when you have warts on your body.

"We know of a sorority sister of my older daughter Sharon who was fed a (sugar) cube with heavy LSD at a cocktail party by fraternity guys as a joke, and she didn't even know she had taken it. She didn't know there was anything there. She was just taking a tidbit.

"A Vegetable"

"This is three years ago and she is still at UCLA in a ward, practically a vegetable.

"I know of kids who have taken LSD many times and had no bad effects whatsoever. That particular personality just didn't have a chink that let that poison in."

Since his daughter's death, Linkletter said, he has been invited to testify before the National Crime Commission and a United States Senate committee. The CBS and NBC television networks and national magazines have requested that he record for them "some of the things I think."

"If I can save a few lives"—Linkletter didn't finish the sentence—"just one would be enough."

Why can't the police do anything about it? All these people are using drugs.

MULTIPLE MANIACS

you won't believe this one!

John Waters'
MULTIPLE
MANIACS

A CELLULOID ATROCITY

In *Multiple Maniacs*, Divine runs a traveling troupe of exhibitionists known as the Cavalcade of Perversion, featuring such shocking acts as bicycle seat licking, armpit sniffing, puke eating, and even "two actual queers kissing each other like lovers on the lips!" One day Divine finds herself in a church, where she engages in a sexual dalliance between the pews with a stranger (Mink Stole) who commands her to "think about the stations of the cross!" Waters sacrilegiously intercuts the scene with biblical imagery.

God, you make me puke!

Prolific production designer Vincent Peranio
was credited as "Lobstora designer" on *Multiple
Maniacs*, his first film job. Waters gave Peranio
one of the ubiquitous lobster postcards from
Provincetown as source material for a giant
monster that rapes Lady Divine. Peranio's pencil
sketch served as the blueprint for the final form,
which was made of aluminum tubing, chicken
wire, and papier-mâché and worn and operated
by Peranio and his brother Ed.

I'm a maniac . . . a maniac that cannot be cured. Divine . . . I am Divine!

1972

PINK
FLAMINGOS

In *Pink Flamingos*, it is established that Divine (alias Babs Johnson) is the filthiest person alive—a point of contention for Connie and Raymond Marble, who believe they have a rightful claim to the title. The filming location for the Marbles' house was 3900 Greenmount Avenue in Baltimore, the actual residence at the time of Waters and Mink Stole, who plays Connie. Years later, Stole swiped the house number from their former residence as a gift for Waters.

We'll see who's the filthiest person alive!

Get everything real good, honey!

Just let me finish you off . . .

Eat shit!
Filth is my politics!
Filth is my life!

This page: Divine in *Pink Flamingos*. Opposite: handwritten script draft, revised, for *Pink*

You are about to receive into your community the filthiest people alive!

42) (Babs, Crackers and Cotton walking up a city street carrying suitcases. Crackers has a sign saying "Boise")

Narrator The filthiest people alive? Well, you think you know someone filthier? Watch, as Divine prooves that not only is she the filthiest person in the world, she is also the filthiest actress in the world! What you are about to see is THE REAL THING!

(as they continue walking, a boy passes walking a Hungarian Sheep dog)

(They break into a broad grin and Babs rubs her stomach)

(The final take is one medium shot without cuts. editing. Babs rushes over to the dog as it takes a shit. She scoops up the shit and puts it in her mouth. She rolls it around on her tongue and gags and winks at the camera. Zoom in on Babs giving a shit eating grin to the camera and the audience.)

1974 FEMALE
TROUBLE

"HIGH COMEDY. Divine is marvelously funny and John Waters is a very funny man... Female Trouble' can't be dismissed."
—Judith Crist, New York Magazine

"COMIC OBSENITY... NASTILY FUNNY!"
—Wolf, Cue Magazine

"THE EXUBERANCE AND ENERGY OF GENIUS... Insanely logical, horribly funny."
—Interview Magazine

"SEX OFFENSES THAT WOULD SHOCK THE MARQUIS DE SADE."
—Rex Reed, N.Y. Daily News

DIVINE and the whole "Pink Flamingos" gang in JOHN WATERS'

Female Trouble

She has a lot of problems

ABOUT THIS Ⓧ
Preview audiences have indicated that "Female Trouble" includes scenes of extraordinary perversity. The distributor therefore wishes to caution the potential viewer that "Female Trouble" may be seen as sexually and morally offensive.

STARRING AND AS IDA
DIVINE · DAVID LOCHARY · MARY VIVIAN PEARCE · MINK STOLE · EDITH MASSEY
A DREAMLAND PRODUCTION FROM SALIVA FILMS, INC. A DIVISION OF NEW LINE CINEMA CORP.

114

Ida	Ooh - ah - ooh!
Gator	Aunt Ida! Aunt Ida!
Ida	You really like it?
Gator	Yeah! Alright Aunt Ida! Alright!
Ida	(caressing herself) Oh God! Ooh --- ahhhh.
Gator	Don't you look hot today!
Ida	Why thank you honey. (she caresses her herself and gyrates wildly) I feel more comfortable. (She walks to bar stool and sits down) Pour me a drink, would ya?
Gator	(going behind bar) Sure Aunt Ida, what would you like?
Ida	Sherry.
	(Gator hands her a drink)
Ida	Have you met any nice boys in the salon?
Gator	Some are pretty nice.
Ida	I mean any nice queer boys. Do you fool with any of them?
Gator	Aunt Ida, you know I dig women.
Ida	Ah, don't tell me that!
Gator	Christ, let's not go through this again.
Ida	All those beauticians and you don't have any boy dates?
Gator	I don't WANT any boy dates.
Ida	Oh, honey, I'd be so happy if you turned nellie.
Gator	Ain't no way! I'm straight! I mean, I like a lot of queens but I don't dig their equipment; I like women.
Ida	But you could change. Queens are just better. I'd be so proud if you was a fag and had a nice beautician boyfriend - I'd never have to worry.
Gator	(laughing) There ain't nothing to worry about.
Ida	I'd worry that you'd work in an office, have children, celebrate wedding anniversaries. The world of a heterosexual is a sick and boring life!
Gator	(shaking his head in disbelief) Sometimes I think you're

In *Female Trouble*—which chronicles the life of Dawn Davenport (Divine) from juvenile delinquency to death row—the introduction to Edith Massey's Ida finds the character strutting her stuff in a pair of zingy black zip-up heels from Frederick's of Hollywood. She receives much encouragement from her nephew Gator, Dawn's soon-to-be husband: "Ooh, Aunt Ida!" The original handwritten draft script includes Ida's most famous line, in which she laments her nephew's heterosexuality as consigning him to "a sick and boring life."

Production designer Vincent Peranio converted an abandoned apartment into most of the film's interior sets, which he decorated with hand-painted wallpaper meant to be garish and tacky but considered iconic by fans today. Peranio and his brother Ed owned an ironworks shop at the time and constructed set dressing, including Ida's cage, the Lipstick Beauty Salon sign, and the blue-and-pink bed frame belonging to the Dashers (Mary Vivian Pearce and David Lochary).

I wouldn't suck your lousy dick if I was suffocating and there was oxygen in your balls

Electric Chair

1977 DESPERATE LIVING

JOHN WATERS'

Desperate Living

It isn't very pretty.....

"I DARE ANYONE NOT TO TAKE JOHN WATERS SERIOUSLY AFTER "DESPERATE LIVING" He remains the visionary of camp and the den mother of the bizarre...This film is a triumphant example of the most vital bad taste in America." *— VILLAGE VOICE*

"THE FOREMOST PUNK OF THE FILM WORLD." *—DAILY TEXAN, Austin, Texas*

"Waters cultivates sleaze like a rare orchid... he is to Baltimore what Ingmar Bergman was to Sweden." *— BALTIMORE SUN*

"Desperate Living" is an astounding accomplishment, a superior work. There are few if any American releases of 1977 that can equal this film." *— TAKE ONE MAGAZINE*

"...has to be seen to be believed. Features the grossest looking creatures since 'The Blob!' " *— PLAYBOY MAGAZINE*

"DESPERATE LIVING" IS A BRILLIANT AND DISTURBING FILM." *— CREEM MAGAZINE*

The handwritten stage directions for the film's opening credits establish the hilarity and vulgarity of *Desperate Living*, the third entry in Waters's "trash trinity." During the title sequence, designed by Alan Rose, a formal dinner is elegantly set and consumed. The main course is boiled rat, and Waters recounts in his book *Shock Value* that he solved the challenge of finding someone who was willing to offer their kitchen to prepare the dish by suggesting Rose and Vincent Peranio cook it in one of their enemies' houses surreptitiously.

Production Manager
PAT MORAN

Unit Manager
ROBERT MAIER

Directed,
Written
and Filmed
by

JOHN
WATERS

CAST OF CHARACTERS

MUFFY ST. JACQUES................LIZ RENAY
PEGGY GRAVEL.....................MINK STOLE
MOLE MCHENRY.....................SUSAN LOWE
QUEEN CARLOTTA...................EDITH MASSEY
PRINCESS COO-COO.................MARY VIVIAN PEARCE
GRIZELDA BROWN...................JEAN HILL
FLIPPER.........................COOKIE MUELLER
SHINA...........................MARINA MELIN
SHOTSIE.........................SHARON NIESP
LT. WILSON......................ED PERANIO
LT. GROGAN......................STEVE BUTOW
LT. WILLIAMS....................CHANNING WILROY
BOSLEY GRAVEL...................GEORGE STOVER
MOTORCYCLE COP..................TURKEY JOE
MUFFY'S HUSBAND.................ROLAND HERTZ
BABYSITTER......................PIRIE WOODS
BIG JIMMY DONG..................H. C. KLIEMISCH
HERBERT.........................GEORGE FIGGS
PERVERT.........................PAT MORAN
NURSE...........................DOLORES DELUXE
GOONS...........................PETER KOPER, STEVE PARKER, CHUCK YEATON,
 PETE DENZER, RALPH CROCKER, DAVID KLEIN

SETS BY VINCENT PERANIO..........COSTUMES AND MAKEUP BY VAN SMITH
DIRECTOR OF PHOTOGRAPHY- THOMAS LOIZEAUX.........SOUND- ROBERT MAIER
EDITOR- CHARLES ROGGERO...MUSIC COMPOSED AND ARRANGED BY CHRIS LOBINGIER & ALLEN YARUS
WRITTEN, DIRECTED AND FILMED BY JOHN WATERS

Page 1

(Opening credits are super-imposed over elegant table setting.
A pair of hands serves an entree dish and pours some wine.
Another course is served — this time a boiled rat heavily garnished.
Another pair of hands with knife & fork enters the frame, cuts rat
and spears hunks of rat-meat. & Finally the fork
is set down and a rat bone is placed on center of plate)

The sets for the fictional slum of Mortville in *Desperate Living* were constructed on a twenty-six-acre farm belonging to Waters's friend Peter Koper, using mostly trash that the production design team—led by Vincent Peranio—had been saving to create the cartoonishly ugly aesthetic demanded by the character of Queen Carlotta (Edith Massey). For her castle exterior, only a facade was erected.

Look at those dummies... Hi, Stupid! Hi, Ugly!

POLYESTER

1981

Waters's first studio film, *Polyester*, was shot
in a prim suburb of his native Baltimore, a
neighborhood unaccustomed to film shoots—
especially one that starred a drag actor playing the
matron of a family with a pornographer father,
an abortion-seeking daughter, and a foot-stomping
son. Further exacerbating the disruption, the
helicopter used to shoot the opening scene was
forced to make an emergency landing on the golf
course of a nearby country club, requiring an
apology from the film's locations manager to the
quiet community's residents.

of Chartwell CC + Community

Sat. Sept. 20

Dear Members,

On behalf of our film company
as well as myself, who set up the
locations, I would like to apologize
for the inconvenience and extreme
annoyance of our helicopter last
Friday Sept. 19. I offer no excuses
and realize that you were not
properly informed of the filming.
Some of you may know that we
are shooting a feature film in the
Baltimore - Severna Park area, and
that some of our locations are in
the Chartwell area. We can only
assure you that this type of
inconvenience will not happen again
to you or members of your
community.
Again, we ask you to accept
our deepest (sp). apologies for the incident of
last Thursday Friday

Sincerely
Stephen B. Walker
locations Manager.
Polyester Films Inc.

Inspired by classic theatrical gimmicks such as those employed by director William Castle and producer Kroger Babb, scratch-and-sniff cards were distributed to *Polyester* audience members so they could "smell along" with the protagonist's (Divine) heightened olfactory abilities. The system, which Waters dubbed Odorama, functioned via corresponding numbers that appeared on both the screen and the card. The card's scents are roses, flatulence, model airplane glue, pizza, gasoline, skunk, natural gas, new car smell, dirty shoes, and air freshener.

you will experience some odors that may shock you . . .

133

Francine Fishpaw, the long-suffering matriarch played by Divine, wants nothing more than to keep a respectable suburban home, but her happiness is thwarted first by her philandering husband (David Samson) and then by a scheming new suitor, played by 1950s heartthrob Tab Hunter in a career-reviving role. Meanwhile, her juvenile delinquent son, Dexter (Ken King), is sent to reform school for the fetish crime of foot stomping (inspired by real-life news stories clipped and saved by Waters). A rehabilitated Dexter learns how to satisfy his foot cravings through art instead of violence.

Meet your polyester queen

Top: prop and set decoration paintings by Jim Blevins; bottom: Ken King, Divine, and Tab Hunter in *Polyester*

The Baltimore Foot Stomper has struck again!

WEATHER

Today: Mostly sunny and mild, less humid.

Tomorrow: Sunny and mild.

TEMPERATURE RANGE
Yesterday 2 p.m. 38%; Today 60–82.

HUMIDITY
Yesterday 2 p.m. 38%; Today 35–46.

Reports and Maps—Page 32

Complete New York Stocks Full Coverage Sports Events

The Baltimore Chronicle

FINAL EDITION

VOL. LXXXVIII TWO PARTS—PART ONE PUBLISHED DAILY 68 PAGES DAILY 20c

Foot Stomper Released -- Insanity

Board Waives Hearing For Two University Teachers

The facts regarding the situation remain the same, state the authorities. Details concerning the action have been given a preliminary investigation but it is felt that only by a more detailed study will the true facts became known.

Thus at this conference all our governments found themselves in unanimous agreement regarding this undertaking. Arrangements for dealing with questions and disputes between the republics were further improved.

Of no less importance was the common recognition shown of the fact that any menace from without to the peace of our continents concerns all of us and therefore properly is a subject for consultation and cooperation. This was reflected in the instruments adopted by the conference.

A suggestion that public hearings on applications be limited to one every six months was taken under advisement by the commission.

Many persons feel at this stage that some legal action is forthcoming but it now becomes common knowledge that there is pressure from the inside which will materially change the aspect of the case.

An immediate investigation is assured and indications are that some

DIPLOMATS FETED AS IMPORTANT ISSUES GO BY THE BOARD

Thus at this conference all our governments found themselves in unanimous agreement regarding this undertaking. Arrangements for dealing with questions and disputes between the republics were further improved.

Of no less importance was the common recognition shown of the fact that any menace from without to the peace of our continents concerns all of us and therefore properly is a subject for consultation and cooperation. This was reflected in the instruments adopted by the conference.

An immediate investigation is assured and indications are that some new light will be shed on the situation in the near future. Available facts seem vague but authorities feel that time will disclose some means of arriving at a solution.

The facts regarding the situation remain the same, state the authorities.

House Plans Program to Fight Crime

Of no less importance was the common recognition shown of the fact that any menace from without to the peace of our continents concerns all of us and therefore properly is a subject for consultation and cooperation. This was reflected in the instruments adopted by the conference.

A suggestion that public hearings on applications be limited to one every six months was taken under advisement by the commission.

The facts regarding the situation remain the same, state the author-

The dinner was well presented and served hot, something that other executive committee of the association. Nat Brown, George B. ss superintendent of the forest protective forces

STATE ASSEMBLY APPROVES
Education Bill Met With Overwhelming Support

Many persons feel at this stage that some legal action is forthcoming but it now becomes common knowledge that there is pressure from the inside which will materially change the aspect of the case.

An immediate investigation is assured and indications are that some new light will be shed on the situation in the near future. Available facts seem vague but authorities feel that time will disclose some means of arriving at a solution.

The facts regarding the situation remain the same, state the authorities. Details concerning the action have been given a preliminary investigation but it is felt that only by a more detailed study will the true facts became known.

Thus at this conference all our governments found themselves in unanimous agreement regarding this undertaking. Arrangements for dealing with questions and disputes between the republics were further improved.

Of no less importance was the common recognition shown of the fact that any menace from without to the peace of our continents concerns all of us and therefore properly is a subject for consultation and cooperation. This was reflected in the instruments adopted by the conference.

A suggestion that public hearings on applications be limited to one every six months was taken under advisement by the commission.

Many persons feel at this stage that some legal action is forthcoming but it now becomes common knowledge that there is pressure from the inside which will materially change the aspect of the case.

An immediate investigation is assured and indications are that some new light will be shed on the situ-

An immediate investigation is assured and indications are that some new light will be shed on the situation in the near future. Available facts seem vague but authorities feel that time will disclose some means of arriving at a solution.

Face-Lifting Job to Start On City Hall

Thus at this conference all our governments found themselves in unanimous agreement regarding this undertaking. Arrangements for dealing with questions and disputes between the republics were further improved.

Of no less importance was the common recognition shown of the fact that any menace from without to the peace of our continents concerns all of us and therefore properly is a subject for consultation and cooperation. This was reflected in the instruments adopted by the conference.

The facts regarding the situation remain the same, state the authorities. Details concerning the action have been given a preliminary investigation but it is felt that only by a more detailed study will the true facts became known.

Many persons feel at this stage that some legal action is forthcom-

LINDA S. TYRRELL

Stomper Leaves Women Limping

(B) GEORGE MITCHELL

A WOMAN, even if she is alone, doesn't expect to be physically assaulted at midday on the crowded sidewalks of downtown Atlanta.

I know I never would have suspected such a thing could happen. But that was before I fell prey to the city's "foot-stomper." 1971

At least 23 other women attacked by a man who mysteriously ran up to

Linda S. Tyrrell is an Atlanta Journal copy editor.

them, ground his heavy platform shoe into their feet and then disappeared into the bustling throng.

My foot still bears the black-and-blue trademark of the stomper, and I'm fairly sure I was one of his first targets here.

It was a typical weekday lunch hour downtown when he took aim at my feet, defenseless and vulnerable in a pair of open-toed high heels.

I was entering a savings and loan office at the corner of Broad and Marietta streets. As I opened the door, I didn't notice anyone behind me. But it seems now that I had been noticed by the foot-stomper, eyeing his next victim.

Inside the building's lobby, I paused a moment, picked out my destination and started toward a second door on my left.

Suddenly a tall, slender man collided with me with unsteadying force. I felt an excruciating jab into my left foot.

Wincing, I yelped an unusually loud "ouch!" A jostle in public would not normally elicit such an outcry, but this agony could not be absorbed in meek silence. I bent over in pain and saw a cut several inches wide. It took a great effort not to collapse — it's amazing how tender are one's feet.

Despite my obvious discomfort, the man said nothing. I looked up at him in disbelief and indignation, expecting at least an apology.

Turning his face away, he muttered a gruff "I'm sorry." His dark coat seemed to rush past in a blur as he fled to a nearby escalator. All I saw of him was his back gliding slowly up to the next floor.

I could not have chased him; in fact I didn't want to, since at the moment I thought the inci-

dent had been merely a slightly bizarre accident. I barely managed to limp the next few steps—a sensation shared by at least some of the other stomping victims, I later learned from newspaper stories.

As quickly as possible, I completed my noon errand and returned, somewhat warily, to my office. I did not see the man again and did not bother to tell my coworkers about the incident.

But as articles about a stomper began to multiply and the circumstances of other attacks —time, place, suspect and victim descriptions—all matched, it became obvious that my foot-grinding was no accident.

Although the stomp-and-run attacks appear almost inconsequential in comparison with more serious and violent assaults, the women whose toes were crushed no doubt found the experience unnerving and unpleasant. Some of them suffered deep gashes and broken bones.

What is most puzzling to me still is the motivation for the man's behavior. Why were all the victims young, white women? Did the stomper take pleasure in the actual attack, its grim effect on a victim or both? Some accounts of stompings indicated he had lingered after the assault to watch the woman grimace in pain.

Since my attack, a Nashville man with a history of previous convictions for similar offenses was apprehended and bound over to Fulton County Criminal Court on 25 charges of simple battery in the stompings here. Bond was set at $100,000. A conviction on such a charge could draw as much as one year in jail.

Despite the arrest, I have taken to wearing closed-toe shoes. In fact, I trudge around in boots much of the time, in the event another rash of attacks should ensue.

And I am prepared to get a better look at an attacker if there is a next time, so that I can testify in court.

He should beware. I was always taught an "eye for an eye," and as far as I'm concerned, that also applies to feet.

Defendant Admits Stomping on Toes

By KEN WILLIS

The defendant in Atlanta's downtown foot-stomping case admitted on the stand Monday that he had indeed stepped on some people's toes.

The suspected stomper, 28-year-old George Mitchell of Nashville, Tenn., was bound over to state court by Municipal Court Judge Arthur Kaplan on 8 counts of simple battery during the court session, Kaplan dropped one charge against Mitchell.

Mitchell made his admission when he took stand to refute a claim that he had stomped one victim on Feb. 11. He testified he had not come to Atlanta until Feb. 12.

However, a city prosecutor then asked him: "At any time since then have you stomped anybody's foot?"

Mitchell glanced at his lawyer, got no response, and said, "Yes, sir."

Judge Kaplan would not allow him to testify about specific incidents.

Six women in their 20s testified against Mitchell Monday. Two of them, both pregnant, said he had stomped their feet twice in the same day at different locations in the Broad Street area.

"This guy was coming through the crowd so fast I thought he was trying to catch a bus," one witness said, "so I tried to step out of his way.

"This foot comes out and stomps my feet," she said, and added she struggled to maintain her balance and composure.

"I tried not to be so obvious about it," she said, "but I looked to see if my foot was bleeding, or still there."

One pregnant woman said she was entering a store in the area "when a man came up behind me and grabbed the door. I thought he was going to hold it open for me but he went on in, turned around, looked at me and deliberately stepped on my foot. I was looking right at him."

Some 40 minutes later, when she had finished shopping and was heading back to work, she testified she was standing on a corner "telling a friend of mine what had happened at the store and I saw a foot come over and step on this other foot." She indicated one of her feet.

1988 HAIRSPRAY

1962…
JFK was in
The White House…
John Glenn was in orbit…
Cadillacs had fins…
Beehives were in…

And girls _really_
knew how to
tease!

"OUTRAGEOUS!"
—Bruce Williamson, PLAYBOY

A new movie by John Waters

HAIRSPRAY

The 60's Comedy That Shows No Mercy!

NEW LINE CINEMA PRESENTS IN ASSOCIATION WITH STANLEY F. BUCHTHAL A ROBERT SHAYE PRODUCTION
"HAIRSPRAY" STARRING SONNY BONO · RUTH BROWN · DIVINE · DEBBIE HARRY
RICKI LAKE AND JERRY STILLER · WITH SPECIAL APPEARANCES BY RIC OCASEK AND PIA ZADORA
CHOREOGRAPHER EDWARD LOVE EXECUTIVE PRODUCERS ROBERT SHAYE AND SARA RISHER
CO-PRODUCERS STANLEY F. BUCHTHAL AND JOHN WATERS PRODUCED BY RACHEL TALALAY
WRITTEN AND DIRECTED BY JOHN WATERS

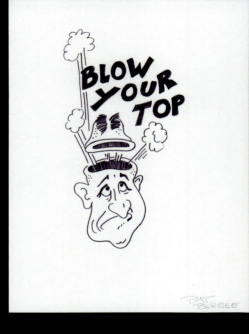

Set in the 1960s, *Hairspray* centers on Tracy Turnblad (Ricki Lake), a plus-size teenager who attempts to integrate a fictional teen dance show. The *Corny Collins Show* was modeled after Baltimore's popular *Buddy Deane Show*, a real-life segregated teen dance program that aired daily from 1957 to 1964. Waters depicts Tracy and her best friend, Penny (Leslie Ann Powers), dancing in the Turnblads' living room, where Tracy's mother, Edna (Divine), does her ironing-for-hire above the Har-de Har Hut joke shop owned by Tracy's father, Wilbur (Jerry Stiller).

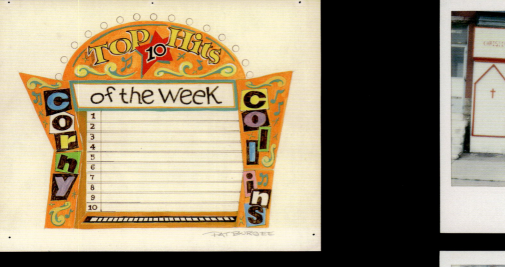

Production design drawings and location-scouting Polaroid photographs (this page) were instrumental in realizing the look of the film's key settings, including the *Corny Collins Show*, Motormouth Maybelle's store, and the Miss Auto Show pageant. The storefront of Baltimore record shop Music Liberated was transformed into Motormouth Maybelle's and an adjoining fake church with handpainted signage elements drawn from real local churches.

I love you, Baltimore!

Clockwise from top left: production design drawing by Pat Burgee; location-scouting Polaroids; drawing of auto show throne by Vincent Peranio

THE MUSICAL INTERLUDE

Clockwise from top left: music and dance scenes from *Hairspray* (1988), *Cecil B. Demented* (2000), *Polyester* (1981), *Cry-Baby* (1990), *A Dirty Shame* (2004), and *Female Trouble* (1974)

Song-and-dance sequences are featured throughout Waters's filmography. His first film, *Hag in a Black Leather Jacket*, ends with Mary Vivian Pearce doing a libidinous dance called the Bodie Green, and his most recent, *A Dirty Shame*, includes a suggestive version of the Hokey Pokey in which Sylvia Stickles (Tracey Ullman) picks up a water bottle from the ground without using her hands. Waters foregrounds music and dance most prominently in *Hairspray*, which he characterizes as his dance film, and *Cry-Baby*, which he characterizes as his musical.

Featuring songs such as "I'm Blue (The Gong-Gong Song)" by the Ikettes and "Please, Mr. Jailer" by Wynona Carr and the Bumps Blackwell Band, these movies spotlight Waters's deep musical interest and knowledge. Catchy original songs have also been composed for his films, including "Female Trouble," with lyrics by Waters, performed by Divine; "Polyester," with music and lyrics by Chris Stein and Debbie Harry, performed by Tab Hunter; and "Hairspray," with music, lyrics, and performance by Rachel Sweet.

Mona Montgomery (this page) and Mary Vivian Pearce (opposite) in *Hag in a Black Leather Jacket* (1964)

Top: Tom Diventi, Mary Garlington, and Stiv Bators in *Polyester* (1981); middle: Mo Fischer and Billy Tolzman in *Pecker* (1998); bottom: Tracey Ullman in *A Dirty Shame* (2004)

1990 **CRY-BABY**

A JOHN WATERS FILM

JOHNNY DEPP

He's a doll.
He's a dreamboat.
He's a delinquent.

Cry-Baby

IMAGINE ENTERTAINMENT Presents "CRY-BABY" AMY LOCANE · SUSAN TYRRELL
IGGY POP · RICKI LAKE · TRACI LORDS
and POLLY BERGEN As Mrs. Vernon-Williams Music Supervised by BECKY MANCUSO
and TIM SEXTON Original Score by PATRICK WILLIAMS Edited by JANICE HAMPTON
Director of Photography DAVID INSLEY Executive Producers JIM ABRAHAMS BRIAN GRAZER Produced by RACHEL TALALAY

PG-13 PARENTS STRONGLY CAUTIONED
Some Material May Be Inappropriate for Children Under 13.
SOUNDTRACK ON MCA RECORDS, CASSETTES AND CDs
DOLBY STEREO IN SELECTED THEATRES
Written and Directed by JOHN WATERS A UNIVERSAL RELEASE
© 1989 UNIVERSAL CITY STUDIOS, INC.

NSS 900021 PRINTED IN U.S.A.

Cry-Baby don't dig squares

et in the 1950s, *Cry-Baby* follows two rival
een groups, the delinquent Drapes and
he conformist Squares. The leader of the
Drapes, Wade "Cry-Baby" Walker (Johnny
Depp), is adorned with rebellious symbols
uch as a leather jacket and a guitar—a period-
ccurate Gretsch chosen with Depp's input
fter considering other similar models. This
conography extends to all the Drapes, as
very member is outfitted with an identical
acket emblazoned with Cry-Baby's name,
ven little Snare-Drum (Jonathan Benya), who
vears a miniature version.

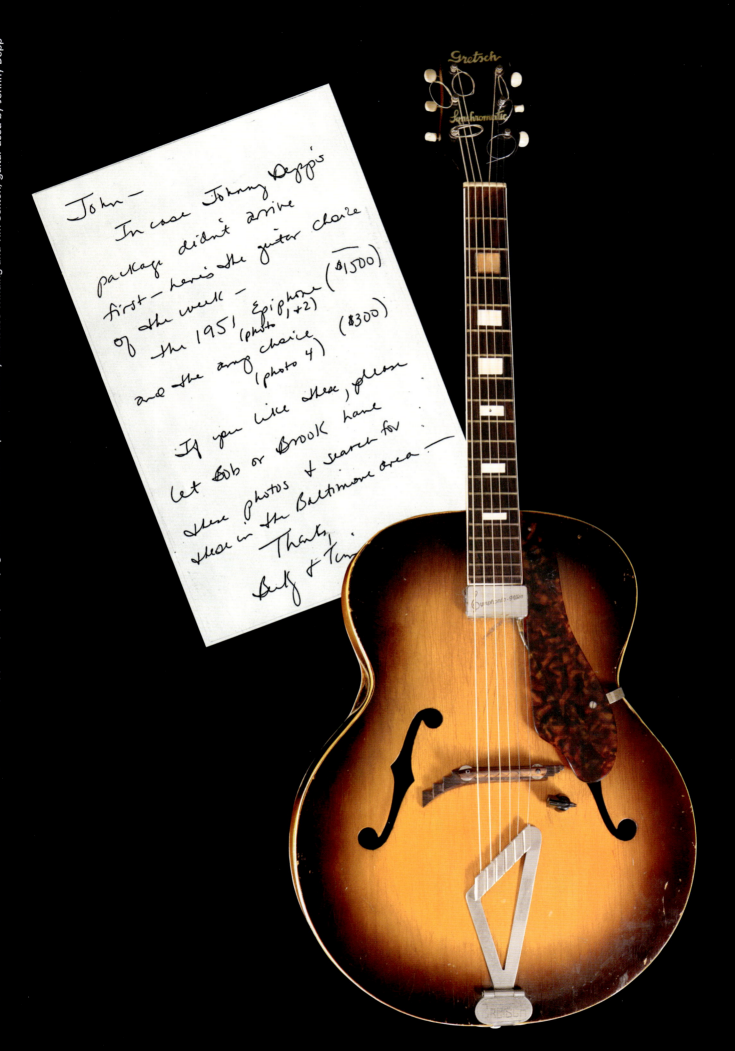

John —

In case Johnny Depp's package didn't arrive first — here's the guitar choice of the week —

the 1951 Epiphone ($1500) (photo 1+2)

and the amp choice ($300) (photo 4)

If you like these, please let Bob or Brook have these photos + search for these in the Baltimore area!

Thanks,
Becky + Tim

Top: Patricia Hearst (left) and Darren E. Burrows, Kim McGuire, Ricki Lake, and Johnny Depp (right) in *Cry-Baby*. Bottom: Kim McGuire, Darren E. Burrows, Amy Locane, Johnny Depp, Traci Lords, Iggy Pop, Susan Tyrrell, Ricki Lake, and Jonathan Benya in *Cry-Baby*

Like many of Waters's protagonists, Cry-Baby finds himself behind bars. A scene in a license-plate factory, filmed on location at a real prison, finds him stamping the name of his love, Allison (Amy Locane), onto every plate, several of which became souvenirs for the cast and crew. Another Waters trademark is a prop newspaper used as exposition.

Please Mr. Jailer, won't you let this jailbird free?

167

ON TODAY'S EDITORIAL PAGE
Everybody's for It!: Editorial
What the Post Office Should Do: Editorial
To Eat, or Not to Eat?: Cartoon

BALTIMORE — THE — NEWS-POST
AN INDEPENDENT NEWSPAPER
Five Great News and Picture Services: Associated Press, International News Service, United Press, Sound Photo, Wirephoto.

FINAL ★★

Vol. 102. No. 219.　　　SATURDAY MORNING, JUNE 5, 1954　　　PRICE 5 CENTS

GANG WAR IN BALTIMORE

Oratorical Contest Winner To Compete Again Sunday

By C. BROOKS PETERS

Dad Blames Self In Son's Navy Commission Delay

Fair and Warmer

THE TEMPERATURES

FUNDS APPROVED TO MAKE RUBBISH PICKUP CITY-WIDE

$200,000 OK'd by Estimate Board and Aldermen Are Expected to Vote Appropriation.

Grammer Learns He'll Die

Miss Betty Renner's body was found yesterday with all her clothing except a brassiere stripped off. Medical examination disclosed she died of suffocation. No evidence of rape was found.

Missing Boy Sleeps Night at Pal's Home; Found, Spanked, Put to Bed

Eight-year-old David Creek, missing since yesterday when he left home to visit a playmate, was found cuddled in bed at a neighbor's home today.

David Creek

Earle Mack Says 'A's For Sale'

CHICAGO, April 30 (AP)—A strike against four of the nation's biggest railroad systems has been called for next Wednesday morning. The strike could affect all transportation.

Biggest Hunt In State

WOMAN FATALLY INJURED WHEN TRUCK LEAVES ROAD

Mrs. Mary Joan Snyder, 18 year old, of Freeburg, Ill., died today at St. Elisabeth's Hospital in Belleville of injuries suffered when the truck operated by her husband, R. T. Snyder, ran off the highway near Freeburg and struck two telephone poles.

U.S. Asks China To Free 83

Waters used pages from photographer Bob Mizer's *Athletic Model Guild: 160 Young Americans* (1987), a collection of Mizer's vintage erotic male photographs, to pitch the film to studio executives (without revealing the imagery's source). The subject of one of Mizer's photographs—a nude model "bathing in washtub, legs hanging out, scrubbing his back"—inspired the stage direction for the scene introducing Cry-Baby's stepfather, Uncle Belvedere Rickettes, played by the musician Iggy Pop.

You caught me in my birthday suit!

1994 **SERIAL MOM**

"AN OUTRAGEOUS, WILD & CRAZY COMEDY. KATHLEEN TURNER IS HILARIOUS."

– Susan Granger, CRN/AMERICAN MOVIE CLASSICS

KATHLEEN TURNER

A New Comedy By John Waters.

SERIAL MOM

SAM WATERSTON

RICKI LAKE

SAVOY PICTURES Presents A POLAR ENTERTAINMENT Production A Film By JOHN WATERS
KATHLEEN TURNER "SERIAL MOM" SAM WATERSTON RICKI LAKE And SUZANNE SOMERS Music Supervisor BONES HOWE Music By BASIL POLEDOURIS
Edited By JANICE HAMPTON And ERICA HUGGINS Director of Photography ROBERT STEVENS, A.S.C. Executive Producer JOSEPH CARACCIOLO, JR.
Produced By JOHN FIEDLER And MARK TARLOV Written and Directed By JOHN WATERS A SAVOY PICTURES RELEASE
© 1994 Savoy Pictures, Inc. All Rights Reserved.

R RESTRICTED UNDER 17 REQUIRES ACCOMPANYING PARENT OR ADULT GUARDIAN

DOLBY STEREO IN SELECTED THEATRES

SAVOY PICTURES

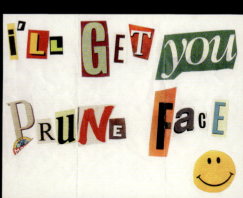

In *Serial Mom*, Beverly Sutphin (Kathleen Turner) may seem like a shining example of the June Cleaver model of motherhood, but she's actually a serial killer who torments and murders her neighbors for violating the rules of propriety, such as wearing white after Labor Day or neglecting to rewind their rented videos. For the crime of taking her parking spot, Beverly subjects neighbor Dottie Hinkle (Mink Stole) to obscene phone calls and lewd mail. For the latter, two versions of the threatening letter were made: one for theatrical release and one censored for television.

Didn't I just say, "Fuck you!?"

Beverly's husband (Sam Waterston) begins to suspect his wife's extracurricular criminal activities when he stumbles upon her scrapbook of newspaper clippings related to notorious figures, including Richard Speck, John Wayne Gacy, Ted Bundy, Jeffrey Dahmer, and Charles Manson. The film prop mirrors Waters's personal collection of serial killer articles.

We all have our bad days

A kiss for Sam from his pen pal

THERE'LL BE ROOM FOR BERKOWITZ

By LINDSAY MILLER

Rosina Belpedio kisses the picture of her pen-pal David Berkowitz every night, but she's afraid her romance with the suspected Son of Sam killer is not meant to be.

"David said hello and goodby in one letter," said Miss Belpedio, a tiny woman with short, frizzy red hair as she sat in her possession-filled room in the once-elegant St. George Hotel in Brooklyn Heights.

Her two love letters to Berkowitz offered friendship and a place to stay when he gets out of the hospital.

Berkowitz wrote back, thanking her for her "lovely letters." But, he said, "I don't think we could ever get together, it just cannot be."

Currently Miss Belpedio, who says she's 40, shares the room with 72-year-old Jack Licht and a cat named Mendelssohn. But she said there'd be room for Berkowitz because "Jack's moving out."

Miss Belpedio's letters were among many—full of both love and hate—which have poured into Kings County Hospital where Berkowitz is undergoing psychiatric tests.

SELLS REPLY

Except for letters to reporters and others connected with the case, this is the first letter by Berkowitz to surface since his capture Aug. 10.

It came to light because Miss Belpedio decided to sell the letter to Charles Hamilton, the autograph dealer, for $100. She had read in The Post on Wednesday that Hamilton paid

Post Photos by Joe DeMaria

Rosina Belpedio looks lovingly at a picture of her pen pal.

$50 for a checking-account application signed by Berkowitz.

"I needed the money. I was broke," she said. "I hope Sam forgives me."

She kept her correspondence with Berkowitz a secret until this week.

"I didn't even tell Ja she said, as her roomn cupped his head in hands in laughter.

Her reason for writi "No one was being nic him. And I think he's

Rosalynn meets Gacy

To John Gacy,
Best Wishes
Rosalynn Carter

1998 **PECKER**

written
and directed by

john waters

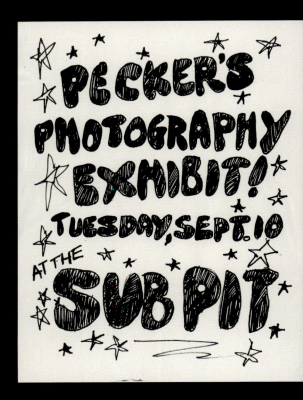

I can't figure out what this one is, but I kinda like it

Pecker (Edward Furlong), a Baltimorean version of the real-life gritty street photographer Weegee, captures the everyday in his Hampden neighborhood. When his photographs are displayed in the sandwich shop where he works, he is discovered by a New York City gallerist and takes the art world by storm with a Chelsea gallery exhibition. This brings him into the circles of the artists Cindy Sherman and Greg Gorman (who play themselves in the film). The graphic design of the flyers announcing the two different exhibitions emphasizes the cultural contrast between Baltimore and New York City, which is explored in *Pecker*.

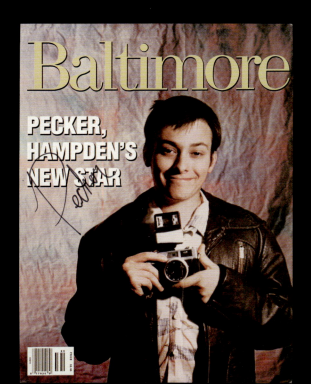

PECKER'S PHOTOGRAPHY EXHIBIT! TUESDAY, SEPT. 10 AT THE **SUB PIT**

Baltimore

PECKER, HAMPDEN'S NEW STAR

NEW YORK OBSERVER

VOLUME 12 NUMBER 2 NEW YORK NOVEMBER 9, 1998 ONE DOLLAR

Real Estate
New Property Up
For Grabs on the
West Side
Page 22

8-Day Week
What's New for
Those Who Never
Have the Time
Page 12

MAYOR CLOSES THE LAST OF THE AFTER-HOURS CLUBS

BY JOHN HATT

Lorem ipsum dolor sit amet, consectetuer adipiscing elit, sed diam nonummy nibh euismod tincidunt ut laoreet dolore magna aliquam erat volutpat. Ut wisi enim ad minim veniam, quis nostrud exerci tation ullamcorper suscipit lobortis nisl ut aliquip ex ea commodo consequat.

Duis autem vel eum iriure dolor in hendrerit in vulputate velit esse molestie consequat, vel illum dolore eu feugiat nulla facilisis at vero eros et accumsan et iusto odio dignissim qui blandit praesent luptatum zzril delenit augue duis dolore te feugait nulla facilisi. Lorem ipsum dolor sit amet, consectetuer adipiscing elit, sed diam nonummy nibh euismod tincidunt ut laoreet dolore magna aliquam erat volutpat.

Ut wisi enim ad minim veniam, quis nostrud exerci tation ullamcorper suscipit lobortis nisl ut aliquip ex ea commodo consequat. Duis autem vel eum iriure dolor in hendrerit in vulputate velit esse molestie consequat, vel illum dolore eu feugiat nulla facilisis at vero eros et accumsan et iusto odio dignissim qui blandit praesent luptatum zzril delenit augue duis dolore te feugait nulla facilisi.

Nam liber tempor cum soluta nobis eleifend option congue nihil imperdiet doming id quod mazim placerat facer possim assum. Lorem ipsum dolor sit amet, consectetuer adipiscing elit, sed diam nonummy nibh euismod tincidunt ut laoreet dolore magna aliquam erat volutpat. Ut wisi enim ad minim veniam, quis nostrud exerci tation ullamcorper suscipit lobortis nisl ut aliquip ex ea commodo consequat.

Duis autem vel eum iriure dolor in hendrerit in vulputate velit esse molestie consequat, vel illum dolore eu feugiat nulla facilisis.

Lorem ipsum dolor sit amet, consectetuer adipiscing elit, sed diam nonummy nibh euis-

FLAVOR OF MONTH CAUSES TIZZY IN ARTWORLD

"I support Pecker's decision" claims red-faced curator.

BY JANE WEIMO

te feugait nulla facilisi. Lorem ipsum dolor sit amet, consectetuer adipiscing elit, sed diam nonummy nibh euismod tincidunt ut laoreet dolore magna aliquam erat volutpat.

Ut wisi enim ad minim veniam, quis nostrud exerci tation ullamcorper suscipit lobortis nisl ut aliquip ex ea commodo consequat. Duis autem vel eum iriure dolor in hendrerit in vulputate velit esse molestie consequat, vel illum dolore eu feugiat nulla facilisis at vero eros et accumsan et iusto odio dignissim qui blandit praesent lupta-tum zzril delenit augue duis dolore te feugait nulla facilisi.

Nam liber tempor cum soluta nobis eleifend option congue nihil imperdiet doming id quod mazim placerat facer possim assum. Lorem ipsum dolor sit amet, consectetuer adipiscing elit, sed diam nonummy nibh euismod tincidunt ut laoreet dolore magna aliquam erat volutpat. Ut wisi enim ad minim veniam, quis nostrud exerci tation ullamcorper suscipit lobortis nisl ut aliquip ex ea commodo consequat.

Duis autem vel eum iriure dolor in hendrerit in vulputate velit esse molestie consequat, vel illum dolore eu feugiat nulla facilisis.

Lorem ipsum dolor sit amet, consectetuer adipiscing elit, sed diam nonummy nibh euismod tincidunt ut laoreet dolore magna aliquam

et accumsan et iusto odio dignissim qui blandit praesent luptatum zzril delenit augue duis dolore te feugait nulla facilisi. Lorem ipsum dolor sit amet, consectetuer adipiscing elit, sed diam nonummy nibh euismod tincidunt ut laoreet dolore magna aliquam erat volutpat.

Ut wisi enim ad minim veniam, quis nostrud exerci tation ullamcorper suscipit lobortis nisl ut aliquip ex ea commodo consequat. Duis autem vel eum iriure dolor in hendrerit in vulputate velit esse molestie consequat, vel illum dolore eu feugiat nulla facilisis at vero eros et accumsan et iusto odio dignissim qui blandit praesent luptatum zzril delenit augue duis dolore te feugait nulla facilisi.

Nam liber tempor cum soluta nobis eleifend option congue nihil imperdiet doming id quod mazim placerat facer possim assum. Lorem ipsum dolor sit amet, consectetuer adipiscing elit, sed diam nonummy nibh euismod tincidunt ut laoreet dolore magna aliquam erat volutpat. Ut wisi enim ad minim veniam, quis nostrud exerci tation ullamcorper suscipit lobortis nisl ut aliquip ex ea commodo consequat.

Duis autem vel eum iriure dolor in hendrerit in vulputate velit esse molestie consequat, vel illum dolore eu feugiat nulla facilisis.

185

PECKER

OPENING: OCTOBER 10, 6:30—8:30

530 WEST 22nd STREET NEW YORK NY 10001

ROREY WHEELER GALLERY
NEW YORK CITY

Hey, Cindy! Thank you for coming to my show!

2000 **CECIL B.
DEMENTED**

Melanie Griffith
Stephen Dorff

LONG LIVE
GUERRILLA FILM
MAKING!

Cecil B.
Demented

Written and Directed by John Waters

ARTISAN ENTERTAINMENT PRESENTS IN ASSOCIATION WITH LE STUDIO CANAL+ A POLAR ENTERTAINMENT PRODUCTION A JOHN WATERS FILM MELANIE GRIFFITH STEPHEN DORFF "CECIL B. DEMENTED" ALICIA WITT ADRIAN GRENIER
LARRY GILLIARD, JR. MINK STOLE RICKI LAKE PATRICIA HEARST AND KEVIN NEALON CASTING PAT MORAN, C.S.A. AND HOPKINS SMITH BARDEN EXECUTIVE PRODUCER CHRISTOPHER BROOKS MUSIC ZOE POLEDOURIS & BASIL POLEDOURIS EDITED JEFFREY WOLF, A.C.E.
DIRECTOR OF PHOTOGRAPHY ROBERT STEVENS, A.S.C. PRODUCED ANTHONY DiLORENZO FRED BERNSTEIN PRODUCED JOHN FIEDLER JOE CARACCIOLO, JR. MARK TARLOV WRITTEN AND DIRECTED JOHN WATERS

www.dementedforever.com

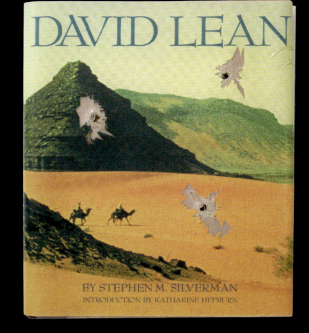

Cecil B. Demented follows a ragtag crew of underground guerrilla filmmakers known as the Sprocket Holes. They abhor mainstream cinema and rebel against it in any way they can, from supporting pornography to using a book about the revered highbrow director David Lean for target practice. Each Sprocket Hole bears a tattoo with the name of a subversive director who has challenged or worked outside the cinematic status quo.

This page: prop bullet-riddled book (top) and "Sticky Bunz" sex toy (bottom). Opposite: Melanie Griffith, Adrian Grenier, Stephen Dorff, and Lawrence Gilliard Jr. in *Cecil B. Demented*

I have a vision!

Overleaf: Michael Shannon, Lawrence Gilliard Jr., Jack Noseworthy, Alicia Witt, Maggie Gyllenhaal, Adrian Grenier, Erika Auchterlonie, Eric Barry, Zenzele Uzoma, and Harry Dodge

2004 A DIRTY SHAME

TRACEY
ULLMAN

JOHNNY
KNOXVILLE

SELMA
BLAIR

CHRIS
ISAAK

◦THREATENING THE VERY LIMITS OF COMMON DECENCY◦

A DIRTY SHAME

A JOHN WATERS FILM

FINE LINE FEATURES PRESENTS THIS IS THAT KILLER FILMS/JOHN WELLS PRODUCTION IN ASSOCIATION WITH CITY LIGHTS PICTURES A JOHN WATERS FILM "A DIRTY SHAME"
TRACEY ULLMAN JOHNNY KNOXVILLE SELMA BLAIR CHRIS ISAAK MUSIC SUPERVISOR TRACY McKNIGHT ORIGINAL SCORE BY GEORGE S. CLINTON CASTING BY PAT MORAN, C.S.A. COSTUME DESIGNER VAN SMITH
EDITED BY JEFFREY WOLF, A.C.E. PRODUCTION DESIGNER VINCENT PERANIO DIRECTOR OF PHOTOGRAPHY STEVE GAINER, ASC CO-PRODUCER ANN RUARK CO-EXECUTIVE PRODUCERS MICHAEL ALMOG AND BOB JASON EXECUTIVE PRODUCERS JOHN WELLS
THE FISHER BROTHERS EXECUTIVE PRODUCERS MARK ORDESKY MARK KAUFMAN MERIDETH FINN PRODUCED BY CHRISTINE VACHON TED HOPE WRITTEN AND DIRECTED BY JOHN WATERS FINE LINE FEATURES

COMING SOON

SOUNDTRACK AVAILABLE ON NEW LINE RECORDS
www.adirtyshamemovie.com

A Dirty Shame follows repressed mother Sylvia (Tracey Ullman) and her daughter, Caprice (Selma Blair), as they make their way in a world where head injuries have caused people to shift back and forth between being uptight prudes and being sex fiends addicted to a specific fetish. Among these newfound fetishists are badge bunnies (people attracted to cops), adult babies, and mysophiliacs (those attracted to dirt).

I don't want to feel normal

W-H-E-R-E

I'm Sylvia Stickles, and I've got the itch

N-E-U-T-E-R

As the characters of *A Dirty Shame* experience a sexual awakening, so too does the nature that surrounds them. Production designer Vincent Peranio and his team decorated the sets with trees, bushes, and other plants shaped to resemble male and female genitalia. The concept drawings by Peranio were realized as animated forms that could gyrate, blossom, and become erect.

201

THE JOHN WATERS ARCHIVE
A LEGACY OF SHOC

Jeanine Basinger

Most people picture the world of John Waters as a wild ride down the rabbit hole into a psychedelic scene decorated with cha-cha heels, Divine's breasts, beehive hairdos, and dog poop. No. The world of John Waters is Baltimore. Just Baltimore. He's not the guy who takes us to someplace we've never seen or never will see. He's the guy who takes us around the corner in our own neighborhood to show us what we didn't realize was there or what we've chosen to act as if we didn't know was there. His world is a wild ride, all right, but someone sane is driving.

John Waters is an original American artist and thinker. He represents that "dancing to a different drummer" thing that makes us who we are as a nation (for good or ill). John's art, his books, his fashion influence, and his films all reflect a unique and personal point of view, and he doesn't get rattled if some people are horrified by it. ("I learned that people like my work because I praise things that others don't like…. As far as socially redeeming value, I hope I don't have any.") By being deadly honest—in a matter-of-fact and hilarious way—he at first became King of the Outsiders who were all very happy to recognize themselves in his bizarro universe. They saw his movies for what they were: the Big Joke on all the winners who didn't realize they were really losers. ("Nobody likes a bore on a soapbox…. Humor is the only answer.") What most people didn't see coming was that John's appeal would grow much, much wider, so that, over time, America was going to embrace John Waters in gratitude for relieving it of the burden of always pretending to be proper.

In 1986 I decided to invite John to donate his archival papers, costumes, props, and personal memorabilia to the Wesleyan Cinema Archives in Middletown, Connecticut. We were building what we hoped would be a connoisseur's collection of truly American filmmakers who all presented a sharp visualization of their times. We had, among others, Frank Capra for the Depression, Elia Kazan for the postwar McCarthy era, Clint Eastwood for the casually hip "Dirty Harry" seventies, and an actress who, although not born in this country, was surely a definitive example of the studio-era Hollywood movie star: Ingrid Bergman. I wanted John Waters because his work had style. It was unlike anyone else's, and it reflected what was really going on in America. He was outside his times, but insightfully inside them too, which put him totally ahead of everyone. He was perfect for us.

I had never met John. I decided to simply call him up on the telephone, and guess what? He was listed in the Baltimore directory. I thought of my

Materials from the John Waters Archive at the Ogden and Mary Louise Reid Cinema Archives, Wesleyan University, 2022

203

cold call as a very John Waters thing to do, so I just dialed him, and he just picked up! With barely a hello, I breathlessly proposed that he allow us to become the home of the John Waters Archive, which would be housed with Frank Capra, Elia Kazan, Clint Eastwood, and Ingrid Bergman. There was ever so slight a pause, and then he said, "Is this a joke?"

It was, after all, 1986. He was obviously dubious, but John has probably never met a risk he wasn't willing to take, so he came to Connecticut to check us out, dutifully arriving punctually on a mid-December day. We met on the front porch of the original archive building, where he digested the news that he couldn't smoke inside but came in anyway, sat down, and ate a slice of the homemade apple pie we hoped would seduce him. We started talking (and bonding) over things we felt really mattered. Lana Turner. *Susan Slade* (USA, 1961). My weird collection of Christmas tree decorations. (He liked the tiny washing machine that could rinse out doll undies while hanging on the tree, but he rejected

I WANTED JOHN WATERS BECAUSE HIS WORK HAD STYLE. IT WAS UNLIKE ANYONE ELSE'S, AND IT REFLECTED WHAT WAS REALLY GOING ON IN AMERICA

From left: Clint Eastwood, John Waters, Martin Scorsese, and Jeanine Basinger, 1995

the dancing penis that could only perform on a tabletop.) At the end of the day, John Waters packed up the leftover pie, said yes, and retreated out to the porch to smoke a cigarette. We were all deliriously happy. Then, of course, we had to tell the world that John Waters would soon be housed with us, and we could display items such as "Deadly School," one of his horror story grade-school writings (on typical lined notebook paper). The announcement brought interesting reactions: "Oh no!" "Who is John Waters?" "I'm scared. Very, very scared." My personal favorite was sent to me in an anonymous letter: "You have disgraced yourself and all of us with your incredible lack of taste and insight. You are a cultural nightmare, and you will regret this terrible error. No other serious archive or museum or arts institution will ever, ever, ever include John Waters."

So here we are in 2023, and not only has John Waters been featured in many art galleries, retrospectives, and "serious" institutions, he's also a best-selling author, a recognized cultural influence, and a household name thanks to a hit Broadway show that's being restaged in high schools and colleges all over America. How perfect is it that a

tribute to him as a respected filmmaker has opened at the new Academy Museum of Motion Pictures? Patricia Hearst's white pumps are in the same galleries that once held Dorothy's ruby slippers from one of John's earliest cinematic influences, *The Wizard of Oz*. ("It opened me up to villainy.")

There's nobody like John, and not just because he draws his mustache on with an eyebrow pencil. He's probably the most quotable person alive. Describing his beloved hometown, he says, "It's as if every eccentric in the South decided to move north, ran out of gas in Baltimore, and decided

"YOU HAVE DISGRACED YOURSELF AND ALL OF US WITH YOUR INCREDIBLE LACK OF TASTE AND INSIGHT. YOU ARE A CULTURAL NIGHTMARE, AND YOU WILL REGRET THIS TERRIBLE ERROR. NO OTHER SERIOUS ARCHIVE OR MUSEUM OR ARTS INSTITUTION WILL EVER, EVER, EVER INCLUDE JOHN WATERS"

to stay." About his favorite holiday (which is not Halloween), he explains, "Being a traditionalist, I'm a rabid sucker for Christmas. In July, I'm already worried that there are only 146 shopping days left." His personal advice is all anyone needs: "True success is figuring out your life and career, so you never have to be around jerks." He also has good dating tips, some of which have been reprinted on coffee cups, but most of which can't necessarily be reprinted here. Being in his presence is a guaranteed laugh fest, and he's also a real gent. When we went to the movies at a Baltimore strip mall, everyone said, "Hi, John," but the surprise of that is not in celebrity recognition but in that he knew in return every one of their names. On a panel discussion at Wesleyan regarding the future of movies, he made Clint Eastwood and Marty Scorsese laugh so hard that I started to worry Marty would fall off his chair and choke to death. And knowing John means you get to participate in his unparalleled contests like the Happy Holidays competition, which had "25 chances to win, 2,025 chances to lose." First prize was ten pounds of ground beef, but if you lost, you might still get a Chipmunks Christmas LP, a one-year subscription to the *National Enquirer*, or a personal set of Maybelline eyebrow pencils.

How can you not love John Waters? And respect him? On the other hand, let's not canonize him too soon and spoil the fun. Luckily there are still a few stragglers out there who don't get it, which is well illustrated by what happened when he signed a contract with a major studio to direct a movie. Everybody celebrated, and a top executive told him, "We're thrilled. So excited. So proud and happy . . . but wait! This isn't going to be one of those John Waters movies, is it?" Every so often someone asks, "Has the world caught up with John Waters?" To quote a line he once used on me, "Is

Exterior of the Ogden and Mary Louise Reid Cinema Archives building at Wesleyan University, 2012

JOHN WATERS WILL ALWAYS BE A MAN WHO IS UNPREDICTABLE, UNAFRAID, ELEGANT, HILARIOUS, AND WISE: THE OFFICIAL OUTSIDER WHO BECAME AN INSIDER WHO STILL LOVES WHAT IT'S LIKE OUTSIDE

this a joke?" We'll never catch up to John Waters. (Read today's newspaper if you want to know why.) John hitchhiked across America at the age of 66, willingly hopping into any car that stopped for him. That kind of openness to what's out there is a challenge to all of us—and one we're not going to win. John accepts life in all its varieties—except for the humorless, the boring, and the closed-minded.

John Waters will always be a man who is unpredictable, unafraid, elegant, hilarious, and wise: the official outsider who became an insider who still loves what it's like outside. What will he say as he's enshrined into more and more cultural institutions? He'll do the John Waters chortle and declare, "I won!"

205

THE RIGHTEOUS
ENEMY OF NORMAL

David Simon

John Waters began his improbable career of deep cultural relevance with the equally improbable notion that people from Baltimore, Maryland, should be allowed to put stories on film. As someone who has directly benefited from such effrontery, I might be accused of crediting Waters too generously, of claiming too much for him as an artist, and granting too much import to his voice. Waters himself, if he reads this, will certainly be quick to engage in self-mockery. He might even plead that his career began with the coprophilic *Pink Flamingos* (1972) as simply "an exercise in poor taste," as that film was in fact billed on its release. And then, as he wrote in his wondrous autobiography *Shock Value* (1981), he might hasten to add, "I like understatement."

Indeed, the more we come to John Waters singing his praises, the more certain he is to graciously mock his own relevance or to deflect any argument that his work carries a fundamental lesson—a lesson, in fact, that all require in this failing new century of human belligerence and misadventure. John Waters is one of the great modern masters of self-effacement, and he has gone to lengths to characterize his entire career as a storyteller and filmmaker in terms that leave him on the inside of an elaborate joke, gazing out. "Thanks," Waters confides to readers in that tone-perfect autobiography, "for letting me get away with it."

Good line. A charming line even. And no accident that, never mind his film work, John Waters is one of the finest prose writers and essayists working today. On the page the man knows exactly what he is doing and why, and he damn sure knows how to turn and twist a phrase. To read *Shock Value* or *Role Models* (2010) or *Carsick* (2014) and watch Waters use the written word to both celebrate and lacerate all that has become of our American experiment is to discover, with growing certainty, that all the dogshit swallowed by all the actors on all the screens of all the art house theaters in the world is not enough to consign Waters to farce or fraud or Barnum. This is a writer who knows not only who he is and what he has to say but also who we are and why we need to hear it.

So, no, we are having no more of his failing-upward, I-was-merely-trying-to-offend disingenuousness. Waters knows exactly what he has done and continues to do with every crafted sentence and camera move. Here we are calling bullshit. To begin with, there is the legacy of John Waters

THERE WAS A FIGHT IN MARYLAND FOR WHAT IDEAS WOULD BE ALLOWED, AND IT MATTERED

Chairman Egbert L. Quinn and Mary Avara of the Maryland State Board of Censors reviewing *The Girl Can't Stop* (*Les chiens dans la nuit*, France, 1965), Baltimore, 1967

as a rigorous, effective front in the war on conformity, prudery, and censorship, a battle that I watched him wage when I was no more than a beer-swilling undergraduate at the University of Maryland, where a late-night run of *Pink Flamingos* at the local theater on Route 1 had the staid, plaid-sport-coat-and-white-patent-leather-belt-wearing Prince George's County political cohort good and affronted. And while theater owners and the student body and the nascent crowd of John Waters fans were having enormous fun using a celluloid provocation to challenge the suburban mores of a county where blue-haired councilwomen talked ill of school integration and 16-year-old Black kids were routinely beaten inside police stations, John himself was up in Baltimore, crossing swords in the belly of the beast, running circles around the state's film censor—yes, you heard that right, the head of the Maryland State Board of Censors—a deeply Catholic spirit named Mary Avara.

This was the late 1970s, which is so long ago that we can too easily forget where we were on the continuum of permissible speech, dissent, and any art that affronts or disturbs or otherwise fails to capture an immediate majority. There was a fight in Maryland for what ideas would be allowed, and it mattered. And John, of all those people on the side of open speech, made that battle amusing— even, at some points, delightfully ridiculous—as well as important. But it was in fact a war, a Middle Atlantic frontier of the same cultural conflagration in which Vladimir Nabokov, Jack Kerouac, Alfred Kinsey, William S. Burroughs, and Lenny Bruce found themselves conscripted. In his public persona, his essays, and his testimony before the state censor board, John Waters transformed Mary Avara into a magnificent cartoon of bloviating, scripture-quoting self-righteousness. No one who ever watched that bedeviled and furious woman vent about Waters and his early films could see the ethic of government censorship as anything but an abomination.

Go back far enough in time, and that's how most of us in Maryland knew Waters in the beginning, when he and his small, happy crew of brigands were churning out those early movies, when the films were shot in guerrilla fashion on commandeered locations with neither city permits nor censor board permissions, and when the value of shock alone was the only trusted metric for the storytelling. At the dawn of his career, the man entered the collective mind of Baltimore as more provocateur than auteur, and the idea that John Waters was going to deliver art or insight wasn't credited nearly as much as the idea that John Waters—flanked,

perhaps, by a coterie of pro bono civil liberties lawyers—was going to artfully and insightfully make fools of every last spittle-flecked puritan in the Old Line State. At a distance, many of us admired him not for his oeuvre but for having had the unrivaled chutzpah to film as he did and then to time and again tell the state of Maryland where to stick it.

That's certainly what I knew of John Waters before I met him, when I was just another scruff in the back row of an art house theater, mouth agape, watching a giant lobster have its way with Divine and wondering, if *Multiple Maniacs* (1970) was only the first part of this midnight double feature, what could possibly ensue. When we finally did meet, years later, I humiliated myself, I'm pretty sure. By then I was a young newspaper reporter sent at the last minute to a memorial gathering for one of John's great character actresses and a local character besides—Edith "the Egg Lady" Massey—and I knew enough of Edith's on-screen adventures to be stupidly flippant about the tastelessness of some of her screen personas. And this at a time when John was grieving the loss.

NORMAL IS A MYOPIC, FASCISTIC SENTIMENT AND ONE THAT PREVAILED WITHIN THE AMERICAN EXPERIMENT FOR FAR TOO LONG

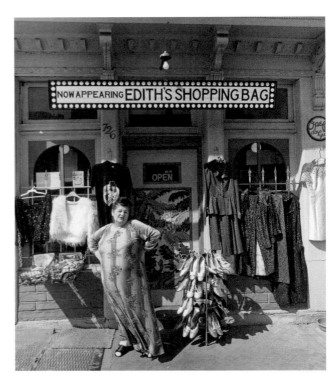

Edith Massey in front of her thrift store, Baltimore, 1975

Walking up to him in a crowd inside Edie's gift shop in Fells Point, I led not with any human sense of Ms. Massey or her connection to John and the others in the room. No, I wanted to shape the life lost around the outrageousness of what I'd seen on-screen. The look on John Waters's face as he used his answer to address the reality shamed me. I never got a second quote from him that day but only because I never tried. I was too embarrassed.

My third and lasting encounter with John was the best and most enduring. By then John's art and narrative force had traveled beyond shock value, beyond even the provocations of a censorious culture. By then, *Hairspray* (1988), *Cry-Baby* (1990), and *Pecker* (1998) were demonstrating how much John Waters actually had to say about the world—and how well he could say it.

Beginning with *Homicide* (1993–99) and journeying through *The Corner* (2000) and *The Wire* (2002–8), I shared a crew with John and learned to love and admire those rogues as colleagues and collaborators. And I came to realize just how much Baltimore and its film community owed to John as a pathfinder and civic presence. But more than that, by then I'd seen enough of John's work to learn its essential lesson about life and people and, really, all of society. This brings us back to my first claim—the one at which John Waters might laugh dismissively, the one that is nonetheless the real gift to us from a great storyteller. And it's this:

Fuck normal.
I'll declare this again, with emphasis.
Fuck. Normal.

There is no normal. Normal is a lie. Normal is a locked gate, a wall, a prison. Normal is a myopic, fascistic sentiment and one that prevailed within the American experiment for far too long. Indeed, today in this country, in the belligerence of our ugliest political strife in decades, we are witnessing a last retrograde and reactionary assertion of whatever the hell normal is supposed to be.

John's filmmaking and storytelling—from the oh-yes-we-did effrontery of *Pink Flamingos* to the sweet civic affirmations of *Hairspray*—are among the most eloquent arguments against standardized modes of being ever lensed. Because none of us are normal. Black, white, brown, Jew, Gentile, Muslim, atheist, Satanist, gay, straight, bi, trans, whatever—the more you honestly assess all the varied allegiances, motivations, and impulses that cause human beings to get up in the morning and face the world and one another, the more you know that none of us are close to normal. Hell, if someone

WE ARE—ALL OF US—AT LEAST TWO STANDARD DEVIATIONS FROM THE MEAN. AND IF YOU THINK YOU ARE NOT, YOU ARE EITHER LYING TO YOURSELF OR, WORSE, IT MAY BE TIME TO REFLECT ON THE GRIEVOUS POSSIBILITY OF AN UNLIVED LIFE.

even managed to ever achieve some Platonic ideal of vanilla-flavored human, they'd be too boring for the worst kitchen corner of the worst house party.

Seriously, conjure even the *known* secrets of yourself, your family, your friends, and your neighbors and realize how ridiculous the very idea of normal is. Hell, if you find anyone with political and social opinions that soothe, someone without racial or religious idiosyncrasy, without sexuality that veers from a strict heterogeneous application of the lights-off missionary position, someone with 1.7 kids and a two-car garage and unrusted lawn furniture on the manicured patio of their suburban split-level rancher, I will argue that nothing is more fucking abnormal than that. We are—all of us—at least two standard deviations from the mean. And if you think you are not, you are either lying to yourself or, worse, it may be time to reflect on the grievous possibility of an unlived life.

Other writers and filmmakers and social voices have argued this very thing in their work. But for John the characters who populate his film work are no mere freak shows and stories, in sum, are not merely for us to shock, gawk, and laugh at. They are, in the last analysis, heroes to Waters and to us as well. And pound for pound we will be hard-pressed to find a greater and more influential enemy of normal—and the lie that normal forces upon human lives—than John Waters. From his earliest films and his earliest confrontations with our society's authoritarian and censorious modes to his greatest and most popular declarations of shared humanity to the precise nonfiction prose in which he has chronicled his life and times with equal measures of honesty and humor, a great writer's legacy is now, in retrospect, entirely apparent, his own flippant denials and self-mockery be damned:

Truths were told.

FROM UNDERGROUND MOVIES

TO THE NEW QUEER CINEMA

B. Ruby Rich

Celebrated as oddball and awful in their time (and sometimes since), the films of John Waters, seen today, are beautiful and thrilling; they reveal the perverse innocence and generous empathy that undergirded them all along. They also have a reputation for shock and outrage that has tended to obscure their status as a key bridge from the post–World War II avant-garde to a US counterculture of underground movies and the emergence of an American independent cinema and finally into the flourishing of what I have termed the New Queer Cinema (NQC).

The filmmakers associated with the NQC movement, which exploded into public attention in 1992, rejected any division of characters into heroes and villains.[1] They embraced the outrageousness of the "I'm here, I'm queer, get used to it" slogans shouted in the marches of the time and—with tiny budgets, offbeat sets, and actors who were not always professionals—bent existing genres to fit their needs. And whether they knew it (some did) or not, John Waters of Baltimore had been there first. With his repertory company, the Dreamlanders, Waters from the very beginning had a vision of an alternative world in which no one was an outcast, where redemption awaited every sexual proclivity and criminalized

WITH HIS REPERTORY COMPANY, THE DREAMLANDERS, WATERS FROM THE VERY BEGINNING HAD A VISION OF AN ALTERNATIVE WORLD IN WHICH NO ONE WAS AN OUTCAST

behavior. Only his narratives' evildoers would be punished; everyone else was embraced.

Waters was born in 1946 into an era of American prelapsarian innocence. He was raised Catholic (his mother's religion) with a successful businessman father and a mother who was active in the gardening club and her church. It was a time when the United States had just won the Good War and the soldiers had come home to build the suburbs, drive new cars, work in offices, get married, and raise children. It was a time of plenty that was equally a time of conformity. Growing up in the 1950s meant growing up in lockstep: imagination in the Eisenhower era was limited, with conformity enforced by parents, teachers, and the cop on the beat. It was the American dream—for white, heterosexual middle- and upper-class citizens devoted to upward mobility

From left: John Waters, Divine, Danny Mills, and Mary Vivian Pearce on the set of *Pink Flamingos* (1972)

From left: Colleen Fitzpatrick, Debbie Harry, Divine, and Ricki Lake on the set of *Hairspray* (1988)

VIEWERS WOULD NEVER TURN ON EVEN HIS MOST EGREGIOUS VILLAINS, A BONUS FOR EVERY QUEER CHARACTER HE EVER WROTE

and postwar capitalism, who played by the rules and colored inside the lines.

With this formation John Waters should have become a pillar of the community, and indeed he did—but of a very different community. His movies may have once outraged his parents, the censorship board, and the upstanding citizens of his hometown, but they are actually filled with sympathy for virtually every character who appears in them. Far from trashing people or behavior, the Waters universe is open to all; he rarely writes a character he doesn't love. Even over-the-top villains like the Marbles (David Lochary and Mink Stole) in *Pink Flamingos* (1972) or Velma Von Tussle (Debbie Harry) in *Hairspray* (1988), whom audiences can unite to hate, are equally hard not to love, given the casting of such fan favorites in the roles. With his and Pat

Moran's brilliant knack for casting, Waters was able to ensure that viewers would never turn on even his most egregious villains, a bonus for every queer character he ever wrote.

As a boy John Waters was treated to a formative outing by his parents. They took him on a trip to the NBC studios in New York City for a broadcast of *Howdy Doody* (1947–60). Entering the set and witnessing multiple Howdy Doody puppets strewn about, the youngster had a momentous realization: "It's all fake!" He recalls that this was the moment he decided he "had to go into show business."[2] And so he did, performing puppet shows for children's birthday parties, chauffeured by his father and earning his own money. He worked hard, two shows a week, and that work ethic stuck: he does much the same today (minus the puppets and daddy) and at a far greater pace, with holiday shows, book signings, talk-show guest slots, and in-person events like the Mosswood Meltdown festival in Oakland and Camp John Waters in Connecticut (which capitalizes on his reputation for "camp"), all wildly popular.

Back then Waters bought the puppets at stores (he was never one for crafts) and presented their dramas on a small "three-screen" stage with red

Howdy Doody in a promotional still for *The Howdy Doody Show*, ca. 1955

THE PUPPET SHOWS WERE POWERFUL CULTURAL ARTIFACTS THAT COULD WELL HAVE OFFERED ALTERNATIVE FANTASY WORLDS, FREE OF TRADITIONAL GENDER AND NARRATIVE NORMS

The puppet shows were powerful cultural artifacts that could well have offered alternative fantasy worlds, free of traditional gender and narrative norms, spaces where laughter was permitted, encouraged, and never inappropriate. Uncoupled from realist conventions, puppet shows could allow a freeing of the imagination, even opening a space of rebellion and experimentation for a generation of kids raised on them.[4] And if those puppets were not queer exactly, they could hardly be accused of heteronormativity either.[5]

Waters graduated from puppet shows to filmmaking, but despite the jokes to the contrary, his actors were never his puppets: the congeniality of their relationships and the longevity of this (originally makeshift, later permanent) repertory company, the Dreamlanders, are proof to the contrary.[6] Some of the actors had been his friends as far back as grade school; others were kindred spirits he met in later years, whether in the neighborhood, as with Divine (Harris Glenn Milstead), or along

Pat Moran and John Waters, Baltimore, 1977

velvet curtains. At the end of each show, he'd storm out from behind the curtains, breaking the fourth wall to reveal himself to the children, working the crowd, biting kids with the dragon puppet on his hand. That audience reacted much as his audiences would continue to react throughout his career: "with horror and glee," as he recalls.

Puppets were an oddly popular presence in the United States in the 1940s and 1950s, appearing on radio and then on television shows, incorporated into adult as well as children's programming. From 1935 to 1943 the federal government's Works Progress Administration program had sponsored thousands of puppet shows around the country. When television was launched, the nonhuman actors were quickly drafted. Puppets filled a niche as the new medium sought to get up to speed with programming to capture audience attention. They helped to fill the otherwise empty hours on the station schedules. *Kukla, Fran and Ollie* (1947–57) was a popular live daily program watched as much (or more) by adults as by children; it was a particular favorite of Waters's.[3] And there were many others: *Captain Kangaroo* (1955–84), *The Shari Lewis Show* with Lamb Chop (1960–63), and Topo Gigio, a mouse character who made regular appearances on *The Ed Sullivan Show* between 1963 and 1971; even Fred Rogers of *Mister Rogers' Neighborhood* (1968–2001) started his career as a puppeteer.

the way; all were committed to the realization of a shared vision. Audiences oddly assumed the actors were actually portraying their real selves rather than fictional characters—that is, *not* acting. Pat Moran, Waters's casting director, assistant director, and lifelong friend, emphasized their religious upbringings: "We were all ex-Catholics . . . or Episcopalian, which is the same thing, [but] Divine was a Baptist."[7] But they weren't good kids gone bad—they were virtuous renegades rebelling against social constraints and hypocrisy and dedicated to creating a different standard. Religion was a recurrent plot device, usually through scenes of desecration or religious hypocrisy.

Waters and his Dreamland company emerged after the so-called underground cinema—which had started in the 1940s and broke into popular consciousness beginning in the early 1960s—achieved broader alternative recognition in the post-1968 cultural sphere. As a precocious teenager, Waters regularly read Jonas Mekas's column in the *Village Voice* and would travel to New York City by bus to see the films he read about in the pages of that weekly guide to the zeitgeist. These would have included works by Jack Smith, George Kuchar, Gregory Markopoulos, Andy Warhol, and Kenneth

THE VAUNTED NEW AMERICAN CINEMA WAS ACTUALLY THE FULLY REALIZED EXPRESSION OF AN INCIPIENT QUEER CINEMA, THOUGH UNHERALDED AS SUCH

Anger, among others. It's no accident that *Mondo Trasho* (1969), Waters's first feature—albeit one with minimal, post-dubbed dialogue—opens with the starlet Mary Vivian Pearce avidly reading Anger's *Hollywood Babylon* (US edition, 1959), identifying his influence right from the start. The book, banned but widely available in bootleg editions, was a sort of underground bible detailing the scandalous off-screen sex lives of Hollywood stars.

The vaunted New American Cinema, enshrined by now in museum collections and departmental syllabi, was actually the fully realized expression of an incipient queer cinema avant la lettre, though unheralded as such. So much attention was paid to the Beat generation of the 1950s and the hippie movement of the 1960s, both resolutely hetero-sexual (apart from Allen Ginsberg and William S.

George Kuchar in *Hold Me While I'm Naked* (USA, 1966)

218

Burroughs), that the gay figures key to the invention of an alternative cinema were eclipsed in terms of sexual identity even when the evidence was plain to see on-screen. Their films were judged to be groundbreaking and aesthetically inventive, rebellious, and antiestablishment but rarely recognized as unambiguous expressions of queer desire and gay sensibility, even after the raid on a screening of Smith's *Flaming Creatures* (USA, 1963) at an experimental film festival in Knokke-Heist, Belgium, in 1963.

Before long, the disparate batch of outsider filmmakers was codified as an "American avant-garde," hailed as an artistic movement waged to counter commercial norms, while "underground" films of the time were more likely to be seen as politically motivated blows against the establishment.[8] Both movements scorned the US commercial film industry and worked to create an alternative. The first tended to wind up in museums, while the latter could be found in midnight shows at the new independent theaters. The distinctions weren't always clear, though the dividing line often was drawn on the grounds of craft: the underground retained roughness and slapdash story lines, while the avant-garde experimented with the materiality of lenses, focus, or drawing on film, but they often overlapped.

Some films included explicitly gay content; others expressed queerness through an exaggerated heterosexuality, cartoonish in its contours; and still others through what used to be called a "gay sensibility." Anger's loving portrayals of hunky young men polishing their cars, Smith's stylized orgies with genderqueer denizens in drag, Kuchar's campy melodramatic excess and big-busted women, Warhol's deadpan studs and superstars: all were rejections of the big-screen status quo and made quite an impression. Waters credits Theater of the Ridiculous, a genre that emerged in New York City in the mid-1960s, as the most direct influence on his feature films and approach to performance.[9] Most associated with Charles Ludlam, but with roots in Warhol's circles as well, it created a vital downtown theater world of irony, transgression, and trash. This was an approach to theater derived in part from commedia dell'arte, opposed to respectable Midtown theater conventions and dedicated to upending all conventions, including gender.

The low-budget constraints and inventive aesthetics of those early Ridiculous works clearly cast their spell on a young John Waters. By 1964, just out of high school, he was making his first short 16mm film, *Hag in a Black Leather Jacket*, a fiercely nonnarrative exercise in adolescent angst shot around his parents' house, including on its rooftop. Over the

Mink Stole and Mimi Lochary in *Mondo Trasho* (1969)

next five years a series of films demonstrates, Waters developing his style, with high jinks and an evolving mise-en-scène suffused with a punk attitude embodied by malcontents who hate the "straights," those people who blindly follow the rules of society and suppress those who are different. It's a nonconformist cinema in essence, in which the rules of narrative are as oppressive as those of society. It was out of this opposition to straight society that a decidedly queer style emerged.

In 1969 Waters made *Mondo Trasho*, a send-up of *Mondo Cane* (Italy, 1962) and the exploitation subgenre it inspired that one-upped its outrage. In 1970 he made *Multiple Maniacs*, his first fully realized feature with synced sound and the template for all that would follow. And in 1972 came *Pink Flamingos*, the breakthrough film that made both Waters and Divine, director and diva, into stars.

The films are very much in the spirit of the oppositional movements that inspired them but with an aesthetic all their own that thumbs its nose at propriety and conservativism while celebrating the unique virtues of that which is despised. In *Mondo Trasho*, for instance, two upstanding neighbors are horrified by the appearance of Mary Vivian Pearce wandering the streets, and they speculate as to whether she is "a drag queen . . . a dyke . . . a communist . . . a baby butch?" In *Multiple Maniacs*, Divine's Cavalcade of Perversion features a house of freaks who wreak revenge on straitlaced citizens who come to gawk at them; the so-called natural order is inverted as the outcasts deceive and rob and finally kill their customers. Forces of repression get their comeuppance in the early films. *Multiple Maniacs* even transcends the human in its finale: Divine is raped by a giant lobster (an homage to Provincetown's lobster postcards), goes insane, and

Channing Wilroy in *Pink Flamingos* (1972)

is gunned down by the National Guard. Obviously Waters's films could speed past queerness in their quest for egregious sexual "deviance."

As he built up his alternative universe, Waters often incorporated references to politics, current headlines, film influences, or jokes. Lesbian characters were included, along with plenty of men who would show up naked, engage in sex acts with women, or play-act blow jobs, sometimes for no apparent reason other than delivering gay insider jokes or presumed audience enjoyment. Sometimes the references or acts would signal the virtue or evil of the characters.

In *Pink Flamingos*, a portrait of Nixon hangs on the wall of the post office, and a poster advertising the movie *Boom!* (UK, 1968), with Elizabeth Taylor and Richard Burton, decorates the wall of a house where evil owners dwell. They may have aspired to Taylor/Burton fame, but this couple makes money by kidnapping women, impregnating them, and selling the babies to lesbian couples who want to adopt. And there's a poster for Pier Paolo Pasolini's *Teorema* (Italy, 1968). Pasolini, too, influenced Waters with his radical films of gay rebellion and overturning of proper society, most notably in this film about a sexy young man who moves in and seduces every member of a family,

one by one. Later Waters would make a pilgrimage to Casarsa to pay his respects at Pasolini's grave. How he loved to smuggle his own heroes and obsessions into the set design; along with the plots and characters he created, they constitute an homage that equally functions as a secret code for his audiences.

As is so often the case in a Waters film, the heterosexuals are perverse maniacs; the lesbians, here at least, are family-loving "normies" who just want a child. Divine, as always, exceeds the bounds of every other character and plot device. Oddly, the act that made the performer famous (eating dog excrement) is tame compared to an earlier act in the film: cannibalism, for Divine and her guests kill and eat the policemen who try to bust her party (though the scene was staged, whereas the act with the dog was allegedly the real deal).

These early Waters films were a breakthrough, matching a new aesthetic to a new social order, and they stand up as such today. Every film has some twist on sexuality, social hierarchy, and the protocols of good taste. Zones of tolerance were so narrow at the time that it was easy to be an outsider and, as one thing led to another, just as easy to be queer. Characters shift in and out of sexual proclivities as the mayhem escalates.

THESE EARLY WATERS FILMS WERE A BREAKTHROUGH, MATCHING A NEW AESTHETIC TO A NEW SOCIAL ORDER

Desperate Living (1977) has the most flagrantly queer characters. After Peggy Gravel (Mink Stole) and her maid, Grizelda Brown (Jean Hill), kill Peggy's husband, they escape to Mortville, the shantytown ruled over by Queen Carlotta (Dreamland favorite Edith Massey), whose court is composed of gay guys in black leather, a Village People cast who perversely also have to sexually service their queen. A women's outhouse has "glory holes" through which breasts are thrust. Gravel and Grizelda improbably become lovers. Their landlady, Mole McHenry (Susan Lowe), is a butch dyke with a high femme partner whom she seeks to please with a "sex change operation," as she declares, employing the nomenclature of the time. When her girlfriend is horrified by her new organ, they chop it off together. This may not be the positive image that a modern lesbian or trans viewer would want, but for 1977 it was stunningly radical, subversive, and entirely unlike anything else seen on screens of the time.

The US film industry of the 1970s was so normative, its stories and players so "straight," that anything that deviated was ostensibly, inevitably queer. But just four years later, Waters cast 1950s heartthrob Tab Hunter in *Polyester* (1981) as a handsome gold digger who double-crosses Divine after winning her over. Despite appearing in this transgressive opus, in

Divine and Tab Hunter in *Polyester* (1981)

which he played Todd Tomorrow, lover of Divine's Francine Fishpaw (and her evil mother too), another two decades would pass before Hunter finally came out as gay in his memoir of 2005.

By the time of *Polyester*, the script has become a polysemic text, referencing Waters's own past as well as off-screen events. Divine's Francine is glimpsed reading a copy of *Cahiers du Cinema* no. 314, its appearance a sign that Waters tracked French cinematic theory as much as tabloids. In a scene of a demonstration, "Women Against Pornography" picket signs dominate in a nod to the new censors. At the Fishpaw family home, there's a poster for Russ Meyer's *Faster, Pussycat! Kill! Kill!* (1965), an example of the kind of winking 1960s exploitation film that had inspired Waters. And on the evening news, a bulletin announces: "A member of the Manson family escaped from the women's house of detention." In his memoir Waters would later write of his friendship with former Manson follower Leslie Van Houten, whose release from prison he continues to champion to this day.

Queer is a state of mind in the John Waters universe, as actors and characters move in and out of sexual identities. It's a virtuous state, suggesting less a fixed sexual identity than a stand against propriety and a generous identification open to new arrivals and interpretations. The Dreamlanders perform like Robin Hood and his band of merry men, stealing privilege from the "straights" and elevating the status of all the freaks and misfits—and dykes and queers—that Waters rounds up in his films.

After *Polyester*, Waters would make his biggest hit, *Hairspray*. Divine was so accepted by then that the film could naturalize her persona while focusing on race, class, and evildoers. Music, which had always

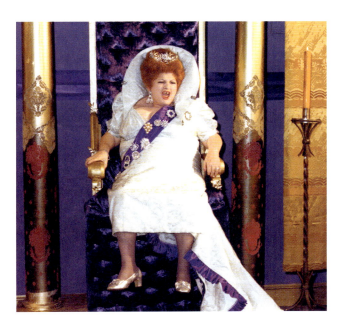

Edith Massey in *Desperate Living* (1977)

Harry Dodge in *Cecil B. Demented* (2000)

been central to his films, takes center stage. Waters had long culled the finest rockabilly, blues, and rock and roll hits of the 1950s for his movies, shaping soundtracks you could dance to as well as tunes to signal character. Here, though, music and dancing became central to the plot, while the centrality of Divine (as Edna Turnblad) was balanced by a new discovery, Ricki Lake (as Tracy Turnblad), who would become a star in her own right. With civil rights and integration battles reframed through a television dance contest, Waters began his shift toward a broader canvas and bigger budgets.

With *Cry-Baby* (1990), *Serial Mom* (1994), and *Pecker* (1998), Waters widened his scope and further enlarged his universe of references and narratives, taking on genres and movie stars but never relinquishing the queerness of his work. *Cecil B. Demented* (2000) maintained this queer trajectory even as he updated his universe by casting the artist Harry Dodge, lesbian outlaw turned genderqueer figure turned trans hero, in the role of a revolutionary gangstah bent on revolutionizing cinema itself.[10] In the 1988–94 period that started with the success of *Hairspray* and *Polyester*, Waters was no longer the super-low-budget outsider. Propelled into the mainstream by his box-office success and the longtime support of Robert Shaye at New Line Pictures and of the other studios that came calling, he had

real budgets. His casts included Kathleen Turner, Melanie Griffith, Christina Ricci, even Waters's pal Patricia Hearst. The participation of a star like Tab Hunter was no longer a fluke: stars old and new appeared in his films—and some even joined the Waters troupe in other roles. The outsider had become an insider, a renegade in a Comme des Garçons suit, without compromising his vision.

By the time of *A Dirty Shame* (2004), Waters had acquired Christine Vachon as coproducer. It was Vachon who had helped shepherd the New Queer Cinema into being. She has produced Todd Haynes's *Poison* (USA, 1991) and all Haynes's films since, Tom Kalin's *Swoon* (USA, 1992), Rose Troche's *Go Fish* (USA, 1994), Mary Harron's *I Shot Andy Warhol* (USA, 1996), and the many dozens of films that followed. The collaboration between Waters and Vachon, like his friendship with Strand Releasing's codirector Marcus Hu, makes the connection between the NQC movement and Waters undeniable.

In *A Dirty Shame*, Waters maintains one of his signature elements: the hilarious complaints of upstanding citizens, such as the imperious mother who rages at the gay bears who've moved into the neighborhood and, even more, at a dyke couple she spots: "Dykes! Used to be, Harford Road was for families, now it's a lesbian aorta!" The film becomes an all-are-welcome exercise in sexual liberation and

WATERS'S REFUSAL TO SUBSCRIBE TO ANY NOTION OF "POSITIVE" OR "NEGATIVE" IMAGES IN FILM SIGNALS HIS ALIGNMENT WITH THE MOST IMPORTANT CREDO OF THE NEW QUEER CINEMA

addiction, as characters enter into a delirium of sex acts whenever they are hit on the head. Waters is an equal-opportunity trickster, featuring perverse heterosexuals along with gays and lesbians, as he detects hypocrisy everywhere. At a meeting for recovering sex addicts in a church, AA slogans with a twist abound: "Make a list of everyone you fucked and apologize to their parents."

Waters's refusal to subscribe to any notion of "positive" or "negative" images in film emerges as a crucial element, signaling his alignment with the most important credo of the NQC. The filmmakers associated with the movement scanned history for gay and lesbian monsters (as in Haynes's *Poison* and Kalin's *Swoon*), adapted genres to capture queer desire (Gregg Araki's *The Living End* [USA, 1992]), and manufactured histories to support their desires (as in Cheryl Dunye's *The Watermelon Woman* [USA, 1997]), with Derek Jarman (*Edward II* [USA, 1991]) doing all of it. Thumbing its nose at the gay/lesbian establishment as much as at the heterosexual movie industry, the NQC signaled a new era in filmmaking that was officially marked at the Sundance Film Festival in 1992, just four years after Waters had stood onstage at the Egyptian Theater in Park City, Utah, to present *Hairspray* to a sold-out house.[11]

Film history is, of course, an accretive practice. As the NQC movement evolved and went mainstream, moving from outsider to insider, its focus has continued to shift and expand, mutate and adapt. But let it never be forgotten that Mr. John Waters was there first, beaming out of Baltimore an example of fearless clarity, redeeming deviance and defending difference, always with a sense of humor about human folly that has never diminished.

Notes

1. For a detailed history, see B. Ruby Rich, *New Queer Cinema: The Director's Cut* (Durham, NC: Duke University Press, 2013).

2. All quotations from John Waters are from telephone conversations with the author, summer and autumn 2022.

3. For more on the widespread appeal of the show, see Jacqui Shine, "Together with the Kuklapolitans: In the Middle of the Past Century, a Gentle Crew of Puppets United the TV Watchers of America," *Slate*, February 16, 2015, https://slate.com/culture/2015/02/kukla-fran-and-ollie-the-gentle-puppets-that-bewitched-america-in-the-1950s.html.

4. It is tempting here to reference Todd Haynes's brilliant debut, *Superstar: The Karen Carpenter Story* (USA, 1987), for its use of dolls and music in the construction of a queer-infused history.

5. Judith (Jack) Halberstam has made a parallel argument about animation in "Animating Revolt / Revolting Animation: Penguin Love, Doll Sex and the Spectacle of the Queer Nonhuman," in *Queering the Non/Human*, ed. Noreen Giffney and Myra J. Hird (Aldershot, UK: Ashgate, 2008), 265–82.

6. Waters speaks often of their commitment to being buried together in the same Baltimore cemetery where Divine already lies. He has already dubbed their plots "DisGraceland."

7. Pat Moran, in "Dreamland Memories," bonus content on *Polyester*, directed by John Waters (Criterion Collection, 2019), DVD and Blu-ray.

8. For background on these movements from three distinct perspectives, see Sheldon Renan, *An Introduction to the American Underground Film* (New York: Dutton, 1967); Parker Tyler, *Underground Film: A Critical History* (New York: Grove, 1969); and P. Adams Sitney, *Visionary Film: The American Avant-garde, 1943–1978* (New York: Oxford University Press, 1974).

9. For a recent reappraisal, see Elyssa Goodman, "How Theater of the Ridiculous Changed Drama, Performance, and Queer Visibility Forever," *Them*, April 18, 2019, https://www.them.us/story/theater-of-the-ridiculous.

10. The casting of Harry Dodge is a rare example of Waters choosing an outsider figure independently known in their own right, instead of the aboveground celebrities he'd bent to his will in earlier films (Tab Hunter, Johnny Depp). Dodge was a key figure in San Francisco's Bearded Lady Café performance space who, together with Silas Howard, cowrote, directed, and starred in *By Hook or By Crook* (2001) and is known today as a visual artist.

11. I was there that night in January 1988, seated on a folding chair outside the projection booth, thanks to former Sundance director Tony Safford. It's fair to say that all my thinking about the New Queer Cinema started in that moment.

INTERVIEW
JOHN WATERS

Sean Baker, Debbie Harry, Barry Jenkins, Johnny Knoxville, Bruce LaBruce, Ricki Lake, Orville Peck, Iggy Pop, Cindy Sherman, Kathleen Turner, Christine Vachon, Edgar Wright

Debbie Harry John Waters, always a groundbreaker with a mission, it seems. As a young child, when did it seem obvious to you that you were unique?

John Waters I never thought of myself as unique, believe me. I just felt I didn't fit in. I never understood why I was the only person in my grade school class who didn't like Ike and wanted Adlai Stevenson. I didn't understand why all the other boys talked about football instead of Dagmar on television. It never bothered me that other people weren't interested in what I was interested in, but I realized it early and wondered why.

Edgar Wright You have always been drawn to the forbidden, what Hollywood wouldn't or couldn't show you in its golden age. What were the films that shocked you when you were growing up?

JW Probably Herschell Gordon Lewis's gore movies, like when I first saw *Blood Feast* [USA, 1963] and they had vomit bags in the theater. Certainly Russ Meyer's *Faster, Pussycat! Kill! Kill!* [USA, 1965], which

Tura Satana in *Faster, Pussycat! Kill! Kill!* (USA, 1965)

I LOVED TO SEE THINGS THAT WERE BREAKING THE RULES. WHAT SHOCKED ME WAS WHEN SOMETHING WAS SO CRUDE AND EXPLOITATIVE THAT IT WAS JOYOUS

I went to see every night at the drive-in. Those kinds of movies shocked me before all the gore and sex became routine on television. I loved to see things that were breaking the rules. The foreign films probably did it the most, but they didn't shock me. What shocked me was when something was so crude and exploitative that it was joyous in a way. I remember those audiences and how much they loved those films. And they didn't love them ironically. They were masturbating at Russ Meyer's movies; they were screaming at Herschell Gordon Lewis's. They didn't think those films were funny. I did.

Kathleen Turner Did you always want Hollywood fame? Were you working toward that or always expecting to be cult?

JW I never use the word *cult* when I'm in Hollywood. It's the worst word you can use. It means seven smart people liked the film and it lost money. No, I always wanted every one of my movies to be the number one film in America, even though they certainly never were.

Ricki Lake Has there ever been a time when you thought you might have gone too far in your quest to shock people? Did you ever worry that things might backfire on you?

JW In show business, there's always the possibility that something will backfire. You have to be prepared for that. I always tried to shock people, but I never felt I went too far if they were laughing. If they didn't laugh, then yes, I probably did go too far. Would I do the chicken scene again in *Mondo Trasho*? Probably not. But that was a parody of *Mondo Cane* [Italy, 1962], which had come out a few years earlier. If I ever thought I was going too far, I didn't film it in the first place.

Orville Peck Did you ever think the late, great Divine would have the massive cultural impact she has? Did you know just how famous of an icon she would become?

JW Well, I knew at the time that Divine was the star of all my films. The audiences *loved* Divine—straight,

John Waters, Baltimore, 2022

Andy Warhol, *Divine*, 1974

Sean Baker If you were to remake someone else's movie, what would it be?

JW Maybe *Ice Castles* [USA, 1978]. And if not that, remake *Boom!* [UK, 1968] with Gina Gershon and Jeff Stryker. Or if I could go beyond the grave and make it in another world, Isabel Sarli and Brad Renfro, both of whom are no longer with us. They are in cinema Hell or Heaven, either way.

Bruce LaBruce In my humble opinion, your movies—*Mondo Trasho*, *Multiple Maniacs*, *Desperate Living*, and others—are some of the greatest avant-garde films ever made, as pretentious as that may sound. I truly believe that *Multiple Maniacs* is a work of art that bears comparison to, say, Pier Paolo Pasolini's *The Gospel According to St. Matthew* [Italy, 1964]. The stations of the cross scenes in the two films are equally brilliant and moving. But my question is: Your films weren't embraced by the highfalutin film festivals and highbrow critics when they were released. Is that something that ever irritated you, or did you wear it as a badge of honor? When evaluating our

229

gay, bikers, everyone. Nobody was homophobic about Divine in any way, it seemed. Divine was one of the first drag queens with a hard edge. The real drag queens of that period hated him because they thought he was making fun of drag, which he was in a way. I say "him" because when I think of Divine, I think of the man who played the part; I call him "she" when he's in character. Divine didn't want to be a woman. He would certainly be for the trans movement, but he wasn't trans. Divine wanted to be Godzilla with a little Elizabeth Taylor thrown in.

Barry Jenkins John, you're an extremely funny man who cares deeply about the world. Is it still OK to laugh with everything seemingly going to shit?

JW Thank you, Barry. It is OK to laugh, as long as you're using humor to try to change things. Every joke is political.

Johnny Knoxville Who is your all-time favorite felon and why?

JW I taught in prison for a long time, so I guess I'm proudest of the double murderer I helped get out after serving twenty-seven years. He's doing great now. He is completely rehabilitated and greatly sorry for what happened when he was young. He owns a home now and even got a job back at the prison.

DIVINE WANTED TO BE GODZILLA WITH A LITTLE ELIZABETH TAYLOR THROWN IN

Elizabeth Taylor in *Boom!* (UK, 1968)

own movies, my friends and I used to ask ourselves, "Cannes or trash can?"

JW First of all, thank you, Bruce. Up until *Multiple Maniacs*, my films weren't known at the festivals, but that doesn't surprise me much. *Pink Flamingos* was shown off-market at Cannes to a packed screening. I mean, the Cannes Film Festival was great to me. A lot of my films played there, especially the later ones. The Berlin Film Festival showed *Female Trouble*, and the Deauville Film Festival showed *Desperate Living*—so I actually did have some respect from some of the foreign film festivals right from the beginning. I was even on the Cannes jury in 1995 with Jeanne Moreau. How much higher can you rise in show business than that?

I was never bitter about anything that happened to me in show business, really. In my book *Mr. Know-It-All* [2019], I tell all the stories about negotiating my way from the underground to Hollywood and back down to the underground. I think people treated me fairly. Some films were hits; some weren't. Some did well much later, and that helps me but doesn't help the executive who greenlit the movie and wants it to be a hit right when it comes out, not twenty years after its release.

Cindy Sherman John, I know you're super organized and make lists of what you need to accomplish each day. I'm very organized too, but find I waste so much time lately. How do you keep it up, and did it falter at all during COVID? Do you actually schedule times when you're going to make work or go see art or watch a film?

JW I do, and I never do all those three things at the same time. Every morning, I think up fucked-up things, but it could be an art project, it could be a movie, it could be writing a Christmas show. I never do two things at the same time. I can't walk and chew gum or whatever that expression is.

A lot of writers told me they couldn't write during COVID because suddenly they had no excuse not to, but it didn't change anything for me. I write every morning, in my house or at a hotel or wherever I am. Sometimes I schedule my flights for the afternoon so I can write in the morning. I wrote most of my novel *Liarmouth* [2022], or many of the drafts of it, during lockdown. So no, it didn't change my scheduling.

Iggy Pop Have you ever fallen in love?

JW Yes. Seven times.

Johnny Knoxville and Tracey Ullman on the set of *A Dirty Shame* (2004)

Sean Baker If you had a boutique video label and could release any favorite lost films, what would be at the top of your list?

JW Probably *Mondo Trasho*. I'd get a celluloid sugar daddy to pay for all the music rights—I never did—so I could release it again.

Johnny Knoxville You are inarguably one of the greatest auteur filmmakers of all time—my personal favorite—but you haven't directed a film since *A Dirty Shame*. That movie received an NC-17 rating, which severely limited the number of people who could see it. How did that affect you? Did it sour you on the film industry? And lastly, will you ever make another film? Please say yes.

JW Did it sour me? Not really. Was the NC-17 rating the reason *A Dirty Shame* did not do well at the box office? Who knows. The critics who didn't like it could argue otherwise. I certainly think it didn't help and may have made people less eager to screen or review it. It didn't affect me. I've had many development deals since then. Am I ever going to make another film? I certainly hope so, because *Liarmouth* has been optioned, with me writing and directing.

Edgar Wright Many films prematurely proclaim themselves to be cult or midnight movies, but *Pink Flamingos* was one of the very first that truly earned that status. Do you have any specific memories of feeling that something significant was happening to your movie?

JW There were three times in my career when things completely changed. The first was in the second week that *Pink Flamingos* played at the Elgin Theater. Only about forty people came the first

week. The second week I went with Bob Shaye, the head of New Line, and the line was around the block—it was a hit. The next was being onstage at the Tony Awards when *Hairspray* won Best Musical in 2003. And the third was when my book *Role Models* [2010] made the *New York Times* bestseller list. I would say that those three moments were a kind of success that changed things forever for the better.

I NEVER HAD FUN MAKING A MOVIE IN MY ENTIRE LIFE. FUN IS WHEN YOU'RE OFF WORK, IT'S A HIT, AND YOU'RE OUT HAVING DINNER

Christine Vachon Which movie of yours was the most fun to make and why?

JW I never had fun making a movie in my entire life. Fun is when you're off work, it's a hit, and you're out having dinner. I would say, though, that *Hairspray* probably had the most festive atmosphere the whole time we were making it, with all those kids dancing and many of them being in their first movie. I think the cast would agree with me.

Iggy Pop How much did it cost to make *Desperate Living*? How did the idea come about for the set of Mortville, which appeared to be made out of cardboard packing cases? What were the ingredients of the stage blood in the sex change scene?

JW *Desperate Living* cost $65,000 to make. It was my idea to make the whole town out of garbage but also [production designer] Vincent Peranio's, because he had been making all of my sets out of garbage for so long anyway. He went around and collected all the garbage to build it, so it was really a giant sculpture by Vincent. The ingredients in the stage blood, Tom Watkins did it, a special effects and horror guy from Delaware, and he also made Mole's fake penis. He's no longer alive, and I don't know how he made the blood.

Ricki Lake Do you prefer making the smaller-budget films or the bigger ones? Did you have more control over the projects when less was at stake?

JW I much prefer the bigger ones. I'm too old to go to the bathroom in the woods between takes like we did on the early movies. I'm happy to have a trailer. I don't have any yearning to go back to the beginning and start over. Did I have more control

231

Crew member dismantling the Mortville set built for *Desperate Living* (1977)

over the early, cheaper movies? Not really, because I didn't know what I was doing and had to ask people for help all the time. There was something at stake in every movie I ever made. When I made *Pink Flamingos*, the budget was $10,000—that was a big budget for me at the time. I think whether a budget is big or not depends very much on where you are in your career.

WHEN THE MPAA GAVE ME THE NC-17 RATING FOR *A DIRTY SHAME*, I SAID, "WHAT CAN I CUT TO GET AN R?" THEY SAID, "WE STOPPED TAKING NOTES"

Johnny Knoxville I have received some hysterical notes back from the MPAA [Motion Picture Association of America] over the years. What are some of the most memorable notes you have received from them? You can include ridiculous studio notes as well.

JW When the MPAA gave me the NC-17 rating for *A Dirty Shame*, I said, "What can I cut to get an R?" They said, "We stopped taking notes." That was the scariest. And maybe the stupidest was when another film got a positive test screening and the studio said, "Yeah, but that doesn't count. They know who you are. We're going to do it again with a different audience, and they'll have to prove they don't already know you." And I thought, Well, why did you hire me?

Barry Jenkins John, you've filmed some of the wildest events, bodily and otherwise, in the history of cinema. What haven't you filmed that you wish you had?

JW The films I never completed: *Dorothy, the Kansas City Pot Head*; *Flamingos Forever*; *Raving Beauty*; *Glamourpuss*; and *Hairspray* numbers two, three, and four. All scripts that were started that were never filmed.

Sean Baker Do you still monitor the Catholic Church's film ratings and bans? Besides Elia Kazan's *Baby Doll* [USA, 1956], what are some of your favorite movies rated C for condemned or, starting in the 1980s, O for morally offensive?

JW When they changed it to O for offensive, I found that not as catchy and stopped following

them. "Condemned" sounded so great. "Offensive" just sounds like what I purposely advertise for. My favorite condemned films were *The Bed* [France/Italy, 1954], *The Naked Night* [Sweden, 1953], *She Shoulda Said No!* [USA, 1949]. I love that title. I loved it when the nuns would read us the titles and say things like "Love is my profession"—*Love Is My Profession* [France, 1958], that was another one. *A Cold Wind in August* [USA, 1961], *Viridiana* [Spain/Mexico, 1961], *Never on Sunday* [Greece/USA, 1961]. I was shocked to look at the list and see that *Pink Flamingos* was condemned by the Catholic Church. How did they even see it at midnight? I never knew until I looked it up. I was honored.

Debbie Harry Though I have never seen you dance, John, you seem to love and use dance music in your films. Were you ever a stripper?

JW I have never been a stripper, but who knows? Maybe in hospice I will finally begin to take it off for other people's enjoyment.

Orville Peck What is your favorite memory of the incredible Edith Massey?

JW It's my favorite memory in hindsight, but she'd drive me crazy with this. We would drive to college lectures together, and she would just say out loud everything that she saw. "Lawn, telephone pole, pretty lady, car, car, lawn, lawn, telephone pole." She just said it out loud if she saw it. So the fact that internalization was impossible for Edith Massey— I'm very fond of remembering that. I'd look at her, and she'd say, "What? What?"

Sean Baker If you could cast anyone for *Liarmouth*, living or dead—at any age you specify—who would we see on-screen?

JW Since I'm already getting calls from agents and actors, I'll say I'm going to go back in history and cast Lana Turner when she was 40.

Barry Jenkins Most people know which of your films is the most challenging to watch, but which was the most challenging to make?

JW I've never made a film that wasn't challenging. Have you, Barry? You never have enough money or time, and when you look at the first assemblage, it's never the movie you set out to make. I would say every single one of them was challenging. I defy any filmmaker to say otherwise of their films.

Edith Massey in Fells Point, 1982

Iggy Pop Do you vote?

JW Of course. I have never missed an election in my entire life.

Bruce LaBruce I love how Mary Vivian Pearce is styled like Jean Harlow in *Mondo Trasho*. I assume that was deliberate and really want to know if that idea was yours or hers or both. But my real question is: What gave you the idea of putting one of your main characters in a coma for almost the entirety of the movie, and what are some of your other favorite movies with people in comas?

JW It's funny. Mary Vivian Pearce looked like Jean Harlow every single day. That is how she dressed, day in and day out, which was really startling. What gave me the idea of putting her in a coma? I never thought of that. That is odd, I think. What other coma movies are there? I guess *Johnny Got His Gun* [USA, 1971] and the movie about Sunny von Bülow, *Reversal of Fortune* [USA, 1990]. Did anybody make a movie about Karen Ann Quinlan? I guess that would be one too. But my favorite is that when the movie *Coma* [USA, 1978] came out, they had trouble with the title because everybody thought it was called "comma."

Kathleen Turner Would you agree women are often labeled difficult when they are decisive? What's your approach?

JW I would never call a woman difficult if she was decisive. I like it. Difficult to me is amateurish and unprepared. What I do with a woman like you, Kathleen, who is decisive and absolutely great to work with: I never leave her alone on the set. She's your star. Pay attention.

Christine Vachon Is there one drug you would love to try before you die?

JW No. I think I've tried all the ones I wanted to try. There's no bucket list of drugs left. I guess I was always curious about that operation where you drill a hole in your head and are high forever. But I think I've reached a certain level of maturity where I would reject that if it were offered.

Cindy Sherman What's the dumbest or most embarrassing hobby that you have?

JW I have never had a hobby in my life. Only dumb careers.

Kathleen Turner Did you have any idea that *Serial Mom* would become such a phenomenon?

JW Not really, because it was not a success when it came out. But now it plays every Mother's Day and will for eternity.

Debbie Harry Did Bill Murray surprise you with his singing in *Polyester*?

JW Yes. And Bill Murray is in *Polyester* because of you, Debbie Harry. I'm so thrilled that you brought him along. He was so famous—much more famous than I was at the time—so I was really flattered that he did it, and I was totally surprised. And it was you and Chris [Stein] who talked him into it, I'm sure.

Christine Vachon Who plays John Waters in your biopic?

234

JW When I'm young, Kodi Smit-McPhee. Middle age, Matthew Gray Gubler. And my age now, Steve Buscemi.

Ricki Lake Does Divine and his memory and spirit still influence your work to this day? If yes, how so?

JW No one could follow Divine. I actually never used a drag queen again. Not that I don't love them. It's just that out of respect for him I didn't. Certainly he helps keep my old movies alive and doing better than they ever have. And yes, he is still in my spirit of making movies every single day. He was there in the making of *Cecil B. Demented*, in what Cecil was doing. He probably would've played the grandmother neuter, Big Ethel, in *A Dirty Shame*. So yes, his memory is very, very important to me when I'm thinking about movies in any way.

Edgar Wright For me, a joy of making amateur movies was working with my friends and nonactors. I have always admired that you brought this same spirit from your early movies into even your later studio movies. Can you talk about this aspect of your casting and what it means to you?

JW Well, Mink Stole always used to say, "I don't know how they can call us amateurs when we memorized eight pages of dialogue and had to do them in one take." And she does have something there. I think the spirit you're talking about is discovering somebody new that you've never seen before in a movie, who isn't already established. So yes, I could plead guilty

From left: Debbie Harry, John Waters, and Bill Murray during the production of *Polyester* (1981)

David Lochary and Mink Stole on the set of *Pink Flamingos* (1972)

I DON'T THINK ANYBODY I EVER WORKED WITH WAS AN AMATEUR, EXCEPT ME

to that. You can call the films either amateur or raw—they're the same thing, but one means you didn't like the movie and the other means you did. On casting I still use Mink in every one of my movies. She's right there with Kathleen Turner in *Serial Mom*, so I like to mix and match. And by now Mink has made so many different movies, not just with me but with other people. I don't think anybody I ever worked with was an amateur, except me.

Barry Jenkins Over your career you've gone from public menace to one of cinema's respectably naughty dads. How the hell did *that* happen?!

JW Dads? I hope that's not a sexual type. Well, Barry, if you're crazy and you have loyal audiences that get older, they become powerful and spread the germ of you to the young. I didn't change; everybody else did.

Orville Peck Is there anything you know now that you wish you had known in the early days?

JW When you're editing one of your movies, if you think something is too long, it is. Cut it.

FILMOGRAPHY

Compiled by Esme Douglas

1964
Hag in a Black Leather Jacket

Produced, written, directed, filmed, and edited by John Waters
Cast: Mary Vivian Pearce, Mona Montgomery, Trish Waters, Bobby Chappel
Production: Dreamland Studios, 17 min., mono, black and white, 1.33:1, 8mm

1967
Roman Candles

Produced, written, directed, filmed, and edited by John Waters
Cast: Maelcum Soul, Bob Skidmore, Judy Boutin, Mink Stole, Mary Vivian Pearce as Bonnie Pearce, David Lochary, Divine, Mark Isherwood, Pat Moran
Production: Dreamland Studios, 24 min., mono, color, 1.33:1, three 8mm reels projected simultaneously
Premiere: May 11, 1967

1968
Eat Your Makeup

Produced, written, directed, filmed, and edited by John Waters
Cast: Maelcum Soul, David Lochary, Bob Skidmore, Divine, Judy Boutin, Mary Vivian Pearce (as Bonnie Pearce), Mark Isherwood, Pat Moran, Marina Melin, Margie Skidmore (as Margie Holland), Howard Gruber
Production: Dreamland Studios, 45 min., mono, black and white, 1.33:1, 16mm
Premiere: February 23, 1968

1969
Mondo Trasho

Produced, written, directed, filmed, and edited by John Waters
Cast: Mary Vivian Pearce, Divine, David Lochary, Mink Stole, Bob Skidmore, Pat Moran, Susan Lowe, Marina Melin, Howard Gruber, Margie Skidmore, Berenica Cipcus, Mark Isherwood
Production: Dreamland Studios, 97 min., mono, black and white, 1.37:1, 16mm
Premiere: March 14, 1969

1970
The Diane Linkletter Story

Produced, written, directed, filmed, and edited by John Waters
Cast: David Lochary, Mary Vivian Pearce, Divine
Production: Dreamland Studios, 10 min., mono, black and white, 1.37:1, 16mm
Premiere: April 10, 1970

1970
Multiple Maniacs

Produced, written, directed, filmed, and edited by John Waters
Cast: Divine, David Lochary, Mary Vivian Pearce, Mink Stole, Cookie Mueller, Edith Massey, Susan Lowe, Paul Swift, Vincent Peranio, Bob Skidmore, Susan Walsh, Pat Moran
Lobstora by Vincent Peranio
Production: Dreamland Studios, 96 min., mono, black and white, 1.66:1, 16mm
Premiere: April 10, 1970

1972
Pink Flamingos

Produced, written, directed, filmed, and edited by John Waters
Cast: Divine, David Lochary, Mary Vivian Pearce, Mink Stole, Danny Mills, Edith Massey, Channing Wilroy, Cookie Mueller, Susan Walsh, Linda Olgeirson, Pat Moran, Bob Skidmore, Elizabeth Coffey, Vincent Peranio, Bob Adams, Van Smith
Art director: Vincent Peranio
Divine's makeup and costumes: Van Smith
Production: Dreamland Studios, 93 min., mono, color, 1.85:1, 16mm
Premiere: March 17, 1972

1974
Female Trouble

Produced, written, directed, and filmed by John Waters
Cast: Divine, David Lochary, Mary Vivian Pearce, Mink Stole, Edith Massey, Cookie Mueller, Susan Walsh, Paul Swift, Susan Lowe, Bob Adams, Channing Wilroy, Chris Mason, Pat Moran, Marina Melin, Elizabeth Coffey
Production chief: Pat Moran
Editors: John Waters, Charles Roggero
Sets: Vincent Peranio
Costumes and makeup: Van Smith
Hairstylists: David Lochary, Chris Mason, Van Smith
Production: Dreamland Studios, 89 min., mono, color, 1.66:1, 16mm
Premiere: October 11, 1974

1977
Desperate Living

Produced, written, directed, and filmed
by John Waters
Cast: Liz Renay, Mink Stole, Susan Lowe,
Edith Massey, Mary Vivian Pearce, Jean Hill,
Channing Wilroy, Peter Koper, Paul Swift,
Marina Melin, Cookie Mueller, Pat Moran
Production manager: Pat Moran
Associate producers: William Platt, David Spencer,
James McKenzie
Director of photography: Thomas Loizeaux
Editor: Charles Roggero
Art director and set designer: Vincent Peranio
Costumes and makeup: Van Smith
Hairdresser: Chris Mason
Sound: Robert Maier
Music: Chris Lobinger
Production: Charm City Productions, 90 min.,
mono, color, 1.37:1, 16mm
Premiere: May 27, 1977

1981
Polyester

Produced, written, and directed by John Waters
Cast: Divine, Tab Hunter, Edith Massey,
Mink Stole, Jean Hill, Mary Vivian Pearce,
Cookie Mueller, Susan Lowe, David Samson
Executive producer: Robert Shaye
Director of photography: David Insley
Editor: Charles Roggero
Art director: Vincent Peranio
Costumes and makeup: Van Smith
Assistant director, casting: Pat Moran
Music: Chris Stein, Michael Kamen
Production: New Line Cinema, 86 min., mono,
color, 1.85:1, 35mm
Premiere: May 15, 1981

1988
Hairspray

Written and directed by John Waters
Cast: Sonny Bono, Ruth Brown, Divine,
Colleen Fitzpatrick, Debbie Harry, Ricki Lake,
Leslie Ann Powers, Clayton Prince, Michael
St. Gerard, Jerry Stiller, Mink Stole, Shawn
Thompson, Cyrkle Milbourne, Mary Vivian
Pearce, Peter Koper, Susan Lowe, Alan J. Wendl
Executive producers: Robert Shaye, Sara Risher
Producer: Rachel Talalay
Coproducers: Stanley F. Buchthal, John Waters
Production manager, casting director (Baltimore):
Pat Moran
Director of photography: David Insley
Editor: Janice Hampton

Art director: Vincent Peranio
Costumes and makeup design: Van Smith
Hair design: Christine Mason
Choreographer: Edward Love
Casting director: Mary Colquhoun
Production: New Line Cinema, 92 min.,
Ultra Stereo, color, 1.85:1, 35mm
Release date (US): February 26, 1988

1990
Cry-Baby

Written and directed by John Waters
Cast: Johnny Depp, Amy Locane, Susan Tyrrell,
Polly Bergen, Iggy Pop, Ricki Lake, Traci
Lords, Kim McGuire, Darren E. Burrows,
Stephen Mailer, Mink Stole, Susan Lowe,
Mary Vivian Pearce
Executive producers: Jim Abrahams, Brian Grazer
Producer: Rachel Talalay
Production associate: Pat Moran
Director of photography: David Insley
Editor: Janice Hampton
Production designer: Vincent Peranio
Wardrobe and makeup design: Van Smith
Hair design: Christine Mason
Choreography: Lori Eastside
Music: Patrick Williams
Music consultants: Larry Benicewicz,
Channing Wilroy
Casting: Paula Herold, Pat Moran
Production: Universal Pictures, Imagine
Entertainment, 85 min., stereo, color, 1.85:1,
35mm
Release date (US): April 6, 1990

1994
Serial Mom

Written and directed by John Waters
Cast: Kathleen Turner, Sam Waterston, Ricki Lake,
Matthew Lillard, Justin Whalin, Patricia
Dunnock, Mink Stole, Mary Jo Catlett, Suzanne
Somers, Patricia Hearst, Susan Lowe, Mary
Vivian Pearce
Executive producer: Joseph Caracciolo Jr.
Producers: John Fiedler, Mark Tarlov
Associate producer: Pat Moran
Director of photography: Robert M. Stevens
Editors: Janice Hampton, Erica Huggins
Production designer: Vincent Peranio
Costumes: Van Smith
Music: Basil Poledouris
Casting: Paula Herold, Pat Moran
Production: Savoy Pictures Entertainment, Polar
Entertainment, 95 min., Dolby, color, 1.85:1,
35mm
Release date (US): April 13, 1994

1998
Pecker

Written and directed by John Waters
Cast: Edward Furlong, Christina Ricci, Bess
 Armstrong, Mark Joy, Mary Kay Place, Martha
 Plimpton, Brendan Sexton III, Mink Stole,
 Lili Taylor, Mary Vivian Pearce, Susan Lowe,
 Channing Wilroy
Executive producers: Mark Ordesky, Joe Revitte,
 Jonathan Weisgal, Joe Caracciolo Jr.
Producers: John Fiedler, Mark Tarlov
Associate producer: Pat Moran
Director of photography: Robert Stevens
Editor: Janice Hampton
Production designer: Vincent Peranio
Costumes: Van Smith
Music: Stewart Copeland
Casting: Pat Moran, Billy Hopkins, Suzanne Smith,
 Kerry Barden
Production: Fine Line Features, Polar
 Entertainment, 87 min., Dolby digital, color,
 1.85:1, 35mm
Release date (US): September 25, 1998

2000
Cecil B. Demented

Written and directed by John Waters
Cast: Melanie Griffith, Stephen Dorff, Alicia Witt,
 Adrian Grenier, Lawrence Gilliard Jr.,
 Maggie Gyllenhaal, Jack Noseworthy, Mink Stole,
 Ricki Lake, Patricia Hearst, Michael Shannon,
 Kevin Nealon, Eric Barry, Zenzele Uzoma,
 Erika Auchterlonie (as Erika Lynn Rupli),
 Harry Dodge, Susan Lowe, Mary Vivian Pearce,
 Channing Wilroy
Executive producers: Anthony DeLorenzo,
 Fred Bernstein
Producers: Joe Caracciolo Jr., John Fiedler,
 Mark Tarlov
Associate producer: Pat Moran
Director of photography: Robert Stevens
Editor: Jeffrey Wolf
Production designer: Vincent Peranio
Costume designer: Van Smith
Executive music producer: Christopher Brooks
Music: Zoë Poledouris, Basil Poledouris
Casting: Pat Moran, Billy Hopkins, Suzanne Smith,
 Kerry Barden
Production: Artisan Entertainment, Polar
 Entertainment, 87 min., Dolby digital, color,
 1.85:1, 35mm
Release date (US): August 11, 2000

2004
A Dirty Shame

Written and directed by John Waters
Cast: Tracey Ullman, Johnny Knoxville, Selma
 Blair, Chris Isaak, Suzanne Shepherd, Mink
 Stole, Patricia Hearst, Jackie Hoffman, Susan
 Allenbach, Paul DeBoy, Channing Wilroy,
 Mary Vivian Pearce, Jean Hill
Producers: Christine Vachon, Ted Hope
Executive producers: John Wells, the Fisher
 Brothers, Mark Ordesky, Mark Kaufman,
 Merideth Finn
Co-executive producers: Michael Almog, Bob Jason
Coproducer: Ann Ruark
Associate producer: Pat Moran
Director of photography: Steve Gainer
Editor: Jeffrey Wolf
Production designer: Vincent Peranio
Costume designer: Van Smith
Music supervisor: Tracy McKnight
Original score: George S. Clinton
Casting: Pat Moran
Production: Fine Line Features, This Is That /
 Killer Films / John Wells, 84 min., Dolby digital,
 color, 1.85:1, 35mm
Release date (US): September 24, 2004

SELECTED BIBLIOGRAPHY

Compiled by Emily Rauber Rodriguez

Waters as Author and Artist

Hastreiter, Kim, and David Hershkovitz, eds. *From Abfab to Zen: Paper's Guide to Pop Culture.* Introduction and photographs by John Waters. New York: Paper Magazine in association with D.A.P. Distributed Art Publishers, 1999.

Hileman, Kristen. *John Waters: Indecent Exposure.* Exhibition catalogue. Baltimore: Baltimore Museum of Art in association with the University of California Press, 2018.

John Waters: Unwatchable. Essay by Brenda Richardson. Exhibition catalogue. New York: Marianne Boesky; Zurich: De Pury & Luxembourg, 2006.

Phillips, Lisa, and Marvin Heiferman. *John Waters: Change of Life.* Exhibition catalogue. New York: New Museum and Abrams, 2004.

Waters, John. *Carsick: John Waters Hitchhikes across America.* New York: Farrar, Straus & Giroux, 2014.

———. *Crackpot: The Obsessions of John Waters.* New York: Vintage, 1986.

———. *Director's Cut.* Zurich: Scalo, 1997.

———. *Hairspray, Female Trouble, and Multiple Maniacs: Three More Screenplays.* Philadelphia: Running Press, 2005.

———. *Liarmouth: A Feel-Bad Romance.* New York: Farrar, Straus & Giroux, 2022.

———. *Make Trouble.* Chapel Hill, NC: Algonquin, 2017.

———. *Mr. Know-It-All: The Tarnished Wisdom of a Filth Elder.* New York: Farrar, Straus & Giroux, 2019.

———. *Role Models.* New York: Farrar, Straus & Giroux, 2010.

———. *Shock Value: A Tasteful Book about Bad Taste.* New York: Random House, 1981.

———. *Trash Trio: Three Screenplays of John Waters.* New York: Vintage, 1988.

Waters, John, and Bruce Hainley. *Art: A Sex Book.* New York: Thames & Hudson, 2003.

Interviews and Biographies

Brooks, Claude Thomas. "Waters: '. . . I've Always Tried to Sell Out.'" In *John Waters: Interviews,* edited by James Egan, 109-14. Jackson: University Press of Mississippi, 2011. Originally published in *In Motion Film and Video Production Magazine* (1982).

Chang, Chris. "John Waters." *Film Comment* 39, no. 3 (May-June 2003): 17.

Chutte, David. "Still Waters." *Film Comment* 17, no. 3 (May-June 1981): 26-32.

Cooper, Dennis. "John Waters." *Bomb,* no. 87 (Spring 2004): 22-29.

Egan, James, ed. *John Waters: Interviews.* Jackson: University Press of Mississippi, 2011.

Hoberman, J. "Back at the Raunch." *Sight & Sound,* no. 12 (2004): 24-27.

Holmlund, Chris. "John Waters: *Multiple Maniacs* Relaunch." *Film Quarterly* 71, no. 1 (2017): 97-103.

Ives, John G. *John Waters.* New York: Thunder's Mouth, 1992.

Lypchuck, Donna. "John Waters Interview." In *Impulse Archaeology,* edited by Eldon Garnet, 195-97. Toronto: University of Toronto Press, 2005.

MacDonald, Scott. "John Waters' Divine Comedy." *Artforum* 20, no. 5 (January 1982): 52-60.

Musto, Michael. "John Waters." *Out* 10, no. 6 (2001): 62.

Oldham, Todd, and Cindy Sherman. *John Waters.* Place Space, no. 3. Los Angeles: AMMO, 2008.

Peary, Gerald. "John Waters in Baltimore." *Provincetown Arts Magazine* 13 (1997): 22-26.

Pedersen, M. C. "John Waters: Obsessions Rule (An Interview)." *Graphis* 54, no. 314 (1998): 96-101.

Pela, Robert. *Filthy: The Weird World of John Waters.* New York: Alyson, 2002.

Sherman, Dale. *John Waters FAQ: All That's Left to Know about the Provocateur of Bad Taste.* Washington, DC: Rowman & Littlefield, 2019.

Dreamlanders

Abate, Michelle Ann. "NosferatUrsula: *The Little Mermaid* and Vampirism." *Journal of Popular Culture* 54, no. 1 (2021): 165-84.

Brodie, Noah, Dan Marshall, Frances Milstead, and Michael O'Quinn. *Postcards from Divine.* Winter Park, FL: Everything Divine Incorporated, 2011.

Griffin, Chloé. *Edgewise: A Picture of Cookie Mueller.* Berlin: Bbooks, 2014.

Harries, Dan. "Camping with Lady Divine: Star Persona and Parody." *Quarterly Review of Film and Video* 12, nos. 1-2 (1990): 13-22.

Milstead, Frances, with Kevin Heffernan and Steve Yeager. *My Son Divine.* New York: Alyson, 2001.

Mueller, Cookie. *Ask Dr. Mueller*. London: Serpent's Tail, 1997.

Schoonover, Karl. "Divine: Toward an 'Imperfect' Stardom." In *Hollywood Reborn: Movie Stars of the 1970s*, edited by James Morrison, 158–81. New Brunswick, NJ: Rutgers University Press, 2010.

Stole, Mink. "*Pink Flamingos*: November 1972." *Advocate*, November 12, 2002, 48.

Critical Analysis of Waters and His Films

Aufderheide, Pat. "The Domestication of John Waters." *American Film* 15, no. 7 (1990): 32–37.

Banks, Taunya Lovell. "Troubled Waters: Mid-Twentieth Century American Society on 'Trial' in the Films of John Waters." *Stetson Law Review* 39, no. 1 (2009): 153–81.

Connolly, Matt. "Underground Exploiteer: John Waters and the Development of a Directorial Brand, 1964–1981." PhD diss., University of Wisconsin–Madison, 2018.

Curry, Renee R. "*Hairspray*: The Revolutionary Way to Restructure and Hold Your History." *Literature/ Film Quarterly* 24, no. 2 (1996): 165–68.

Feuer, Jane. *The Hollywood Film Musical*. 2nd ed. Bloomington: Indiana University Press, 1993.

Fields, Danny, and Fran Lebowitz. "Pink Flamingos & the Filthiest People Alive?" *Interview*, May 1973, 14–15, 40–41.

Gilroy, Paul. "Exer(or)cising Power: Black Bodies in the Black Public Sphere." In *Dance in the City*, edited by Helen Thomas, 21–34. New York: St. Martin's Press, 1997.

Holmlund, Chris. *Female Trouble: A Queer Film Classic*. Vancouver: Arsenal Pulp Press, 2017.

hooks, bell. *Black Looks: Race and Representation*. Boston: South End Press, 1992.

———. *Reel to Real: Race, Sex, and Class at the Movies*. New York: Routledge, 1996.

Kane-Meddock, Derek. "Trash Comes Home: Gender/Genre Subversion in the Films of John Waters." In *Gender Meets Genre in Postwar Cinemas*, edited by Christine Gledhill, 205–18. Champaign: University of Illinois Press, 2012.

Koob, Nathan. "The Gentrification of John Waters." *Film Criticism* 43, no. 1 (2019). https://quod .lib.umich.edu/f/fc/13761232.0043.104?view =text;rgn=main.

Levy, Emanuel. "John Waters: Queer as Trash and Camp." In *Gay Directors, Gay Films? Pedro Almodóvar, Terence Davies, Todd Haynes, Gus Van Sant, John Waters*, 268–324. New York: Columbia University Press, 2015.

Metz, Walter. "John Waters Goes to Hollywood: A Poststructural Authorship Study." In *Authorship and Film*, edited by David A. Gerstner and Janet Staiger, 157–74. New York: Routledge, 2003.

Nunes, Elise Pereira. "Sex, Gore and Provocation: The Influence of Exploitation in John Waters' Early Films." *Transatlantica*, no. 2 (2015). https:// journals.openedition.org/transatlantica/7881.

Padilla, Elisa. "The Baltimore Artist: Taste, Class, and Distinction in John Waters' *Pecker*." *Quarterly Review of Film and Video* 39, no. 2 (2022): 341–59.

Palladini, Giulia. "A Camp Fairy Tale: The Dirty Class of John Waters' *Desperate Living*." In *The Dark Side of Camp Aesthetics*, edited by Ingrid Hotz-Davies, Georg Vogt, and Franziska Bergmann, 115–26. New York: Routledge, 2018.

Richards, Stuart. "Divine Dog Shit: John Waters and Disruptive Queer Humour in Film." *Senses of Cinema*, no. 80 (September 2016). http:// sensesofcinema.com/2016/american-extreme /john-waters/.

Russell, Curtis. "Four Hairsprays, One Baltimore: The City in Trans-medial Adaptation." *Studies in Musical Theatre* 12, no. 3 (2018): 367–75.

Russell, Kate J. "The Cinematic Pandemonium of William Castle and John Waters." In *ReFocus: The Films of William Castle*, edited by Murray Leeder, 237–54. Edinburgh: Edinburgh University Press, 2018.

Stevenson, Jack. *Desperate Visions: Camp America; The Films of John Waters and the Kuchar Brothers*. London: Creation, 1996.

Weitz, Rose. "Changing the Scripts: Midlife Women's Sexuality in Contemporary U.S. Film." *Sexuality & Culture* 14, no. 1 (2009): 17–32.

Woodward, Suzanne. "Taming Transgression: Gender-Bending in *Hairspray* (John Waters, 1988) and Its Remake." *New Cinemas* 10, no. 2 (2012): 115–26.

Cult, Midnight, Trash, Sleaze, Avant-garde, and Exploitation Cinemas

Andrews, David. *Theorizing Art Cinemas: Foreign, Cult, Avant-garde, and Beyond*. Austin: University of Texas Press, 2013.

Barefoot, Guy. *Trash Cinema: The Lure of the Low*. New York: Columbia University Press, 2017.

Bürger, Peter. *Theory of the Avant-garde*. Translated by Michael Shaw. Minneapolis: University of Minnesota Press, 2007.

Cartmell, Deborah, Heidi Kaye, I. Q. Hunter, and Imelda Whelehan. *Trash Aesthetics: Popular Culture and Its Audience*. London: Pluto, 1997.

Church, David. "Freakery, Cult Films, and the Problem of Ambivalence." *Journal of Film and Video* 63, no. 1 (2011): 3–17.

———. "Notes toward a Masochizing of Cult Cinema: The Painful Pleasures of the Cult Film Fan." *Offscreen* 11, no. 4 (2007). https://offscreen.com/view/masochizing_of_cult_cinema.

Cohn, Lawrence. "Pictures: 10 Years of U.S. Offbeat 'Midnight Movies' Phenom." *Variety* 301, no. 1 (November 5, 1980): 36.

Egan, Kate, and Sarah Thomas, eds. *Cult Film Stardom: Offbeat Attractions and Processes of Cultification.* New York: Palgrave Macmillan, 2013.

Fisher, Austin, and Johnny Walker, eds. *Grindhouse: Cultural Exchange on 42nd Street and Beyond.* London: Bloomsbury, 2016.

Gorfinkel, Elena. "Cult Film or Cinephilia by Any Other Name." *Cineaste* 34, no. 1 (2008): 33–38.

Grey, Rudolph. *Nightmare of Ecstasy: The Life and Art of Edward D. Wood, Jr.* London: Faber, 1995.

Hawkins, Joan. "Sleaze Mania, Euro-Trash, and High Art: The Place of European Art Films in American Low Culture." *Film Quarterly* 53, no. 2 (1999): 14–29.

Hoberman, J., and Jonathan Rosenbaum. *Midnight Movies.* New York: Harper & Row, 1983.

Jancovich, Mark. "Cult Fictions, Cult Movies, Subcultural Capital and the Production of Cultural Distinctions." *Cultural Studies* 16, no. 2 (2002): 206–22.

———. "A Real Shocker: Authenticity, Genre and the Struggle for Cultural Distinction." *Continuum* 14, no. 1 (2000): 23–35.

Jancovich, Mark, Antonio Lazaro Reboli, Julian Stringer, and Andrew Willis, eds. *Defining Cult Movies: The Cultural Politics of Oppositional Taste.* Manchester: Manchester University Press, 2003.

Kael, Pauline. "Trash, Art, and the Movies." In *Going Steady: Film Writings, 1968–1969,* 87–129. London: Marion Boyars, 1970. Originally published in *Harper's Magazine* (February 1969).

Landis, Bill, and Michelle Clifford. *Sleazoid Express: A Mind-Twisting Tour through the Grindhouse Cinema of Times Square.* New York: Fireside, 2002.

MacDowell, James, and Richard McCulloch. "Introduction: 'So Bad It's Good': Aesthetics, Reception, and Beyond." *Continuum* 33, no. 6 (2019): 643–52.

Mathijs, Ernest, "Bad Reputations: The Reception of 'Trash' Cinema." *Screen* 46, no. 4 (2005): 451–72.

Mathijs, Ernest, and Jamie Sexton, eds. *Cult Cinema.* West Sussex, UK: Wiley-Blackwell, 2011.

McCarthy, Todd, and Charles Flynn, eds. *King of the Bs: Working within the Hollywood System; An Anthology of Film History and Criticism.* New York: Dutton, 1975.

Mendik, Xavier, and Graham Harper, eds. *Unruly Pleasures: The Cult Film and Its Critics.* New York: FAB, 2000.

Mendik, Xavier, and Steven Jay Schneider, eds. *Underground USA: Filmmaking beyond the Hollywood Canon.* London: Wallflower, 2002.

Morris, Wesley. "American Culture Is Trash Culture." *New York Times Magazine,* October 12, 2022. https://www.nytimes.com/2022/10/12/magazine/american-trash-culture.html.

Quarles, Mike. *Down and Dirty: Hollywood's Exploitation Filmmakers and Their Movies.* Jefferson, NC: McFarland, 1993.

Rich, B. Ruby. *New Queer Cinema: The Director's Cut.* Durham, NC: Duke University Press, 2013.

Samuels, Stuart. *Midnight Movies.* New York: Collier, 1983.

Schaefer, Eric. *"Bold! Daring! Shocking! True!": A History of Classical Exploitation Films, 1919–1959.* Durham, NC: Duke University Press, 1999.

Sconce, Jeffrey, ed. *Sleaze Artists: Cinema at the Margins of Taste, Style, and Politics.* Durham, NC: Duke University Press, 2007.

———. "'Trashing' the Academy: Taste, Excess, and an Emerging Politics of Cinematic Style." *Screen* 26, no. 4 (1995): 371–93.

Sexton, Jamie, and Ernest Mathijs, eds. *The Routledge Companion to Cult Cinema.* New York: Routledge, 2020.

Studlar, Gaylyn. "Midnight S/Excess: Cult Configurations of 'Femininity' and the Perverse." In *The Cult Film Experience,* edited by J. P. Telotte. Austin: University of Texas Press, 1991.

Telotte, J. P., ed. *The Cult Film Experience.* Austin: University of Texas Press, 1991.

Vale, V., and Andrea Juno, eds. *Incredibly Strange Films.* San Francisco: RE/Search Publications, 1986.

Wassil, Rachel. "Films with a Criminal Record: An Investigation of Exploitation Films." *Film Matters* 6, no. 3 (2016): 83–86.

Queer History, Studies, and Theory

Bersani, Leo. *Homos.* Cambridge, MA: Harvard University Press, 1995.

Brekhus, Wayne. *Peacocks, Chameleons, Centaurs: Gay Suburbia and the Grammar of Social Identity.* Chicago: University of Chicago Press, 2003.

Bronskie, Michael. *Culture Clash: The Making of Gay Sensibility.* Boston: South End, 1984.

Butler, Judith. *Bodies That Matter: On the Discursive Limits of Sex.* New York: Routledge, 1993.

———. *Gender Trouble: Feminism and the Subversion of Identity.* 2nd ed. London: Routledge, 1999.

———. *Undoing Gender*. New York: Routledge, 2004.

Caserio, Robert L., Lee Edelman, Judith Halbertam, José Esteban Muñoz, and Tim Dean. "The Antisocial Thesis in Queer Theory." *PMLA* 121, no. 3 (2006): 819–28.

Chauncey, George. *Gay New York: Gender, Urban Culture and the Making of the Gay Male World, 1890–1940*. New York: Basic Books, 1993.

Corber, Robert J., and Stephen Valocchi, eds. *Queer Studies: An Interdisciplinary Reader*. Malden, MA: Blackwell, 2003.

De Lauretis, Teresa. "Queer Theory: Lesbian and Gay Sexualities; An Introduction." *Differences* 3, no. 2 (Summer 1991): iii–xviii.

Edelman, Lee. *No Future: Queer Theory and the Death Drive*. Durham, NC: Duke University Press, 2004.

Fuss, Diana, ed. *Inside/Out: Lesbian Theories, Gay Theories*. London: Routledge, 1991.

Garber, Marjorie. *Vested Interests: Cross-Dressing and Cultural Anxiety*. New York: Routledge, 1992.

Gross, Larry, and James D. Woods, eds. *The Columbia Reader on Lesbians and Gay Men in Media, Society, and Politics*. New York: Columbia University Press, 1999.

Halberstam, Jack (Judith). *Female Masculinity*. Durham, NC: Duke University Press, 1998.

———. *In a Queer Time and Place: Transgender Bodies, Subcultural Lives*. New York: New York University Press, 2005.

Newton, Esther. *Mother Camp: Female Impersonators in America*. Chicago: University of Chicago Press, 1979.

Van Leer, David. *The Queering of America*. New York: Routledge, 1995.

Warner, Michael, ed. *Fear of a Queer Planet*. Minneapolis: University of Minnesota Press, 1993.

Queer Cinema

Barrios, Richard. *Screened Out: Playing Gay in Hollywood from Edison to Stonewall*. New York: Routledge, 2003.

Damiens, Antoine. "The Queer Film Ecosystem: Symbolic Economy, Festivals, and Queer Cinema's Legs." *Studies in European Cinema* 15, no. 1 (2018): 25–40.

Dyer, Richard. *Now You See It: Studies on Lesbian and Gay Film*. New York: Routledge, 1990.

Doty, Alexander. "Queer Theory." In *The Oxford Guide to Film Studies*, edited by John Hill and Pamela Church Gibson, 146–50. New York: Oxford University Press, 1998.

Hanson, Ellis, ed. *Out Takes: Essays on Queer Theory and Film*. Durham, NC: Duke University Press, 1999.

Russo, Vito. *The Celluloid Closet: Homosexuality in the Movies*. New York: Harper & Row, 1981.

Straayer, Chris. *Deviant Eyes, Deviant Bodies: Sexual Re-orientation in Film and Video*. New York: Columbia University Press, 1996.

Tyler, Parker. *Screening the Sexes: Homosexuality in the Movies*. New York: Da Capo, 1993.

Vachon, Christine, and David Edelstein. *Shooting to Kill*. New York: Avon, 1998.

Camp and Other Queer Aesthetics

Benson-Allott, Caetlin. "Camp Integration: The Use and Misuse of Nostalgia in John Waters' *Hairspray*." *Quarterly Review of Film and Video* 26, no. 2 (2009): 143–54.

Cleto, Fabio, ed. *Camp: Queer Aesthetics and the Performing Subject; A Reader*. Edinburgh: Edinburgh University Press, 1999.

De Villiers, Nicholas. "'The Vanguard—and the Most Articulate Audience': Queer Camp, Jack Smith and John Waters." *Forum: University of Edinburgh Postgraduate Journal of Culture and the Arts*, no. 4 (2007). http://journals.ed.ac.uk/forum/article/view/577.

Hotz-Davies, Ingrid, Georg Vogt, and Franziska Bergmann, eds. *The Dark Side of Camp Aesthetics: Queer Economies of Dirt, Dust, and Patina*. New York: Routledge, 2017.

Kleinhans, Chuck. "Taking Out the Trash: Camp and the Politics of Irony." In *The Politics and Poetics of Camp*, edited by Morris Meyer, 182–201. New York: Routledge, 1994.

Meyer, Morris, ed. *The Politics and Poetics of Camp*. New York: Routledge, 1994.

Padva, Gilad. "Priscilla Fights Back: The Politicization of Camp Subculture." *Journal of Communication Inquiry* 24, no. 2 (2000): 216–43.

Russell, Thaddeus. "The Color of Discipline: Civil Rights and Black Sexuality." *American Quarterly* 60, no. 1 (2008): 101–28.

Sedgwick, Eve. *Epistemology of the Closet*. Berkeley: University of California Press, 1990.

Senelick, Laurence. *The Changing Room: Sex, Drag and Theatre*. London: Routledge, 2000.

Sontag, Susan. "Notes on 'Camp.'" In *Against Interpretation and Other Essays*. New York: Farrar, Straus & Giroux, 1966.

Taylor, Greg. *Artists in the Audience: Cults, Camp, and American Film Criticism*. Princeton, NJ: Princeton University Press, 1999.

Wadlow, Justin S. "Redneck Riviera: Having Fun in the Kitsch World of John Waters." Revue *LISA / LISA e-journal* 15, no. 1 (2017). http://journals.openedition.org/lisa/9078.

Taste

Bourdieu, Pierre. *Distinction: A Social Critique of the Judgment of Taste*. New York: Routledge, 1984.

Holliday, Ruth, and Tracey Potts. *Kitsch! Cultural Politics and Taste*. Manchester: Manchester University Press, 2012.

Levine, Lawrence. *Highbrow/Lowbrow: The Emergence of Cultural Hierarchy in America*. Cambridge, MA: Harvard University Press, 1990.

Ross, Andrew. *No Respect: Intellectuals and Popular Culture*. New York: Routledge, 1989.

Vassilieva, Julia, and Constantine Verevis. "After Taste: Cultural Value and the Moving Image." *Continuum* 24, no. 5 (2010): 643–52.

Disgust, Revulsion, Taboos, and Deviant Behaviors

Adams, Rachel. *Sideshow U.S.A.: Freaks and the American Cultural Imagination*. Chicago: University of Chicago Press, 2001.

Breckon, Anna. "The Erotic Politics of Disgust: *Pink Flamingos* as Queer Political Cinema." *Screen* 54, no. 4 (Winter 2013): 514–33.

Douglas, Mary. *Purity and Danger: An Analysis of Concepts of Pollution and Taboo*. New York: Praeger, 1966.

Goode, Erich, and Nachman Ben-Yehuda. *Moral Panics: The Social Construction of Deviance*. 2nd ed. West Sussex, UK: Wiley-Blackwell, 2009.

Kolnai, Aurel. *On Disgust*. Chicago: Open Court, 2004.

Korsmeyer, Carolyn. *Savoring Disgust: The Foul and the Fair in Aesthetics*. New York: Oxford University Press, 2011.

Kristeva, Julia. *Powers of Horror: An Essay on Abjection*. Translated by Leon S. Roudiez. New York: Columbia University Press, 1982.

Menninghaus, Winfried. *Disgust: Theory and History of a Strong Sensation*. Translated by Howard Eiland and Joel Golb. Albany: State University of New York Press, 2003.

Miller, William Ian. *The Anatomy of Disgust*. Cambridge, MA: Harvard University Press, 1997.

Morawski, Stefan. "Art and Obscenity." *Journal of Aesthetics and Art Criticism* 26, no. 2 (1967): 193–207.

Ngai, Sianne. *Ugly Feelings*. Cambridge, MA: Harvard University Press, 2005.

Randall, Richard S. *Censorship of the Movies: The Social and Political Control of a Mass Medium*. Madison: University of Wisconsin Press, 1970.

Thompson, Kenneth. *Moral Panics*. New York: Routledge, 1998.

Tomkins, Silvan. *Affect, Imagery, Consciousness*. Vol. 2, *The Negative Affects*. New York: Springer, 1963.

Van Ooijen, Erik. "Cinematic Shots and Cuts: On the Ethics and Semiotics of Real Violence in Film Fiction." *Journal of Aesthetics & Culture* 3, no. 1 (2011): 6280–95.

Spectacle, Pleasure, and Perversion

Barthes, Roland. *The Pleasure of the Text*. New York: Hill & Wang, 1975.

Bayman, Louis. "Beyond the Pleasure Principle: Exploring the Limits of a Pervasive Term." *New Cinemas* 14, no. 2 (2016): 123–34.

Gibson, Pamela Church, ed. *More Dirty Looks: Gender, Pornography and Power*. London: British Film Institute, 2004.

Gomery, David. *Shared Pleasures: The History of Movie Exhibition in the United States*. Madison: University of Wisconsin Press, 1992.

Grosz, Elizabeth. *Space, Time, and Perversion: Essays on the Politics of Bodies*. London: Routledge, 1995.

Gunning, Tom. "An Aesthetics of Astonishment: Early Film and the (In)Credulous Spectator." *Art & Text*, no. 34 (Fall 1989): 31–45.

———. "The Cinema of Attraction: Early Film, Its Spectator and the Avant-garde." *Wide Angle* 8, no. 3 (1986): 63–70.

Jenkins, Henry, Tara McPherson, and Jane Shattuc, eds. *Hop on Pop: The Politics and Pleasures of Popular Culture*. Durham, NC: Duke University Press, 2002.

Kendrick, Walter. *The Secret Museum: Pornography in Modern Culture*. Berkeley: University of California Press, 1996.

Marks, Laura Helen. "Porn Drift: Semantic Discord in the World of Gonzo." *Cinema Journal* 58, no. 1 (2018): 164–70.

Rosewarne, Lauren. "The Pervert." In *The Routledge Companion to Media, Sex and Sexuality*, edited by Clarissa Smith, Feona Attwood, and Brian McNair, 416–27. New York: Routledge, 2017.

Schaefer, Eric. "Gauging a Revolution: 16mm and the Rise of the Pornographic Feature." *Cinema Journal* 41, no. 3 (2002): 3–26.

Sobchack, Vivian. *Carnal Thoughts: Embodiment and Moving Image Culture*. Berkeley: University of California Press, 2004.

Thompson, Kristin. "The Concept of Cinematic Excess." In *Narrative, Apparatus, Ideology: A Film Theory Reader*, edited by Philip Rosen, 130–42. New York: Columbia University Press, 1986.

Turan, Kenneth, and Stephen F. Zito. *Sinema: American Pornographic Films and the People Who Make Them*. New York: Praeger, 1974.

Williams, Linda. "Film Bodies: Gender, Genre, and Excess." *Film Quarterly* 44, no. 4 (1991): 2–13.

———. *Hard Core: Power, Pleasure, and the Frenzy of the Invisible*. Berkeley: University of California Press, 1991.

Willis, Paul. *Profane Culture*. London: Routledge, 1978.

Winick, Charles. "Some Observations on Characteristics of Patrons of Adult Theaters and Bookstores." *Technical Report of the Commission on Obscenity and Pornography*, vol. 4. Washington, DC: US Government Printing Office, 1971.

Other Media Cultures and Subcultures

Levy, Emanuel. *Cinema of Outsiders: The Rise of the American Independent Film*. New York: New York University Press, 1999.

Newman, Michael. *Indie: An American Film Culture*. New York: Columbia University Press, 2011.

Spigel, Lynn. *Welcome to the Dreamhouse: Popular Media and Postwar Suburbs*. Durham, NC: Duke University Press, 2001.

Thornton, Sarah. *Club Cultures: Music, Media, and Subcultural Capital*. London: Polity, 1995.

Vogel, Amos. *Film as a Subversive Art*. New York: Random House, 1976.

CONTRIBUTORS

Sean Baker is a writer, director, producer, and editor who has made seven independent features over the past two decades. His acclaimed film *The Florida Project* (2017) received a Best Director award from the New York Film Critics Circle and a Best Supporting Actor Oscar nomination for Willem Dafoe. His previous film, *Tangerine* (2015), won an Independent Spirit Award and two Gotham Awards. Baker's most recent film, *Red Rocket* (2021), premiered at the Cannes Film Festival to critical acclaim and was distributed by A24 in the US and Focus Features internationally.

Jeanine Basinger is the Corwin-Fuller Professor of Film Studies emerita at Wesleyan University, where she founded the College of Film and the Moving Image, as well as the Ogden and Mary Louise Reid Cinema Archives. She has authored thirteen books, including *The Movie Musical!* (2019) and *Hollywood: The Oral History* (2022, coauthored with Sam Wasson). Her writing has appeared in the *New York Times*, *Film Comment*, and the *Washington Post*. She is a trustee of the American Film Institute and the National Board of Review and served as adviser to Martin Scorsese's Film Foundation project the Story of Movies.

Debbie Harry is a seminal rock and roll figure, complex songstress, actor, and fashion icon, best known as the incandescent front woman and cofounder (with Chris Stein) of Blondie. Her chart-topping success and fearless spirit have cemented her as a vibrant global force and a shaper of pop culture. She has more than thirty film and television roles to her credit, including her appearance as Velma Von Tussle in *Hairspray* (1988), and became a best-selling author with the release of her 2019 memoir, *Face It*.

Jenny He is exhibitions curator at the Academy Museum of Motion Pictures. In addition to *John Waters: Pope of Trash*, she has curated exhibitions on Pedro Almodóvar, Hildur Guðnadóttir, animation filmmakers, special and visual effects artists, and numerous other subjects for the museum. Previously, she independently organized and toured *The World of Tim Burton* to multiple venues in Latin America, Asia, and Europe, including the Museum of Image and Sound, São Paulo (2016), and the Mori Arts Center, Tokyo (2014–15). For the Museum of Modern Art (MoMA), among other exhibitions, He curated *Crafting Genre: Kathryn Bigelow* (2011), which was named to *The Village Voice*'s "Best NYC Art Shows of 2011" list, and cocurated *Tim Burton* (2009), the third highest attended exhibition in MoMA's history, and *Pixar: 20 Years of Animation* (2005–6). She holds a BA in film studies from Wesleyan University.

Dara Jaffe is associate curator at the Academy Museum of Motion Pictures. She joined the museum in 2013 and, prior to its opening, assisted on the multifaceted project *From Latin America to Hollywood: Latino Film Culture in Los Angeles 1967–2017* (2017–18). Since the museum's opening in 2021, she has curated galleries dedicated to *Casablanca*, Spike Lee, *The Wizard of Oz*, Oscar Micheaux, and *Citizen Kane*, and she cocurated the exhibition *John Waters: Pope of Trash*. Originally from Austin, Texas, she holds an MA in film studies from Wesleyan University. Jaffe is also a visual artist whose liquid light projections have been featured at historic Los Angeles venues such as the Troubadour and the El Rey Theater and at the LA Pride Parade & Festival.

Barry Jenkins is a critically acclaimed filmmaker whose filmography includes *Moonlight* (2016), winner of three Academy Awards, and the Academy Award–nominated film *If Beale Street Could Talk* (2018), which won for Best Supporting Actress. Most recently, Jenkins served as showrunner and director of *The Underground Railroad* (2021), a ten-part adaptation of Colson Whitehead's 2016 novel, for which he received seven Primetime Emmy nominations, a BAFTA for Best International Series, and the Golden Globe for Best Limited Series.

Johnny Knoxville is an actor and filmmaker best known for starring in and producing the box-office hit franchise *Jackass*, including *Jackass the Movie* (2002) and its sequels: *Jackass Number Two* (2006), *Jackass 3D* (2010), *Jackass Presents: Bad Grandpa* (2013), and *Jackass Forever* (2022). In addition to his starring role as Ray-Ray Perkins in *A Dirty Shame* (2004), his film credits include *Elvis & Nixon* (2016), *Small Apartments* (2012), *The Ringer* (2005), and *The Dukes of Hazzard* (2005). He currently stars in Hulu's ensemble comedy series *Reboot*.

Bruce LaBruce is a filmmaker, photographer, writer, and artist based in Toronto. He has written and directed fourteen feature films, including *Gerontophilia* (2013), which won the Grand Prix at the Festival du Nouveau Cinema in Montreal. As

a writer and photographer, LaBruce has contributed to a variety of international magazines and newspapers. His movie *Saint-Narcisse* was named one of the top ten films of 2021 by John Waters in *Artforum*. His latest porn feature, *The Affairs of Lidia*, was released in 2022.

Ricki Lake is an actress, producer, and television host. She made her film debut as Tracy Turnblad in *Hairspray* (1988) and went on to appear in *Cry-Baby* (1990), *Serial Mom* (1994), *Cecil B. Demented* (2000), and numerous other films. At the age of 24 she began hosting a talk show, *Ricki Lake* (1993–2004), becoming the youngest person at the time to take on that role. For her second series, *The Ricki Lake Show* (2013), she won an Emmy for Outstanding Talk Show Host. Lake is also an independent filmmaker, with credits that include producing the critically acclaimed documentaries *The Business of Being Born* (2008), *Weed the People* (2018), and *The Business of Birth Control* (2021).

Orville Peck is a new breed of country outlaw hell-bent on cracking open a restrictive and stale genre. Since the release of his debut album, *Pony* (2019), he has become a beloved leader for the queer community, a duet partner for Miley Cyrus and Shania Twain, a touring dynamo, and a thoughtful, personal lyricist. His latest album, *Bronco* (2022), is an exploration into love of the self and of others.

Iggy Pop was born in a trailer by the side of the hillbilly highway that goes from Tennessee to Michigan. His first stage dive was at the age of 2, when he leapt out of his crib. His friends in the trailer park had a pet monkey who was a big inspiration. Later he wanted to be in a band and wear grease in his hair. He was a sensitive child and read too many books, so grease sounded like a better life. Later he gave up the grease and became a very old punk. He now resides peacefully anywhere he can escape most assholes.

B. Ruby Rich is a critic, curator, commentator (radio and television), and professor emerita, University of California, Santa Cruz. She is the author of *Chick Flicks: Theories and Memories of the Feminist Film Movement* (1998) and *New Queer Cinema: The Director's Cut* (2013). Rich is a member of The Academy of Motion Picture Arts and Sciences and was editor of *Film Quarterly* from 2013 to 2023. She lives in San Francisco and Paris with her partner. She first met John Waters in 1984 at the Rio Film Festival, where she introduced him to Esther Williams.

Cindy Sherman is an artist who came to prominence in the late 1970s as part of the so-called Pictures Generation. Her groundbreaking photographs have interrogated themes of representation, artifice, and identity in contemporary media for more than four decades. She has received such awards and honors as the Praemium Imperiale, an American Academy of Arts and Letters Award, a MacArthur Foundation Fellowship, and a Guggenheim Memorial Fellowship.

David Simon is a Baltimore-based journalist, author, and television producer. He created and produced the celebrated HBO series *The Wire*, which depicts an American city's political and socioeconomic fissures. A former reporter for the *Baltimore Sun*, Simon is the author of two nonfiction books: *Homicide* (1991), which was the basis for the NBC drama of that name, and *The Corner* (1997), which became an Emmy-winning HBO miniseries. Subsequent television credits include *Generation Kill* (2008), *Treme* (2010–13), *Show Me a Hero* (2015), *The Deuce* (2017–19), and *The Plot against America* (2020). His most recent project, *We Own This City* (2022), is a six-hour limited series chronicling the rise and fall of the Baltimore Police Department's Gun Trace Task Force.

Kathleen Turner's award-winning, critically acclaimed performances span film (*Body Heat* [1981], *The Man with Two Brains* [1983], *Romancing the Stone* [1984], *Prizzi's Honor* [1985], *The Jewel of the Nile* [1985], *Peggy Sue Got Married* [1986], *The Accidental Tourist* [1988], *Serial Mom* [1994], *The Virgin Suicides* [1999]); theater (*Cat on a Hot Tin Roof* [1990], *The Graduate* [2002–3], *Who's Afraid of Virginia Woolf* [2005–7], *Red Hot Patriot: The Kick-Ass Wit of Molly Ivins* [2010], *Mother Courage and Her Children* [2014], *Bakersfield Mist* [2014], *The Year of Magical Thinking* [2016]); and television (*The Kominsky Method* [2019, 2021], *White House Plumbers* [2023]).

Christine Vachon is an Independent Spirit Award and Gotham Award winner who cofounded indie powerhouse Killer Films with partner Pamela Koffler in 1995. Over the past two decades they have produced more than one hundred films, including some of the most celebrated American indie features. Recent releases include Janicza Bravo's *Zola* (2020), distributed by A24; Todd Haynes's *The Velvet Underground* (2021) for Apple TV+; and the Emmy Award–winning limited series *Halston* (2021) for Netflix.

John Waters is a filmmaker, author, actor, and visual artist. He has written and directed sixteen movies including *Pink Flamingos* (1972) and *Hairspray* (1988), which were added to the U.S. Library of Congress's National Film Registry. Waters is the author of *Shock Value* (1981); *Crackpot* (1986); *Art: A Sex Book* (2003, co-written with Bruce Hainley); *Pink Flamingos and Other Filth* (2005); *Hairspray, Female Trouble and Multiple Maniacs* (2005); *Role Models* (2010); *Carsick* (2014); *Make Trouble* (2017); and *Mr. Know-It-All* (2019). His first novel, *Liarmouth: A Feel Bad Romance* (2022), was optioned by Village Roadshow Pictures for Waters to write and direct. He has performed his one man spoken-word lectures and his annual Christmas show, *A John Waters Christmas*, at colleges, museums, film festivals, and comedy clubs around the world. Waters is a member of The Academy of Motion Picture Arts and Sciences and the National Academy of Recording Arts and Sciences, and he is currently on the Board of Directors for the Baltimore Museum of Art and the Maryland Film Festival.

Edgar Wright is a director, writer, and producer best known for *Shaun of the Dead* (2004), *Hot Fuzz* (2007), *Scott Pilgrim vs. the World* (2010), *The World's End* (2013), *Baby Driver* (2017), *Last Night in Soho* (2021), and *The Sparks Brothers* (2021).

249

LENDERS TO THE EXHIBITION

Bob Adams

Beinecke Rare Book & Manuscript Library at Yale University, New Haven, Connecticut

Jonathan Benya

Noah Brodie, Divine Official Enterprises

David Davenport

Tony Gardner

Jeffrey Pratt Gordon

Traci Lords

Margaret Herrick Library, Academy of Motion Picture Arts and Sciences, Los Angeles

Gene Mendez

Pat Moran

Ogden and Mary Louise Reid Cinema Archives, Wesleyan University, Middletown, Connecticut

Deborah Rausch

Ted Sarandos

Emily Sienicki

Mink Stole

Rachel Talalay

John Waters

Brook Yeaton

Among the generous lenders to this exhibition are several individuals who grew to be mainstays in John Waters's orbit after the early phase of his career, which is explored in the essay "Welcome to Dreamland" in this volume, and became part of his cast and crew or extended network of friends. This group of second-generation Dreamlanders includes Brook Yeaton, son of Pat Moran and godson of Divine, whose extensive career as a property master began with his work for Waters. Rachel Talalay, director and producer, received her first film credit as a production assistant on *Polyester* (1981). When she saw the announcement of a casting call for the film in the *Baltimore City Paper*, Talalay phoned the production office and asked if she could join as a gofer. David Davenport was employed as a stylist for commercials when he entered the Dreamland scene with *Hairspray* (1988), his first film credit, working as a wardrobe supervisor alongside costume designer Van Smith. He continued on Waters's next four films, which helped launch his robust current career as a costume supervisor. In *Cry-Baby* (1990), Jonathan Benya played Snare-Drum, one of the children, along with Scout Raskin's Susie-Q, of Pepper Walker (Ricki Lake), sister of the titular Cry-Baby Walker. Benya kept Snare-Drum's custom-made leather jacket after production wrapped. When his parents had a house fire, only the family, the pets, and this dear keepsake made it out unscathed. Jeffrey Pratt Gordon began his film career with *Serial Mom* (1994) as art department production assistant. He first met Waters at the Club Charles in Baltimore, where the filmmaker struck up a conversation, a defining moment for the now prolific production designer and property master. When Edith Massey decided to close her Baltimore thrift store, Edith's Shopping Bag, and reopen it across the country in Venice, California, Gene Mendez was her partner in the new business as well as her housemate. The enthusiasm and hospitality extended by all of the lenders is a testament to the kindness and brilliance of John Waters and the devotion shown to him by his longtime collaborators and archivists.

Jenny He
Exhibitions Curator

Dara Jaffe
Associate Curator

Clockwise, from top:
Jonathan Benya (left) with Waters and Scout Raskin during the production of *Cry-Baby* (1990)

Edith Massey and Gene Mendez, 1980s

Rachel Talalay and John Waters at the premiere of *Hairspray* (1988)

Jeffrey Pratt Gordon and Brook Yeaton during the production of *A Dirty Shame* (2004)

ACADEMY MUSEUM OF MOTION PICTURES STAFF LIST

Andrew Acedo
Community and Impact Manager

Marcy Akop
Advancement Reporting and Data Analysis Specialist

Nathan Alexander
Sales Associate

Stacey Allan
Director, Publications

Oskar Alonso Heredia
Custodial Lead

Catrina Alonzo
Assistant Registrar, Permanent Collections

Jackeline Alvarez
Visitor Experience Supervisor

Rafael Alvarez
Custodial Associate

Carlos Anastacio
Visitor Experience Associate

Mitchell Anderson
Visitor Experience Associate

Shawn Anderson
Vice President, Marketing and Group Sales

Arturo Arias Yepez
Visitor Experience Associate

Rosendo Arroyo
Custodial and Set-up Services Supervisor

Shraddha Aryal
Senior Vice President, Exhibition Design and Production

Donicia Atadero
Visitor Experience Associate

Roxana Avelar Castro
Custodial Associate

Lance Bad Heart Bull
Collections Specialist

Blake Ballinger
Visitor Experience Lead

Jose Barajas
Electrician

Sergio Barajas
Carpenter

Ariana Barela
Visitor Experience Associate

Nicholas Barlow
Assistant Curator

Tanya Barnes
Senior Coordinator, Advancement

Jacob Beaver
Graphic Designer

Laura Belevica
Director, Exhibition Design

Caitlin Bell
Visitor Experience Lead

Doris Berger
Vice President, Curatorial Affairs

Robert Berman
Theater Technical Engineer

Chelsea Bingham
Senior Editor, Publications

Cesar Bock-Sarabia
Operating Engineer

Lina Bonilla
Custodial Associate

Robert Brady
Visitor Experience Associate

Laura Bretscher
Retail Coordinator

Heather Brough
Advancement Services Manager

Monay Brown
In-Gallery Programs Specialist

Ashley Bugarin
Registration and Collection Management Coordinator

Damon Burton
Set-up Services Associate

Michael Butler
Safety and Security Associate

Ethan Caldwell
Director, Theater Operations

Lina Candrella
Loans and Exhibitions Registrar

Tino Carlo
Salesforce Administrator

Sarin Cemcem
Digital Strategy Manager

Andrew Cerecedes
Security Operations Center Operator

Tuni Chatterji
Film Education Manager

Spencer Christiano
Senior Projectionist

Aaron Colbert
Safety and Security Associate

Allen Collier IV
Groundskeeper

Gerard Collins
Collection Information Registrar

Adrian Concepcion
Maintenance Technician

Brendan Connell, Jr.
Chief Operating Officer and General Counsel

Christian Contreras
School and Teacher Programs Manager

Lohanne Cook
Public Engagement Manager

Jad Cooskey
Safety and Security Associate

Phyllis Cottrell
Associate Director, Exhibition Installation

Sara Crown
Institutional Archivist

Karina Cruz
Education Specialist

Kristina Cucchia
Buyer

Andrea De La Cruz
Senior Specialist, Recruiting

Luisa Del Cid
Senior Manager, People and Culture

Linsay Deming
Long-form Digital Content Producer

Talha Demir
Senior Coordinator, Membership

Tyrah Dillard
Web Fulfillment Associate

Esme Douglas
Curatorial Assistant

Phillip Duncan
Security Operations Center Operator

Lars Eckstrom
Publications Coordinator

Samantha Elba
Accounting Manager

Ashleymae Elmore
Talent Relations Coordinator

Claire Emerson
Senior Coordinator, Membership

Dinora Escalante
Custodial Associate

Moi Escamilla
Safety and Security Associate

Fabricio Espasande
Web Fulfillment Associate

Joshua Evans
E-commerce Manager

Kelsey Faamausili
Theater Operations Coordinator

Adriana Fernández
Senior Manager, Marketing and Advertising

Aloyea Francis
Set-up Services Lead

Charles Francis
Environmental Health and Safety Manager

Tyler Frost
Visitor Experience Supervisor

Valentina Galindo
Graphic Designer

Citlalie Gallegos
Events Manager

Kenneth Garcia-Farnsworth
Safety and Security Associate

Jason Garone
Custodial Lead

Melissa Garza
Exhibition Installation Specialist

Mariah Gelhard
Director, Retail

Natalie Gohel
Assistant Buyer

Staci Goines
Safety and Security Associate

Erin Golightly
Foundation and Government Relations Manager

Daniel Gomez
Senior Manager, Communications

Wendy Gomez
Exhibitions Coordinator

Joe Gott
Exhibition Installation Manager

Bria Grant
Legal Manager

Jillian Griffith
Associate Registrar, Loans and Exhibitions

Dayssi Guerrero
Custodial Associate

Reginald Guess
Security Supervisor

Juan Guillen-Velazquez
Groundskeeper

J. Raúl Guzmán
Assistant Curator

Cindy Ha
Senior Manager, Exhibition Planning

Emily Hadraba Davis
Corporate Partnerships Specialist

Brooklyn Hall-Grant
Sales Associate

Pablo Hamlin
Visitor Experience Associate

Quinn Hannibal
Visitor Experience Membership Lead

Jenny He
Exhibitions Curator

David Henriquez Andrade
Desktop Support Specialist

Madeleine Heppermann
Editorial Manager, Marketing and Communications

Joseph Hernandez
Security Supervisor

Madeleine Hiller
Visitor Experience Associate

Julia Hines
Visitor Experience Associate

Byron Hinojosa
Visitor Experience Associate

Ian Hodges
Security Supervisor

Amy Homma
Chief Audience Officer

Kelly Howland
Lighting Specialist

Tom Huerta
Safety and Security Associate

Julia Huffman
Digital Content Producer and Editor

Alysa Hughbanks
Stock Associate

Sophie Hunter
Senior Objects Conservator

Matthew Huynh
Desktop Support Specialist

Hyesung ii
Film Programs Manager

Ananya Iyer
Communications Coordinator

Ricardo Jacobo
Senior Manager, Facilities

Dara Jaffe
Associate Curator

Susan Jenkins
Vice President, Exhibition Planning

Kristy Jennings
Exhibition Graphic Design Manager

Ethan Jesse
People and Culture Specialist

Sam John
Visitor Experience Associate

Julia Johnston
Visitor Experience Associate

Cheryl Jones
Visitor Experience Associate

Matthew Kalemba
Events A/V Coordinator

Abby Kavanaugh
Associate Director, Membership and Annual Giving

Renee Kiefer
Permanent Collections Registrar

Peter Knezovich
Senior Manager, Operations

Noah Kodeki
Visitor Experience Associate

Owen Kolasinski
Photography Manager

Anthony Konopski
Safety and Security Associate

Manouchka Kelly Labouba
Research Assistant

Lucas Lacamara
Visitor Experience Supervisor

Michael Lam
Infrastructure Administrator

Dori Langvardt
Safety and Security Associate

Montoya Lee
Safety and Security Associate

Richard Lira Gonzalez
Visitor Experience Associate

Celia Lopez
Youth Programs Specialist

Josue Lopez
Research Assistant

Rio Lopez
Assistant Objects Conservator

Kimberly Lowe
Assistant Manager, Theater Operations

Patrick Lowry
Print Traffic Manager

Maria Loya
Safety and Security Associate

Andria Mack
Director, Operations

André Martinez
Film Education Specialist

Martha Martinez
Maintenance Technician

Chase McKesson
Visitor Experience Associate

Vincent Mead
Group Sales Manager

Peter Meitzenheimer
Safety and Security Associate

Maria Mejia de Rivas
Custodial Associate

Gladys Menjivar
Custodial Associate

Brooke Metayer
Communications Specialist

Chi Min
Desktop Support Specialist

Leslie Moctezuma
Custodial Supervisor

Camille Moore
Visitor Experience Associate

Cyndi Morales
Visitor Experience Associate

Veronica Morales
Custodial Associate

Dawn Mori
Senior Director, Foundation and Government Relations

Bradley Morris
Senior Projectionist

Stephen Morrissey
Senior Specialist, Exhibition Fabrication

Andrew Mueller
Associate Director, Exhibition Fabrication

Kelsey Mui
Sales Associate

Daniel Munoz
Lead Operating Engineer

Jefet Munoz
Security Operations Center Operator

Ovet Munoz Zavala
Lead Groundskeeper

Casey Myer
Visitor Experience Associate

Marina Navarro
Assistant Manager, Safety and Security

Sari Navarro
Film Programs Coordinator

William Nguyen
Store Manager

Jessica Niebel
Exhibitions Curator

Gabriel Nieto Rosario
Events Coordinator

Aka Obphrachanh
Director, Facilities

Ronald Ortez
Custodial Associate

Maria Oyelola
Sales Associate

Camille Papa
Visitor Experience Associate

Sabira Parajuli
Foundation and Government Relations Specialist

Claire Parsons
Events Manager

Gerardo Perez
Director, Safety and Security

Tatiana Plotnikova
Exhibition Design Manager

Martha Polk
Creative Producer, Digital Content

253

Victoria Porras
Safety and Security Associate

Giovina Pranolo
*Security Operations Center
Operator*

Marty Preciado
Director, Community and Impact

Gabriel Prieto
Visitor Experience Associate

Michelle Puetz
Exhibitions Curator

Pearce Quesenberry
*Marketing and Group Sales
Coordinator*

Jacinda Quintanar
Assistant Store Manager

Floyd Rabago
Safety and Security Associate

Maynor Ramirez
Safety and Security Associate

Emily Rauber Rodriguez
Research Assistant

Robin Ray
Visitor Experience Associate

Brandon Reily
Membership Coordinator

K. J. Relth-Miller
Interim Director, Film Programs

Bob Reneau
Film Programs Specialist

Jose Luis Reyes Rodriguez
Custodial Associate

Atshumi Richards
Director, Visitor Experience

Christopher Richmond
Associate Director, Exhibition A/V

Jessie Robertson
Retail Floor Supervisor

Dana Robie
*Assistant Manager, Visitor
Experience*

Molly Robins
Education Studio Coordinator

Christine Joyce Rodriguez
Director, Corporate Partnerships

Sharise Rogers
Visitor Experience Supervisor

Stefan Rogers
Corporate Partnerships Manager

Chris Roginski
Director, Events

Erik Ruiz
Set-Up Services Associate

Quinn Salazar
Visitor Experience Associate

Corey Saldana
Media Production Coordinator

Bernie Sale
Loans and Exhibitions Registrar

Saul Salgado
Custodial Associate

Raffat Salim
Warehouse Manager

Ivan Salinas
Senior Manager, Events A/V

Edna Salonga
Safety and Security Associate

Stephanie Samera
In-Gallery Programs Manager

Eduardo Sánchez
Public Programs Manager

Viviana Santillan
Visitor Experience Associate

Vanessa Sanz
Visitor Experience Associate

Cydney Schaefer
*Assistant Manager, Visitor
Experience*

Michael Shapiro
Visitor Experience Associate

Rayne Shelton
Visitor Experience Lead

Isaac Sherman
Senior Projectionist

Emily Shurtz
Theater Operations Manager

Bridgette Smith
*Senior Coordinator to the Chief
Audience Officer*

Tyreese Smith
Security Supervisor

Kiera Smithson
*Senior Coordinator, Board and
Academy Member Relations*

Miguel Solorio
*Leadership Annual Giving
Manager*

Kimber Stack
Advancement Services Specialist

Agnes Stauber
*Vice President, Digital Content
and Strategy*

Sarah Stearn
Sales Associate

Adair Stephens
Visitor Experience Associate

Kimberly Stephens
Talent Relations Manager

Jacqueline Stewart
Director and President

Ellen Swisher
*Cash and Administration
Coordinator*

Stephanie Sykes
Senior Director, Communications

Naomi Takasu
Sales Associate

Leon Tao
Safety and Security Associate

B. J. Thomas
*Senior Manager, Media
Production*

Gregory Thomas
Safety and Security Associate

Andrew Tiedge
Safety and Security Manager

Kiara Tinch
Major Gifts Officer

Emily Tobias
*Exhibition Graphic Design
Specialist*

Emily Torres
Safety and Security Associate

Tiffany Torres
Security Supervisor

Sergio Torres-Letelier
Theater Operations Manager

Barbara Turman
Director, Gift Planning

Noah Ulin
Senior Manager, Lighting Design

Connor Uretsky
*Associate Digital Product
Manager*

Enoc Urquilla Salinas
Custodial Associate

Eden Uyen Bui
*Community and Impact
Coordinator*

Madison Van Roekel
Visitor Experience Associate

Teresa Vargas
*Security Operations Center
Operator*

Leonard Vasquez
Associate Director, Capital Projects

Patricia Vazquez
Assistant Manager, Facilities

Sophia Wagner Serrano
Assistant Curator

Tracey Walker
Retail Floor Supervisor

McKenna Warde
Creative Specialist

Brecken Ware
Assistant Store Manager

Asia Washington
Sales Associate

Kamari West
Events Manager

Bridgette Wilder
Vice President, People and Culture

Calvin Williams
Safety and Security Associate

Keith Willis
Director, Finance

Lena Wong
Associate General Counsel

Sonja Wong Leaon
*Vice President, Registration and
Collection Management*

Julianne Woo
Operations Assistant

Jaclyn Wu
Curatorial Coordinator

Christina Ybarra
*Interim Director, Education and
Public Engagement*

Dane Yoshida
Visitor Experience Associate

Matthew Youngner
Vice President, Advancement

Zachariah Ziegler
Theater Staff

IMAGE CREDITS

Hag in a Black Leather Jacket, **Roman Candles**, **Eat Your Makeup**, **Mondo Trasho**, and **The Diane Linkletter Story** © Dreamland Studios. Screengrabs courtesy of Academy Film Archive.

Multiple Maniacs and **Pink Flamingos** © Warner Bros. Entertainment, Inc. Unit photography by Lawrence Irvine. Screengrabs courtesy of Criterion Collection.

Female Trouble © Warner Bros. Entertainment, Inc. Unit photography by Bruce Moore. Screengrabs courtesy of Criterion Collection.

Desperate Living © Warner Bros. Entertainment, Inc. Unit photography by Steve Yeager. Screengrabs courtesy of Warner Bros. Entertainment, Inc.

Polyester © Warner Bros. Entertainment, Inc. Unit photography by Larry Dean. Screengrabs courtesy of Criterion Collection.

Hairspray © Warner Bros. Entertainment, Inc. Unit photography by Henny Garfunkel. Screengrabs courtesy of Warner Bros. Entertainment, Inc.

Cry-Baby © Universal City Studios, Inc. and Imagine Films Entertainment, Inc. Unit photography by Henny Garfunkel. Screengrabs courtesy of Universal City Studios, Inc and Imagine Films Entertainment, Inc.

Serial Mom © Savoy Pictures. Unit photography by Phil Caruso. Screengrabs courtesy of Savoy Pictures.

Pecker © Warner Bros. Entertainment, Inc. Unit photography by Michael Ginsburg. Screengrabs courtesy of Warner Bros. Entertainment, Inc.

Cecil B. Demented © Lions Gate Films, Inc. Unit photography by Abbot Genser. Screengrabs courtesy of Lions Gate Films, Inc.

A Dirty Shame © Warner Bros. Entertainment, Inc. Unit photography by Jim Bridges. Screengrabs courtesy of Warner Bros. Entertainment, Inc.

Cover: Robin Marchant/Getty Images

Endpapers (front), p. 231: Paul Hutchins/Baltimore Sun Media

p. 13: Allison Michael Orenstein/Getty Images

pp. 18, 22, 78, 84 (top), 104 (bottom), 115 (bottom), 136 (top left and top right), 147 (bottom right), 174 (top), endpapers (back): © Academy Museum Foundation, photo by Mitro Hood

p. 20: © Ricky O. Studio, courtesy of Ogden and Mary Louise Reid Cinema Archives, Wesleyan University

p. 24: Amy Davis/Baltimore Sun Media

p. 31: Courtesy of John Waters

pp. 32, 43, 71, 75, 77, 89, 91, 95, 104 (top), 123, 133, 137 (bottom), 141, 144 (top left), 163 (top), 168 (bottom), 172 (top and center), 177, 184 (center right), 185 (center): Courtesy of Ogden and Mary Louise Reid Cinema Archives, Wesleyan University

p. 34: Fred W. McDarrah/MUUS Collection via Getty Images

pp. 50, 55, 57 (left), 58, 217 (bottom): Bob Adams

pp. 51 (left), 251 (center left): Jeffrey Pratt Gordon

pp. 52 (right), 65, 215: Steve Yeager

p. 54 (bottom): Ileane Meltzer

p. 54 (top): Courtesy of Marina Melin

p. 59: Dudley Gray

pp. 74, 83, 111, 114, 137 (top), 140 (bottom), 166 (top left), 167, 175 (top), 176 (bottom), 184 (bottom left), 185 (top), 188, 203: © Academy Museum Foundation, photo Chris Gardner, courtesy of Ogden and Mary Louise Reid Cinema Archives, Wesleyan University

pp. 100, 118, 125, 131, 144 (top right, center right, bottom right, and bottom left), 200 (center and bottom): Vincent Peranio Papers, Yale Collection of American Literature, Beinecke Rare Book and Manuscript Library

pp. 103, 113, 121, 129, 139, 161, 171, 179, 187, 195, 235: Courtesy of Margaret Herrick Library, Academy of Motion Picture Arts and Sciences

pp. 130 (center), 251 (bottom right): Courtesy of Rachel Talalay

p. 130 (bottom): Scott Rutherford

p. 162: © Academy Museum Foundation, photo by Alex Jamison

p. 163 (bottom): © Academy Museum Foundation, photo Leah Gallo

p. 166 (top right): © Academy Museum Foundation, photo Jenny He

p. 169 (top): © Bob Mizer and Athletic Model Guild, courtesy of the Bob Mizer Foundation

p. 182–83: Chuck Shacochis. Documentation © Academy Museum Foundation, photo Chris Gardner, courtesy of Ogden and Mary Louise Reid Cinema Archives, Wesleyan University

p. 204: Courtesy of Wesleyan University Photographer's Collection, Special Collections & Archives, Wesleyan University

p. 205: Joe Mabel

p. 209: A. Aubrey Bodine, courtesy of the Maryland Center for History and Culture, MdHS, B1598.1

p. 210: © Elinor B. Cahn, courtesy of the Maryland Center for History and Culture, MdHS, 1982.19.1.132

p. 217 (top): NBC Television/Getty Images

p. 218: © Kuchar Brothers Trust, courtesy of François Ghebaly Gallery

p. 227: © EVE Productions

p. 228: Sinna Nasseri/The New York Times

p. 229 (top): © The Andy Warhol Foundation for the Visual Arts, Inc. / Licensed by Artist Rights Society (ARS), NY

p. 229 (bottom): © Universal

p. 233: © Jim Burger

p. 234: Chris Stein

p. 251 (center right): Courtesy Gene Mendez

p. 251 (top): Jeffrey Raskin

This publication accompanies

JOHN WATERS: POPE OF TRASH

Organized by Jenny He and Dara Jaffe and presented at the Academy Museum of Motion Pictures, Los Angeles, September 17, 2023–August 4, 2024.

John Waters: Pope of Trash is made possible in part by major funding from Robert and Eva Shaye, The Four Friends Foundation.

Generous support provided by Emma Koss and Sara Risher.

Academy Museum Digital Engagement Platform sponsored by Bloomberg Philanthropies.

Bloomberg Philanthropies

Published in 2023 by the Academy Museum of Motion Pictures and DelMonico Books • D.A.P.

Academy Museum of Motion Pictures
6067 Wilshire Boulevard
Los Angeles, California 90036
academymuseum.org

DelMonico Books available through:
ARTBOOK | D.A.P.
75 Broad Street, Suite 630
New York, NY 10004
artbook.com
delmonicobooks.com

Design Content Object
Editing Karen Jacobson
Proofreading Dianne Woo
Color Separations Echelon, Los Angeles

Academy Museum of Motion Pictures
Stacey Allan, Director of Publications
Chelsea Bingham, Senior Editor
Lars Eckstrom, Publications Coordinator

DelMonico Books
Mary DelMonico, Publisher
Karen Farquhar, Director of Production

Printed and bound in China

ISBN: 978-1-63681-085-0
LCCN: 2023933509

Cover: John Waters, 2013

Endpapers, front: Cast and crew on the set of *Desperate Living* (1977). Back row, from left: Tom Watkins, Kevin Weber, Robert Maier, Thomas Loizeaux, Steve Yeager, Richard Ellsberry, Dolores Deluxe, Vincent Peranio, Dave Insley. Middle row, from left: Ed Peranio, Mink Stole, Marina Melin, Susan Lowe, Mary Vivian Pearce, John Waters, Liz Renay. Front row, from left: Van Smith, Jean Hill, Pat Moran, Sharon Niesp, Edith Massey, Cookie Mueller

Frontispiece: Divine in *Female Trouble* (1974)

Endpapers, back: Fan art on display in John Waters's studio, Baltimore, 2022

pp. 8–9: David Lochary in *Multiple Maniacs* (1970)

pp. 14–15: Pia Zadora in *Hairspray* (1988)

pp. 28–29: Mink Stole and Kathleen Turner in *Serial Mom* (1994)

pp. 44–45: Mary Vivian Pearce, David Lochary, and Divine in *Female Trouble* (1974)

pp. 206–7: Johnny Depp in *Cry-Baby* (1990)

pp. 212–13: Michael Potter and Edith Massey in *Female Trouble* (1974)

pp. 224–25: Edward Furlong in *Pecker* (1998)

pp. 236–37: Melanie Griffith in *Cecil B. Demented* (2000)

and wide, but
ver a stranger
treme style.
eccentric in